a century of

modern painting

JOSEPH-ÉMILE MULLER

FRANK ELGAR

a century of
modern painting

THAMES AND HUDSON · LONDON

Designed by René Ben Sussan

First published in Great Britain in 1972 by
Thames and Hudson Ltd, London

© 1966 Fernand Hazan, Paris

Printed in France

ISBN 0 500 23176 1

foreword

The hundred years separating us from the time Manet exhibited his *Olympia* are unquestionably one of the most fascinating periods in the history of art. Painting had never before changed so rapidly; painters had never explored in so many different directions and with such feverishness. Although the purpose of this book is to describe these changes, it does not attempt to give a detailed history and still less a colourful narrative. It limits itself to an account of the movements and artists who have given contemporary painting its most striking and original features. This is why it devotes so much space to the period preceding the last war, and even to the artists who made their mark before 1914; for it is these artists, in fact, who grappled with most of the problems that still preoccupy their successors today.

The very nature of the periods covered by the two writers required a different approach. The end of the nineteenth century and the first four decades of the twentieth are far enough away for us to see their movements in perspective and the artists who made them. The section on this period, which we published before in 1960 with the title,

Modern Painting: from Manet to Mondrian, is composed of a series of short monographs. This means that, although the movements occupy their rightful place in it, the painters who made them famous are not simply considered as pointers in an artistic evolution, but as its creators whose works themselves embody its value and significance.

The second section, on the other hand, covering the last twenty-five years, is primarily concerned with tendencies. History has not yet had time to assess the real importance of individual contributions to the profusion of experimentation in this period and the most suitable way of approaching it seemed to be through a discussion of the ideas informing the main currents in painting. This method of handling the subject has not led the author to sacrifice all consideration of individual artists' work any more than his concern for objective information has prevented him from offering critical judgments.

We think, too, that this book will not only enable the reader to distinguish the original contribution made by each of the great masters of modern painting, but also to understand the meaning and intentions behind frequently contradictory attitudes that form the pattern of artistic life from 1940 to our own day.

The Publisher

contents

impressionism

Édouard Manet. '' M. Manet... neither claimed to throw over old forms of painting, nor to create new ones. He simply sought to be himself and no one else. '' If Manet (1832-1883) thought it necessary to write this in the catalogue of his exhibition of 1867, it was undoubtedly less to reveal his true intentions than to camouflage them before the eyes of a hostile public. He, whose *Déjeuner sur l'Herbe* had been inspired by Raphael and Giorgione, who had painted his *Olympia* inspired by Titian's *Venus of Urbino*, could not fail to realise the novelty of his paintings since they immediately invited one to measure the distance which separated them from their models.

When Giorgione had in his *Pastoral Concert* shown two females naked alongside two men dressed, these nudes were idealised, their faces anonymous and overshadowed, the light which surrounded the figures had the poetry of melancholy twilight, the whole scene took on a legendary aspect. There is nothing of this in Manet. These two men in the *Déjeuner sur l'Herbe*, you might have met them, wearing the same clothes, on the boulevards of Paris. Far from any idealisation, the body of this naked woman is as individualised as her face. As for the light, it is cold and ordinary. The whole picture possesses a realistic note which contradicts the absurd situation in which the figures are shown.

The same applies to *Olympia*. A critic wrote, '' M. Manet who paints sullied virgins will not be accused of idealising foolish virgins. '' What was the meaning, beside that sickly anaemic, '' cadaverous '' nude, of the presence of the negress and that black cat which, wrote Théophile Gautier, '' leaves the imprint of its muddy paws on the bed ? '' The truth is that in these two works the subject is nothing more than a pretext; the essential is not the relationship which might exist between the principal figures, it is that which exists between the colours, between the forms. When Manet wanted to add a light patch, he painted a nude; when he wanted to contrast this light patch with a dark note, he painted a man in a black jacket, a negress, a cat. In other words painting, which up to then had been nothing but a means, becomes an end in itself. This was an innovation too upsetting to ingrained attitudes not to appear a provocation, a challenge thrown at the public.

9

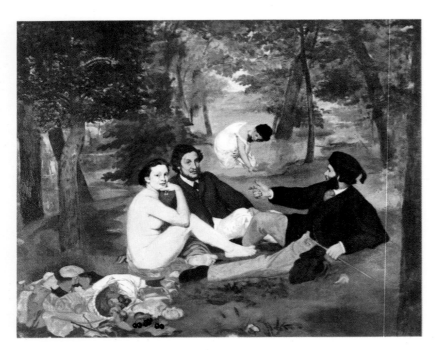

Manet. Le déjeuner sur l'herbe. 1863.
Musée de l'Impressionnisme, Paris.

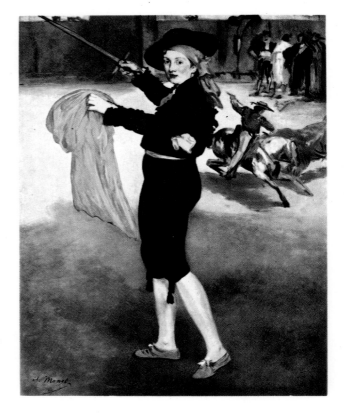

Manet. Mademoiselle Victorine
in the costume of an espada. 1862.
Havemeyer Collection,
Metropolitan Museum,
New York.

The style of *Olympia* was disconcerting too. These flattened volumes, these wiry outlines, these shadows which, adds Théophile Gautier, '' are indicated by streaks of boot polish of varying width '', these vast light areas that collide with dark ones without any intermediate transitional stage, this reduction of depth that brings out the figures with precision, like close-ups on a screen; all this is contrary to painting as it had been practised in Europe ever since the 15th century, all this heralds the painting of the future.

However, although under the influence of Japanese prints, which Paris had just discovered with enthusiasm, in *Olympia*, the *Fifer*, the *Portrait of Théodore Duret*, Manet had moved away from tradition, in other pictures he remained attached to it and limited himself to speaking its language with personal inflections.

In 1874, Berthe Morisot, who had become his sister-in-law, drew him closer to the impressionists. That is to say, Manet altered his palette, making use of brighter, more luminous colours, but he very rarely got down to painting a pure landscape. Although he was ready to observe the play of light, atmospheric effects on the Seine or on the Grand Canal in Venice, he refused to sacrifice tangible elements; he continued to value the presence of human forms, their firmness and their balance.

Without any doubt, he remained faithful to the human image also because he enjoyed watching

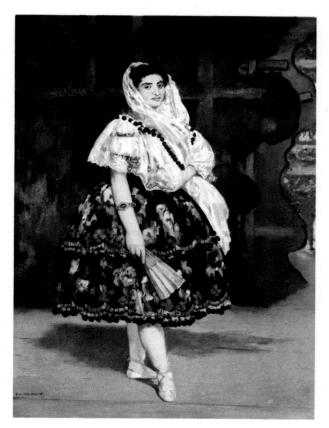

Manet. Lola de Valence. 1861-1862.
Musée de l'Impressionnisme, Paris.

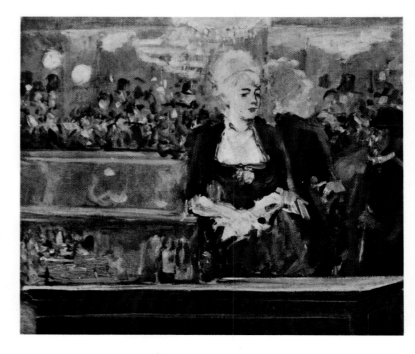

Manet.
Sketch for
the " Bar at the Folies-
Bergère ". 1882.
Kœnings Collection,
Wageningen.

the society of his period. There was in him something of the loiterer and the recorder. The elegant, strolling crowd attracted by the music in the Tuileries or a masked ball at the Opéra, road-menders in the rue de Berne, these were some of his subjects. He looked at them with detachment rather as if they were objects in front of a camera. Yet his art goes beyond a cold objectivity; although Manet was not passionately involved when he was looking, he was when he was painting. Alert, carried away, at the same time very free and very evocative, his touch resembles that of Franz Hals and Velasquez, both of whom he particularly admired.

As for his colouring, it appears to have nothing far-fetched, yet it is distinguished. His somewhat acid freshness at times becomes frigid, but the effect is rich and heady. When Manet adopted the palette of the impressionists he did not, however, give up permanently the greys and blacks with which he had before 1874 been able to create such superb effects. By combining the contributions of impressionism with what visits to museums had taught him, he created works such as *A Bar at the Folies-Bergère* where novelty unites harmoniously with tradition, where the blurred, the impalpable, the fleeting wonder of the moment, co-exists with the solid, the stable, in a picture which is at the same time astonishing and strongly composed.

The painting, which a writer in 1874 in the review *Charivari* labelled " impressionist ", had already

11

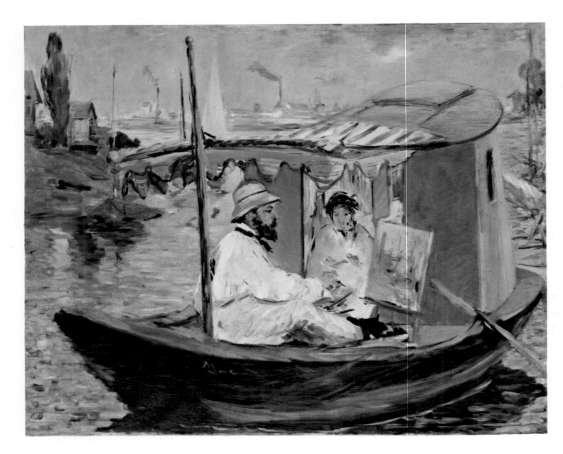

Manet.
Claude Monet painting
in his boat. 1874.
Bayerische
Staatsgemäldesammlungen,
Munich.

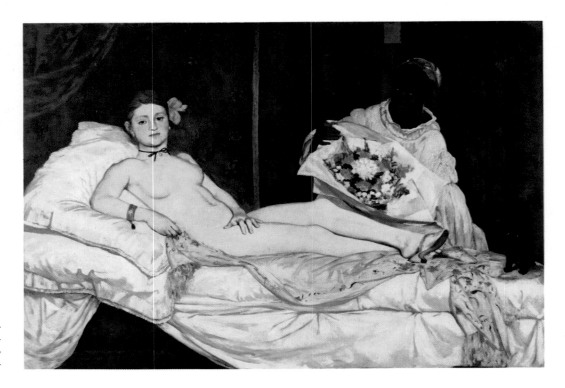

Manet.
Olympia. 1863.
Musée de l'Impressionnisme,
Paris.

existed for several years, when it acquired its name. The very picture that inspired this label, the famous Port of Le Havre, which Monet had called *Impression-Sunrise*, was painted in 1872. The origins of impressionist painting go back to the middle 60's. Monet was at that time working at Paris, in the forest of Fontainebleau and on the Normandy beaches. He had listened to the advice of Boudin and Jongkind and reflected on the pictures of Corot, the Barbizon painters and Courbet. His

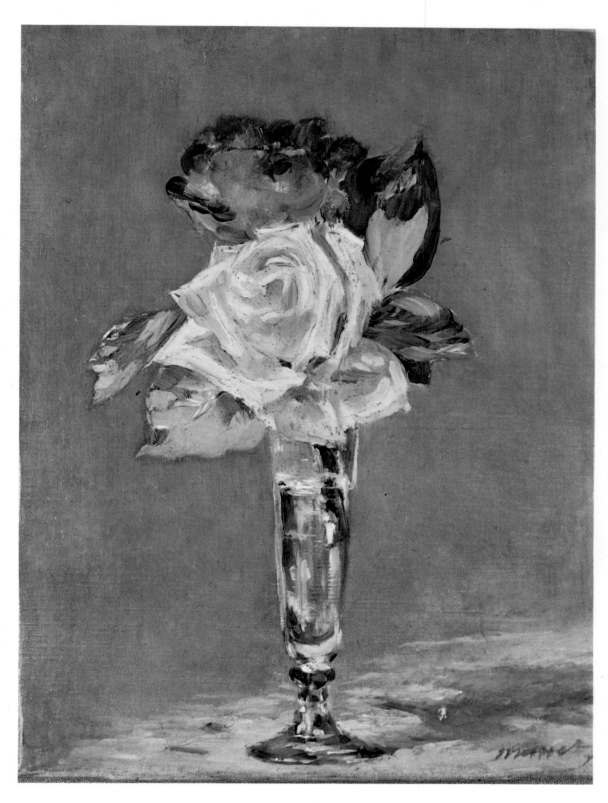

Manet.
Roses in a vase.
About 1877.
Museum
and Art Gallery,
Glasgow.

friends, Renoir, Pissarro, Sisley and Bazille, admired much the same painting as he did and were moving in the same direction.

After the *Olympia* scandal, all these artists grouped themselves around Manet. They were, however, more inclined to approve the attitude he adopted towards official painting than to follow the example of his style. Monet showed it very clearly when in 1866-1867 he painted his *Women in*

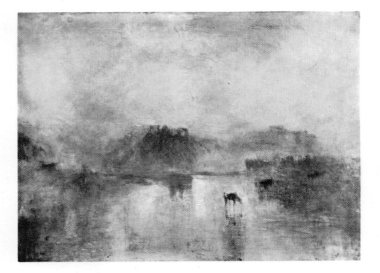

Turner. Norham Castle at sunrise.
After 1830. Tate Gallery, London.

Boudin.
Approaching storm. 1864.
The Art Institute, Chicago.

Jongkind.
The beach at Sainte-Adresse.
1863.
Musée de l'Impressionnisme,
Paris.

the Garden. To begin with he painted his picture entirely in the open, which was in itself a new departure. Also, he no longer indicated shadows over faces and bright clothes by the use of dark tones but replaced them by cold colours, greens and blues; in doing this, he set up an interplay of colours independent of the shape of objects, which even tended to upset and dislocate them. Certainly in the *Women in the Garden* the dislocation of objects is only indicated, the atmospheric veils are barely perceptible before these large figures that he observes close to. Monet had not yet abandoned a form of drawing whose clarity belongs to a tradition of painting in the studio, rather than in the open. Also this new method becomes more emphatic in the landscapes which Monet and Renoir painted in 1869 of the famous *Bathing-place of la Grenouillère*, because there they viewed figures from a distance and were able to concentrate their attention on the play of light and atmosphere, which were to become the principal elements of impressionist painting. A period spent in England, during the Franco-Prussian War of 1870, was responsible for hastening Monet and Pissarro's development. For in London, the two artists saw Constables and Turners and if they did not admire them unreservedly, they found in their work affinities and encouragement.

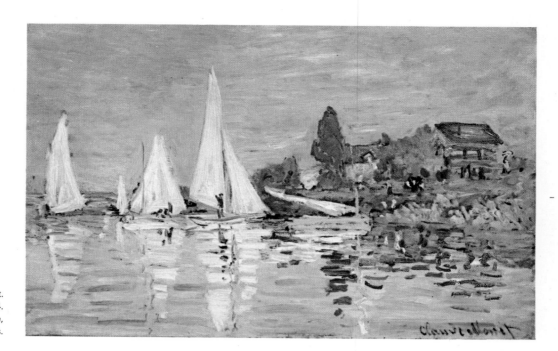

Monet.
Regatta at Argenteuil. 1874.
Musée de l'Impressionnisme,
Paris.

The first exhibition which in 1874 gathered the representatives of the new school of painting together in Paris, at the studio of Nadar the photographer, is for the history of art an event of such importance that one tends to think its organisers too realised its significance and wished to stress it to the public. This was not so. The artists who took part in this exhibition presented themselves to the Parisians under the simple title of a *Limited co-operative company of painters, sculptors, engravers, etc...* They did not think of drawing up a manifesto. They did not want to establish a school. Besides, they did not all belong to the same tendency, nor did they all show the same qualities. In fact thirty of them exhibited and eight of them only—Monet, Renoir, Pissarro, Sisley, Berthe Morisot, Guillaumin, Degas and Cézanne—were to become famous as impressionists.

Does this mean that these formed a homogeneous group? Their temperaments differed and their interests, as we shall see, were on certain points opposed. But what they had in common was the rejection of all that was dear to academic painting, historical, mythological and sentimental subjects, over-polished finish, dull tar-like colours. They also shared the determination to produce contemporary painting; they took their subjects from the everyday reality of their time and tried to express their sensations with sincerity, even should this force them to go against the rules of time-honoured tradition. To a certain extent they were all agreed in wanting to put on canvas, not what the painter knows of things, but only what strikes him at the precise moment when he paints. Besides, most of them showed a preference for the hazy landscapes of the Ile-de-France, for skies continually being transformed by cloud, for the shimmering reflections on the moving waters of the Seine and the Oise.

The analysis of luminous phenomena led them to break new ground in the field of technique. They limited their palette to the colours of the spectrum and took into account the laws of complementary colours. Knowing that complementary colours applied side by side heighten each other, whereas if mixed destroy each other, they applied their colours pure, in little dabs and accents without always avoiding, it is true, their crossing and confusion; for their principles were applied instinctively and not systematically. Nevertheless their painting became much lighter than that of any of their predecessors since Leonardo da Vinci and they gave the world outside a freshness, a youthfulness and, more than anything else, a variety of light effects that had never been known before in Europe.

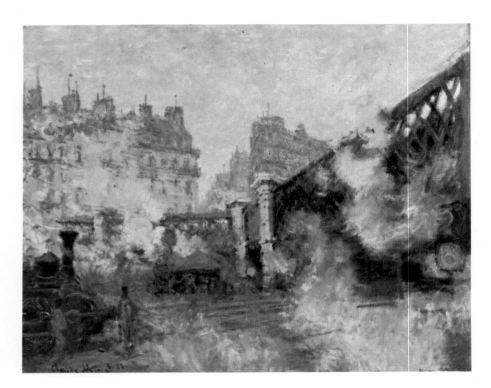

Monet.
Le Pont de l'Europe. 1877.
Musée Marmottan, Paris.

Monet.
The Doges' Palace;
view from San Giorgio Maggiore.
1908.
Durand-Ruel Collection,
Paris.

Claude Monet. No one represents impressionism better than Monet (1840-1926), no one has illustrated it with greater boldness, more logic and less compromise. Does this mean that his work embodies its theory better than anyone else's? He said: " We paint as a bird sings. Paintings are not made with doctrines. " These utterances, which are often quoted, should not be taken too literally. Speculation did unquestionably have a place in his art, a painterly speculation, of course, in which instinct played a part as much as conscious research. After all, Monet was the painter of series and the first of these, the *Gare Saint-Lazare* at Paris, was done as early as 1876.

1876 was the Argenteuil period, the most " naïve " period of impressionism. Monet had just completed on the Seine or in its neighbourhood some of the most successful works of the new paint-

impressionism

Édouard Manet. '' M. Manet... neither claimed to throw over old forms of painting, nor to create new ones. He simply sought to be himself and no one else. '' If Manet (1832-1883) thought it necessary to write this in the catalogue of his exhibition of 1867, it was undoubtedly less to reveal his true intentions than to camouflage them before the eyes of a hostile public. He, whose *Déjeuner sur l'Herbe* had been inspired by Raphael and Giorgione, who had painted his *Olympia* inspired by Titian's *Venus of Urbino*, could not fail to realise the novelty of his paintings since they immediately invited one to measure the distance which separated them from their models.

When Giorgione had in his *Pastoral Concert* shown two females naked alongside two men dressed, these nudes were idealised, their faces anonymous and overshadowed, the light which surrounded the figures had the poetry of melancholy twilight, the whole scene took on a legendary aspect. There is nothing of this in Manet. These two men in the *Déjeuner sur l'Herbe*, you might have met them, wearing the same clothes, on the boulevards of Paris. Far from any idealisation, the body of this naked woman is as individualised as her face. As for the light, it is cold and ordinary. The whole picture possesses a realistic note which contradicts the absurd situation in which the figures are shown.

The same applies to *Olympia*. A critic wrote, '' M. Manet who paints sullied virgins will not be accused of idealising foolish virgins. '' What was the meaning, beside that sickly anaemic, '' cadaverous '' nude, of the presence of the negress and that black cat which, wrote Théophile Gautier, '' leaves the imprint of its muddy paws on the bed ? '' The truth is that in these two works the subject is nothing more than a pretext; the essential is not the relationship which might exist between the principal figures, it is that which exists between the colours, between the forms. When Manet wanted to add a light patch, he painted a nude; when he wanted to contrast this light patch with a dark note, he painted a man in a black jacket, a negress, a cat. In other words painting, which up to then had been nothing but a means, becomes an end in itself. This was an innovation too upsetting to ingrained attitudes not to appear a provocation, a challenge thrown at the public.

9

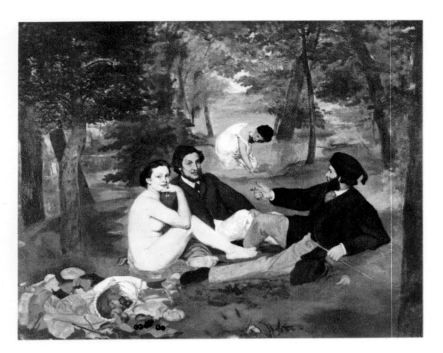

Manet. Le déjeuner sur l'herbe. 1863.
Musée de l'Impressionnisme, Paris.

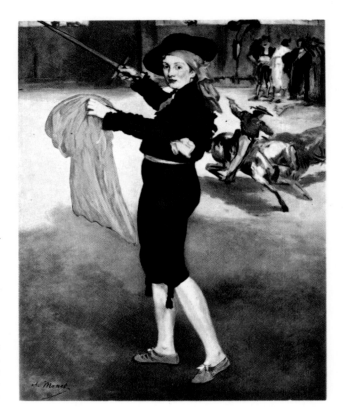

Manet. Mademoiselle Victorine
in the costume of an espada. 1862.
Havemeyer Collection,
Metropolitan Museum,
New York.

The style of *Olympia* was disconcerting too. These flattened volumes, these wiry outlines, these shadows which, adds Théophile Gautier, '' are indicated by streaks of boot polish of varying width '', these vast light areas that collide with dark ones without any intermediate transitional stage, this reduction of depth that brings out the figures with precision, like close-ups on a screen; all this is contrary to painting as it had been practised in Europe ever since the 15th century, all this heralds the painting of the future.

However, although under the influence of Japanese prints, which Paris had just discovered with enthusiasm, in *Olympia*, the *Fifer*, the *Portrait of Théodore Duret*, Manet had moved away from tradition, in other pictures he remained attached to it and limited himself to speaking its language with personal inflections.

In 1874, Berthe Morisot, who had become his sister-in-law, drew him closer to the impressionists. That is to say, Manet altered his palette, making use of brighter, more luminous colours, but he very rarely got down to painting a pure landscape. Although he was ready to observe the play of light, atmospheric effects on the Seine or on the Grand Canal in Venice, he refused to sacrifice tangible elements; he continued to value the presence of human forms, their firmness and their balance.

Without any doubt, he remained faithful to the human image also because he enjoyed watching

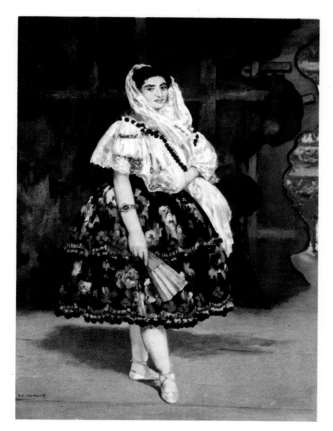

Manet. Lola de Valence. 1861-1862.
Musée de l'Impressionnisme, Paris.

Manet.
Sketch for
the " Bar at the Folies-
Bergère ". 1882.
Kœnings Collection,
Wageningen.

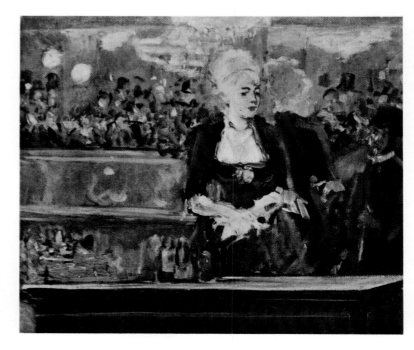

the society of his period. There was in him something of the loiterer and the recorder. The elegant, strolling crowd attracted by the music in the Tuileries or a masked ball at the Opéra, road-menders in the rue de Berne, these were some of his subjects. He looked at them with detachment rather as if they were objects in front of a camera. Yet his art goes beyond a cold objectivity; although Manet was not passionately involved when he was looking, he was when he was painting. Alert, carried away, at the same time very free and very evocative, his touch resembles that of Franz Hals and Velasquez, both of whom he particularly admired.

As for his colouring, it appears to have nothing far-fetched, yet it is distinguished. His somewhat acid freshness at times becomes frigid, but the effect is rich and heady. When Manet adopted the palette of the impressionists he did not, however, give up permanently the greys and blacks with which he had before 1874 been able to create such superb effects. By combining the contributions of impressionism with what visits to museums had taught him, he created works such as *A Bar at the Folies-Bergère* where novelty unites harmoniously with tradition, where the blurred, the impalpable, the fleeting wonder of the moment, co-exists with the solid, the stable, in a picture which is at the same time astonishing and strongly composed.

The painting, which a writer in 1874 in the review *Charivari* labelled " impressionist ", had already

11

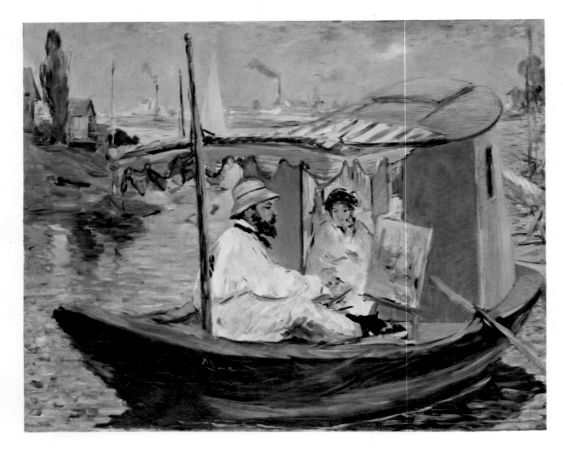

Manet.
Claude Monet painting
in his boat. 1874.
Bayerische
Staatsgemäldesammlungen,
Munich.

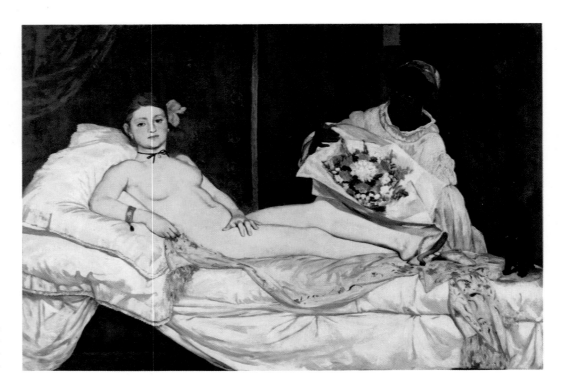

Manet.
Olympia. 1863.
Musée de l'Impressionnisme,
Paris.

existed for several years, when it acquired its name. The very picture that inspired this label, the famous Port of Le Havre, which Monet had called *Impression-Sunrise*, was painted in 1872. The origins of impressionist painting go back to the middle 60's. Monet was at that time working at Paris, in the forest of Fontainebleau and on the Normandy beaches. He had listened to the advice of Boudin and Jongkind and reflected on the pictures of Corot, the Barbizon painters and Courbet. His

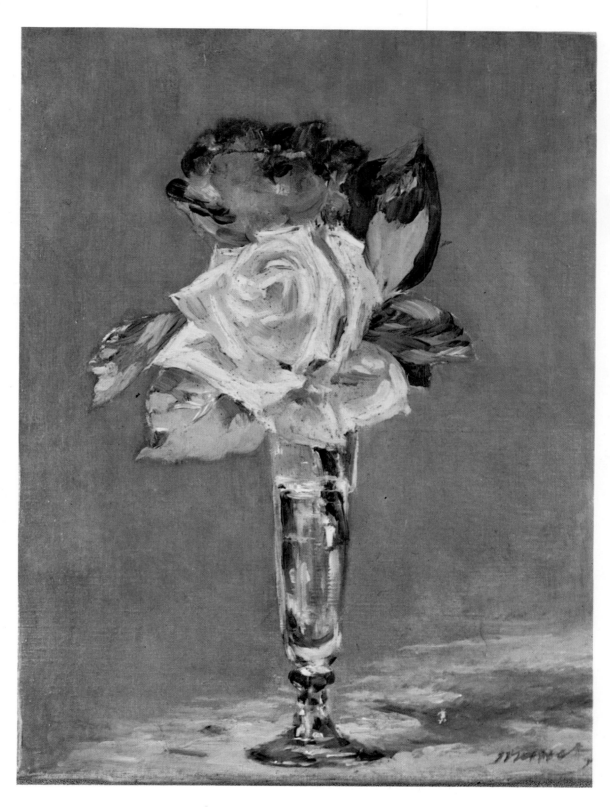

Manet.
Roses in a vase.
About 1877.
Museum
and Art Gallery,
Glasgow.

friends, Renoir, Pissarro, Sisley and Bazille, admired much the same painting as he did and were moving in the same direction.

After the *Olympia* scandal, all these artists grouped themselves around Manet. They were, however, more inclined to approve the attitude he adopted towards official painting than to follow the example of his style. Monet showed it very clearly when in 1866-1867 he painted his *Women in*

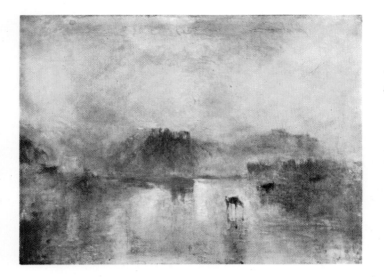

Turner. Norham Castle at sunrise.
After 1830. Tate Gallery, London.

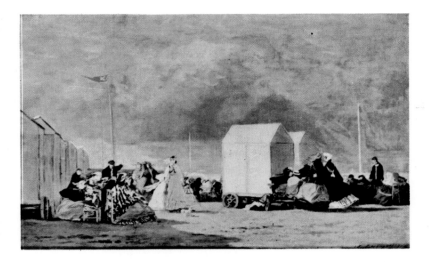

Boudin.
Approaching storm. 1864.
The Art Institute, Chicago.

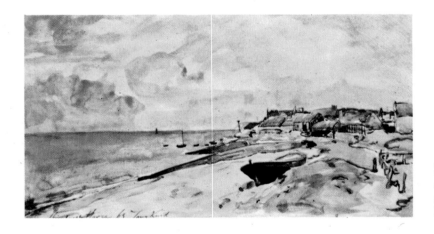

Jongkind.
The beach at Sainte-Adresse.
1863.
Musée de l'Impressionnisme,
Paris.

the Garden. To begin with he painted his picture entirely in the open, which was in itself a new departure. Also, he no longer indicated shadows over faces and bright clothes by the use of dark tones but replaced them by cold colours, greens and blues; in doing this, he set up an interplay of colours independent of the shape of objects, which even tended to upset and dislocate them. Certainly in the *Women in the Garden* the dislocation of objects is only indicated, the atmospheric veils are barely perceptible before these large figures that he observes close to. Monet had not yet abandoned a form of drawing whose clarity belongs to a tradition of painting in the studio, rather than in the open. Also this new method becomes more emphatic in the landscapes which Monet and Renoir painted in 1869 of the famous *Bathing-place of la Grenouillère*, because there they viewed figures from a distance and were able to concentrate their attention on the play of light and atmosphere, which were to become the principal elements of impressionist painting. A period spent in England, during the Franco-Prussian War of 1870, was responsible for hastening Monet and Pissarro's development. For in London, the two artists saw Constables and Turners and if they did not admire them unreservedly, they found in their work affinities and encouragement.

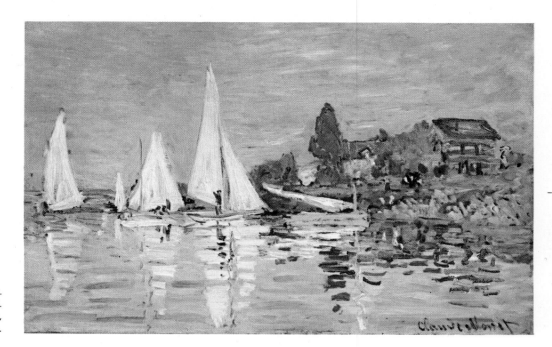

Monet.
Regatta at Argenteuil. 1874.
Musée de l'Impressionnisme,
Paris.

The first exhibition which in 1874 gathered the representatives of the new school of painting together in Paris, at the studio of Nadar the photographer, is for the history of art an event of such importance that one tends to think its organisers too realised its significance and wished to stress it to the public. This was not so. The artists who took part in this exhibition presented themselves to the Parisians under the simple title of a *Limited co-operative company of painters, sculptors, engravers, etc...* They did not think of drawing up a manifesto. They did not want to establish a school. Besides, they did not all belong to the same tendency, nor did they all show the same qualities. In fact thirty of them exhibited and eight of them only—Monet, Renoir, Pissarro, Sisley, Berthe Morisot, Guillaumin, Degas and Cézanne—were to become famous as impressionists.

Does this mean that these formed a homogeneous group? Their temperaments differed and their interests, as we shall see, were on certain points opposed. But what they had in common was the rejection of all that was dear to academic painting, historical, mythological and sentimental subjects, over-polished finish, dull tar-like colours. They also shared the determination to produce contemporary painting; they took their subjects from the everyday reality of their time and tried to express their sensations with sincerity, even should this force them to go against the rules of time-honoured tradition. To a certain extent they were all agreed in wanting to put on canvas, not what the painter knows of things, but only what strikes him at the precise moment when he paints. Besides, most of them showed a preference for the hazy landscapes of the Ile-de-France, for skies continually being transformed by cloud, for the shimmering reflections on the moving waters of the Seine and the Oise.

The analysis of luminous phenomena led them to break new ground in the field of technique. They limited their palette to the colours of the spectrum and took into account the laws of complementary colours. Knowing that complementary colours applied side by side heighten each other, whereas if mixed destroy each other, they applied their colours pure, in little dabs and accents without always avoiding, it is true, their crossing and confusion; for their principles were applied instinctively and not systematically. Nevertheless their painting became much lighter than that of any of their predecessors since Leonardo da Vinci and they gave the world outside a freshness, a youthfulness and, more than anything else, a variety of light effects that had never been known before in Europe.

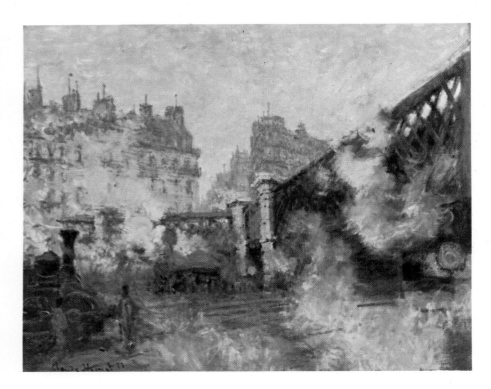

Monet.
Le Pont de l'Europe. 1877.
Musée Marmottan, Paris.

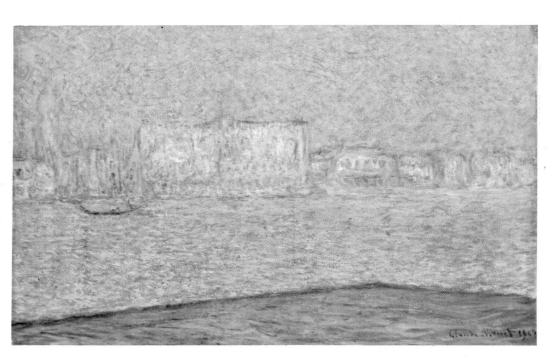

Monet.
The Doges' Palace;
view from San Giorgio Maggiore.
1908.
Durand-Ruel Collection,
Paris.

Claude Monet. No one represents impressionism better than Monet (1840-1926), no one has illustrated it with greater boldness, more logic and less compromise. Does this mean that his work embodies its theory better than anyone else's? He said: '' We paint as a bird sings. Paintings are not made with doctrines. '' These utterances, which are often quoted, should not be taken too literally. Speculation did unquestionably have a place in his art, a painterly speculation, of course, in which instinct played a part as much as conscious research. After all, Monet was the painter of series and the first of these, the *Gare Saint-Lazare* at Paris, was done as early as 1876.

1876 was the Argenteuil period, the most '' naïve '' period of impressionism. Monet had just completed on the Seine or in its neighbourhood some of the most successful works of the new paint-

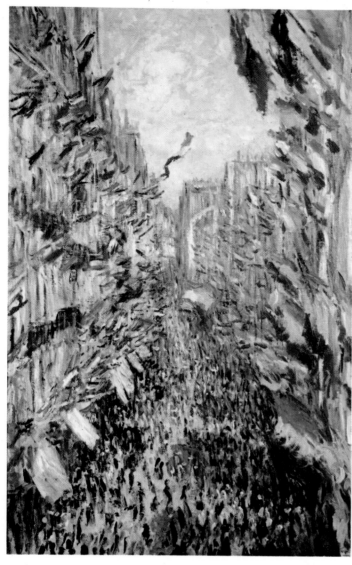

Monet.
Rue Montorgueil.
Celebrations on June 30th.
1878.
Mme Lindon Collection,
Paris.

Monet.
Water-lilies: green harmony.
1899.
Musée de l'Impressionnisme,
Paris.

ing. What then made him change his subject and choose one that seems at first sight far less pictu-resque than those he had painted up to that point? Probably it was this very lack of picturesqueness that attracted him. Great artists have often set themselves the task of finding beauty and poetry where they are least apparent. But the Gare Saint-Lazare gave him the opportunity of studying an even more fugitive element than water: the smoke from engines. The haziness of this smoke, its capricious mean-derings, its fairylike iridescence, the changes that it made on metal surfaces and the neighbouring houses—how could all this fail to fascinate him?

The term " free " series has been similarly applied to these works as to the *Break-up of the Ice* paintings that Monet did at Vétheuil in 1880. Ten years later, the " systematic " series appeared, the

17

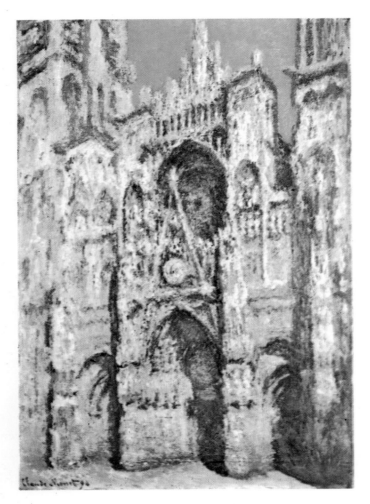

Monet.
Rouen Cathedral
in full sunlight. 1894.
Musée de l'Impressionnisme,
Paris.

Monet.
Yellow irises, Giverny.
Private Collection,
Switzerland.

most significant of which was the one of *Rouen Cathedral* (1892-1894). It comprises more than twenty variations, always of the same façade, nearly always seen from the same angle. Nothing illustrates more clearly that the essential thing for him was not the subject, but the effect it produced at different hours of the day, in fair weather or cloud, in clear air or mist. Never before had anyone changed their position so little and discovered so many facets in a single subject; or rather, never before had anyone caught with such sensibility the miraculous and multiple reality of light and atmosphere. These natural appearances fascinated the artist so much that he sacrificed the substance, consistency and weight of things; the façade of the cathedral is reduced to a subtly coloured veil and there remains only an evanescent reminder of its structure.

This blotting out of the shape itself becomes even more accentuated in the various pictures Monet painted of the *Houses of Parliament* in London at the beginning of the century. Surrounded by either a blue or purplish fog in which an ethereal sun dissolves its yellows, its oranges and its pinks, the building itself is nothing but a ghost that looks as if a mere breath of air would be sufficient to shake it.

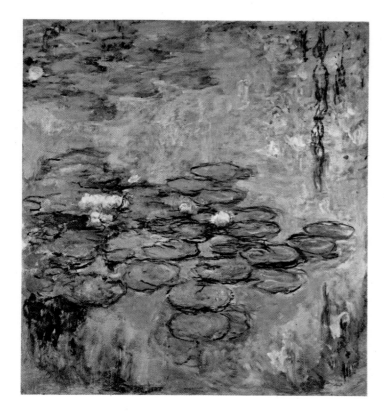

Monet.
Pink clouds. 1918.
Katia Granoff Collection,
Paris.

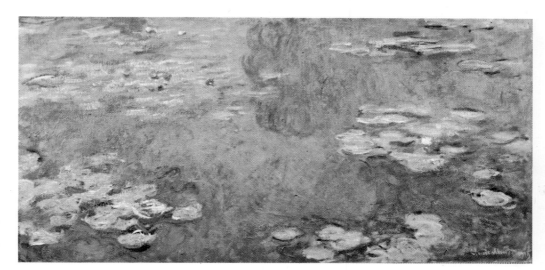

Monet.
Water-lilies, Giverny.
Private Collection,
Paris.

One is reminded of Turner, although Monet is far from possessing his romanticism; for although it is true that there was a visionary in him as well as an observer, it is no less certain that he was careful not to engulf the world in his dreams.

When in 1899 he began painting his *Water-lilies*, his point of departure was still nature. The water garden, which he designed himself in his property at Giverny, provided him with the subject. If, at the beginning, objects are still easily identifiable, the vegetation of the pond and on its banks, the water-lilies, the jonquils, the wistaria, the weeping willows later take on vague shapes and the paintings show us above all blobs, trails, flourishes and tangles of colour which have a strong tendency to be sufficient in themselves. So, at the end of his life, Monet was far from the realism, far even from the impressionism of the Argenteuil period. The *Flower Garden* and the *Pond with Wistaria* suggest certain abstract painters of today. This is why his work has recently enjoyed a fresh interest after being long neglected for a more geometric painting.

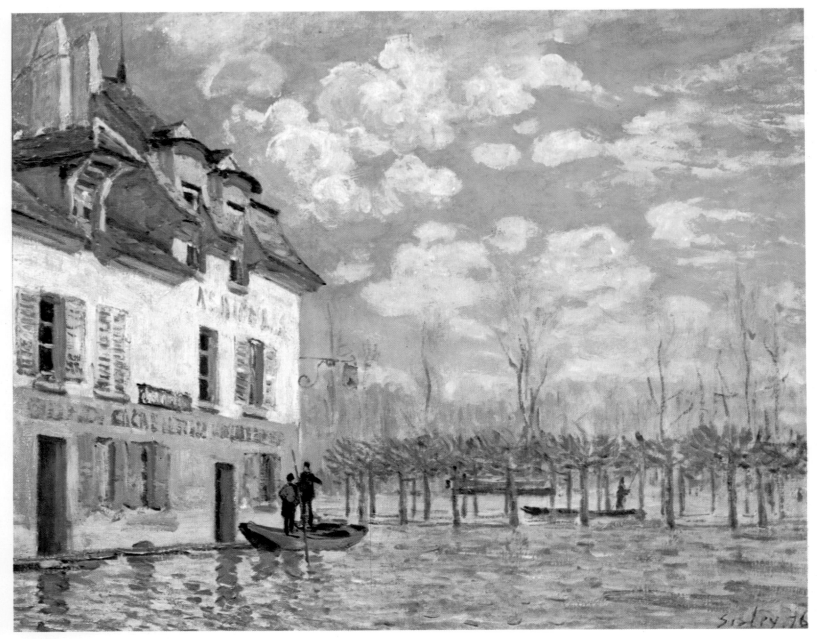

Sisley. Boat during a flood. 1876. Musée de l'Impressionnisme, Paris.

Alfred Sisley. Sisley (1839-1899) at the outset was close to Corot and even when he allowed himself to be led towards impressionism by Monet, he still did not stray far from his master. However, if his senses were as easily awakened and his conception no less tender than that of his predecessor, his colours are more differentiated, as they owe less to fancy than to observation.

He lived and went about in the Ile-de-France, particularly in the Fontainebleau area; here he painted a river bank or a canal, a road leading either towards a village or fading away in the distance, there a village shrouded in soft light by the snow or invaded by the muddy waters of a flood. But whatever his subject, he observed it with calm. The flood as he saw it was not a disaster; clouds which, from the depths of the horizon, climb into the heavens do not bring lightning or rain in their wake; they are not upset by the storm and generally they move at a leisurely pace; one would suppose that their only object was to filter the light and to allow the air to preserve its freshness, and to rid the colours of the world of their sharpness.

Until around 1877, Sisley was a master at expressing shades of meaning and subtle transitions.

20

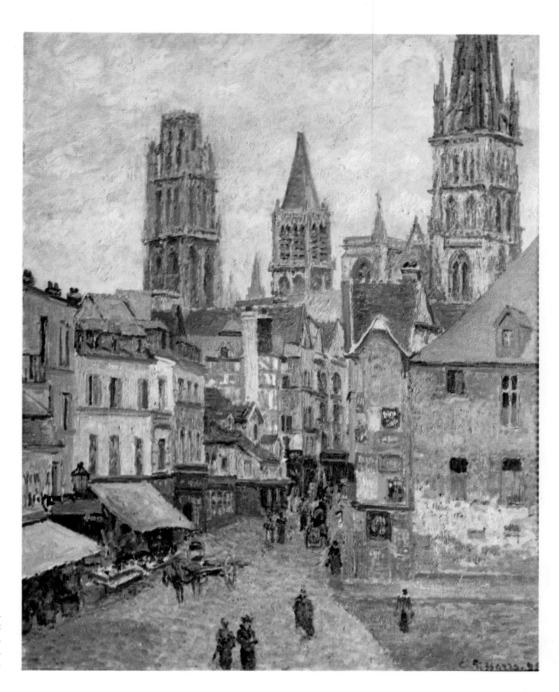

Pissarro.
Rue de l'Épicerie, Rouen;
morning in dull weather. 1898.
Private Collection,
Paris.

However, fired by Monet's example, he wished in his turn to increase the liveliness of his colours. From then on he forced his temperament and was generally less convincing. By losing his restraint, his art lost some of its exquisite delicacy, its distinction and very often its truth.

Camille Pissarro. Like Sisley, Pissarro (1830-1903) began by being under the influence of Corot and like him he was later guided by Monet, both towards impressionism and towards the assertion of his own personality. Pissarro and Sisley also possessed a similar sensibility, although one finds in the former's work a note of anxiety which is lacking in that of the latter.

Up to 1884, Pissarro sought his subjects particularly around Pontoise. Sometimes, he set up his easel on the banks of the Oise, or at the corner of a road, sometimes he stopped by a farm gate opposite a peasant coming home from the fields, or of a woman pushing a wheel-barrow, sometimes he settled in a field where harvesting was in progress, or by a group of houses half hidden by trees.

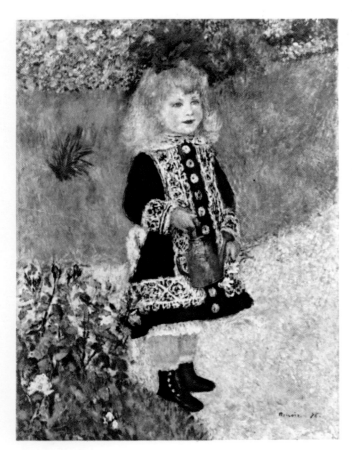

Renoir. Girl with a watering-can. 1876.
Chester Dale Collection,
National Gallery of Art,
Washington.

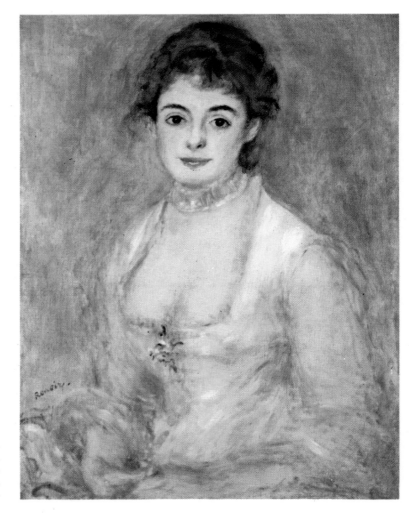

Renoir.
Portrait of Madame Henriot.
About 1876.
National Gallery of Art,
Washington.

These he loved, not only because of their green touches in contrast to the red roofs, but also because of the lines their trunks and branches would design over the canvas. Despite his impressionism, Pissarro does in fact remain the advocate of a certain amount of structure and solidity.

In 1886, Pissarro allowed himself to be drawn beneath the banner of neo-impressionism. He soon realised that he had made a mistake and that his painting had become too systematic and in consequence dried up, so he regained his freedom.

During his last years, he at various periods painted scenes of towns (Paris, Rouen, Dieppe). While looking down from a window onto the avenues, boulevards, bridges and quays of the Seine, he embraces vast spaces and draws us into deep perspectives, thus giving his paintings that breadth and grandeur of vision, which one associates with the name of Paris. The treatment is freer and wider than in the work of the 1870-1880 period, the colouring is often warmer and sometimes the drawing is very elliptical. Nevertheless, for him objects still exist; unlike Monet, Pissarro remained faithful to the realistic origins of impressionism.

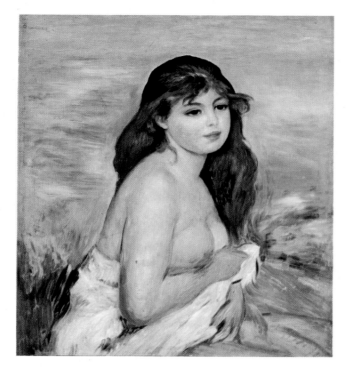

Renoir. The blond bather. 1887.
Nasjonalgalleriet, Oslo.

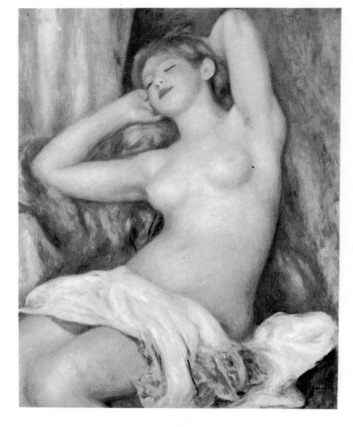

Renoir.
Sleeping woman. 1897.
Oskar Reinhart
Collection,
Winterthur.

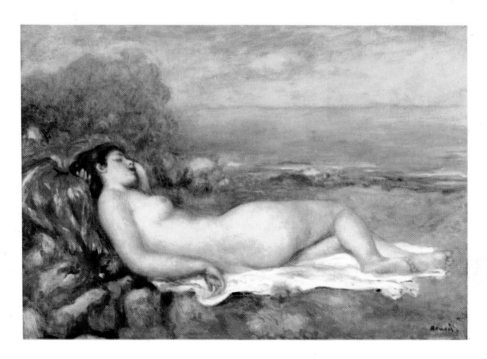

Renoir.
Bather lying
by the sea.
1890.
Oskar Reinhart
Collection,
Winterthur.

23

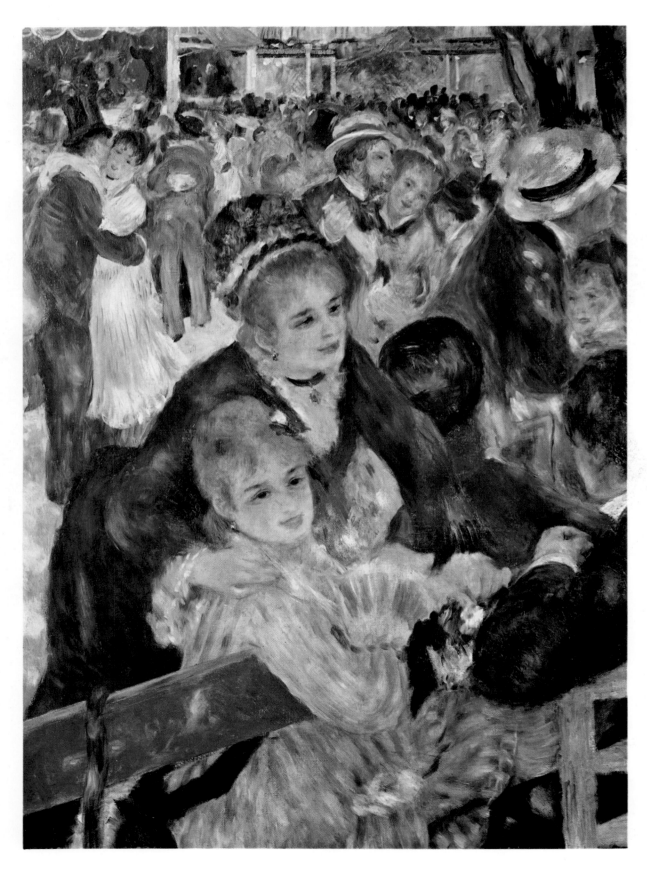

Renoir.
Moulin
de la Galette.
1876. Detail.
Musée de
l'Impressionnisme,
Paris.

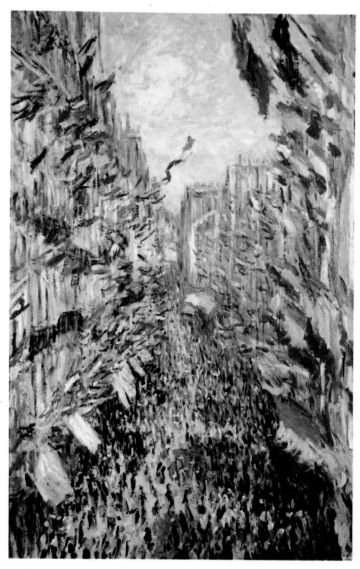

Monet.
Rue Montorgueil.
Celebrations on June 30th.
1878.
Mme Lindon Collection,
Paris.

Monet.
Water-lilies: green harmony.
1899.
Musée de l'Impressionnisme,
Paris.

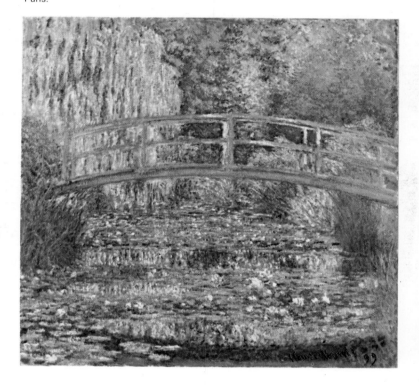

ing. What then made him change his subject and choose one that seems at first sight far less pictu-
resque than those he had painted up to that point? Probably it was this very lack of picturesqueness
that attracted him. Great artists have often set themselves the task of finding beauty and poetry where
they are least apparent. But the Gare Saint-Lazare gave him the opportunity of studying an even more
fugitive element than water: the smoke from engines. The haziness of this smoke, its capricious mean-
derings, its fairylike iridescence, the changes that it made on metal surfaces and the neighbouring
houses—how could all this fail to fascinate him?

The term "free" series has been similarly applied to these works as to the *Break-up of the Ice*
paintings that Monet did at Vétheuil in 1880. Ten years later, the "systematic" series appeared, the

17

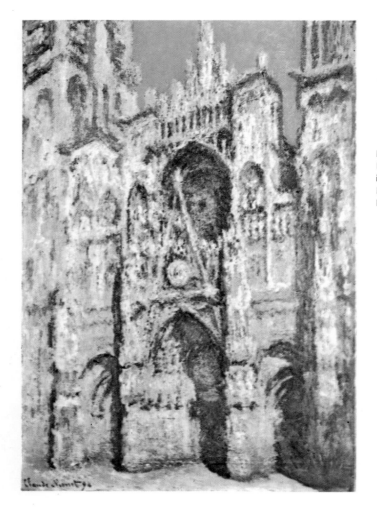

Monet.
Rouen Cathedral
in full sunlight. 1894.
Musée de l'Impressionnisme,
Paris.

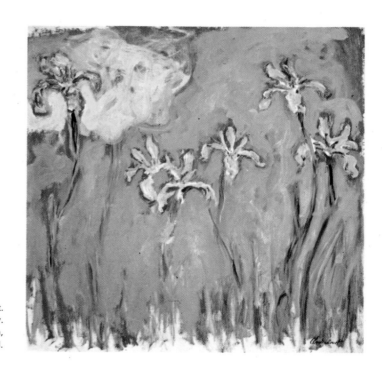

Monet.
Yellow irises, Giverny.
Private Collection,
Switzerland.

most significant of which was the one of *Rouen Cathedral* (1892-1894). It comprises more than twenty variations, always of the same façade, nearly always seen from the same angle. Nothing illustrates more clearly that the essential thing for him was not the subject, but the effect it produced at different hours of the day, in fair weather or cloud, in clear air or mist. Never before had anyone changed their position so little and discovered so many facets in a single subject; or rather, never before had anyone caught with such sensibility the miraculous and multiple reality of light and atmosphere. These natural appearances fascinated the artist so much that he sacrificed the substance, consistency and weight of things; the façade of the cathedral is reduced to a subtly coloured veil and there remains only an evanescent reminder of its structure.

This blotting out of the shape itself becomes even more accentuated in the various pictures Monet painted of the *Houses of Parliament* in London at the beginning of the century. Surrounded by either a blue or purplish fog in which an ethereal sun dissolves its yellows, its oranges and its pinks, the building itself is nothing but a ghost that looks as if a mere breath of air would be sufficient to shake it.

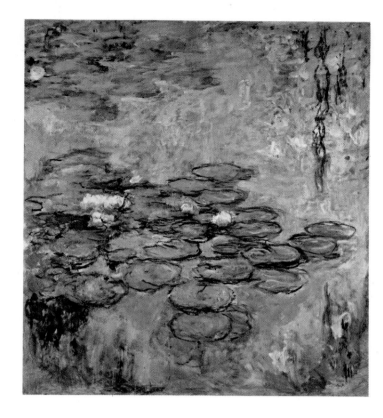

Monet.
Pink clouds. 1918.
Katia Granoff Collection,
Paris.

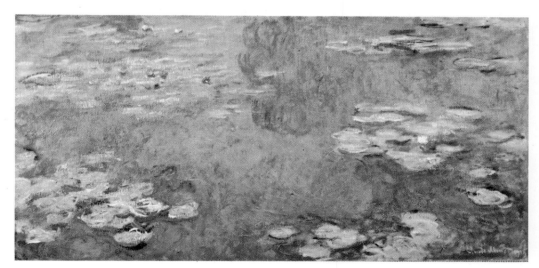

Monet.
Water-lilies, Giverny.
Private Collection,
Paris.

One is reminded of Turner, although Monet is far from possessing his romanticism; for although it is true that there was a visionary in him as well as an observer, it is no less certain that he was careful not to engulf the world in his dreams.

When in 1899 he began painting his *Water-lilies*, his point of departure was still nature. The water garden, which he designed himself in his property at Giverny, provided him with the subject. If, at the beginning, objects are still easily identifiable, the vegetation of the pond and on its banks, the water-lilies, the jonquils, the wistaria, the weeping willows later take on vague shapes and the paintings show us above all blobs, trails, flourishes and tangles of colour which have a strong tendency to be sufficient in themselves. So, at the end of his life, Monet was far from the realism, far even from the impressionism of the Argenteuil period. The *Flower Garden* and the *Pond with Wistaria* suggest certain abstract painters of today. This is why his work has recently enjoyed a fresh interest after being long neglected for a more geometric painting.

19

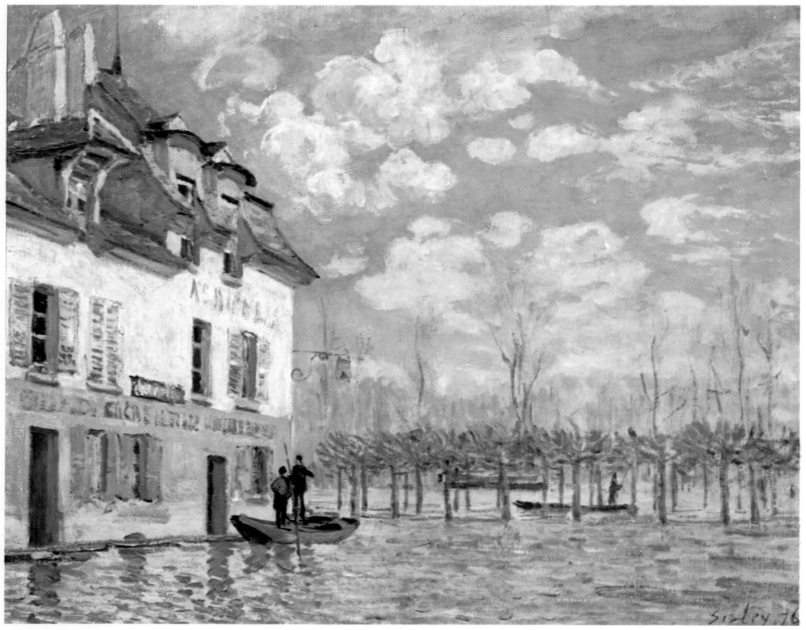

Sisley. Boat during a flood. 1876. Musée de l'Impressionnisme, Paris.

Alfred Sisley. Sisley (1839-1899) at the outset was close to Corot and even when he allowed himself to be led towards impressionism by Monet, he still did not stray far from his master. However, if his senses were as easily awakened and his conception no less tender than that of his predecessor, his colours are more differentiated, as they owe less to fancy than to observation.

He lived and went about in the Ile-de-France, particularly in the Fontainebleau area; here he painted a river bank or a canal, a road leading either towards a village or fading away in the distance, there a village shrouded in soft light by the snow or invaded by the muddy waters of a flood. But whatever his subject, he observed it with calm. The flood as he saw it was not a disaster; clouds which, from the depths of the horizon, climb into the heavens do not bring lightning or rain in their wake; they are not upset by the storm and generally they move at a leisurely pace; one would suppose that their only object was to filter the light and to allow the air to preserve its freshness, and to rid the colours of the world of their sharpness.

Until around 1877, Sisley was a master at expressing shades of meaning and subtle transitions.

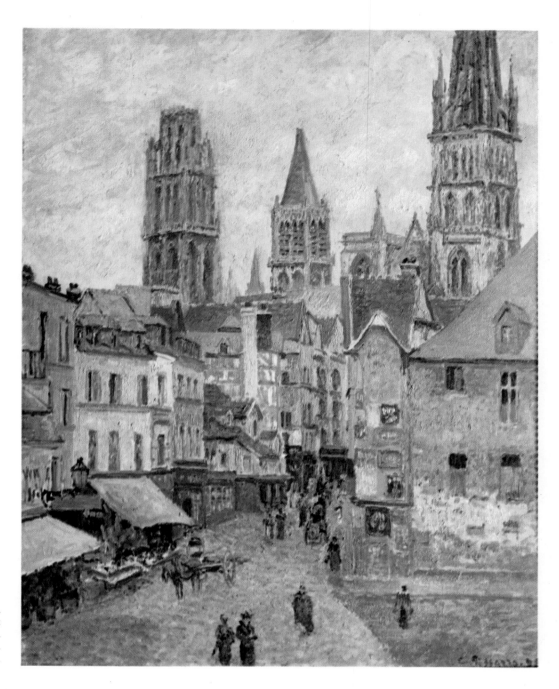

Pissarro.
Rue de l'Épicerie, Rouen;
morning in dull weather. 1898.
Private Collection,
Paris.

However, fired by Monet's example, he wished in his turn to increase the liveliness of his colours. From then on he forced his temperament and was generally less convincing. By losing his restraint, his art lost some of its exquisite delicacy, its distinction and very often its truth.

Camille Pissarro. Like Sisley, Pissarro (1830-1903) began by being under the influence of Corot and like him he was later guided by Monet, both towards impressionism and towards the assertion of his own personality. Pissarro and Sisley also possessed a similar sensibility, although one finds in the former's work a note of anxiety which is lacking in that of the latter.

Up to 1884, Pissarro sought his subjects particularly around Pontoise. Sometimes, he set up his easel on the banks of the Oise, or at the corner of a road, sometimes he stopped by a farm gate opposite a peasant coming home from the fields, or of a woman pushing a wheel-barrow, sometimes he settled in a field where harvesting was in progress, or by a group of houses half hidden by trees.

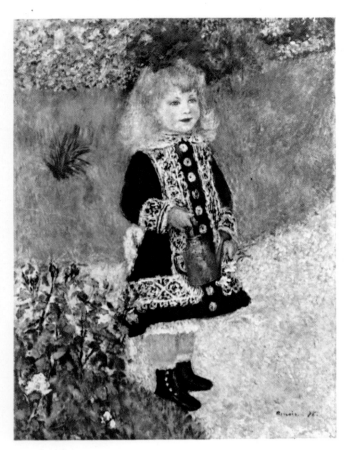

Renoir. Girl with a watering-can. 1876.
Chester Dale Collection,
National Gallery of Art,
Washington.

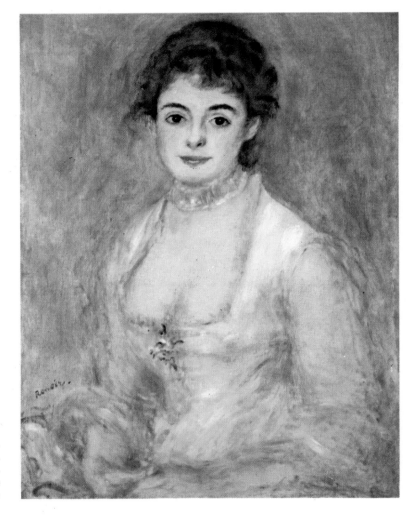

Renoir.
Portrait of Madame Henriot.
About 1876.
National Gallery of Art,
Washington.

These he loved, not only because of their green touches in contrast to the red roofs, but also because of the lines their trunks and branches would design over the canvas. Despite his impressionism, Pissarro does in fact remain the advocate of a certain amount of structure and solidity.

In 1886, Pissarro allowed himself to be drawn beneath the banner of neo-impressionism. He soon realised that he had made a mistake and that his painting had become too systematic and in consequence dried up, so he regained his freedom.

During his last years, he at various periods painted scenes of towns (Paris, Rouen, Dieppe). While looking down from a window onto the avenues, boulevards, bridges and quays of the Seine, he embraces vast spaces and draws us into deep perspectives, thus giving his paintings that breadth and grandeur of vision, which one associates with the name of Paris. The treatment is freer and wider than in the work of the 1870-1880 period, the colouring is often warmer and sometimes the drawing is very elliptical. Nevertheless, for him objects still exist; unlike Monet, Pissarro remained faithful to the realistic origins of impressionism.

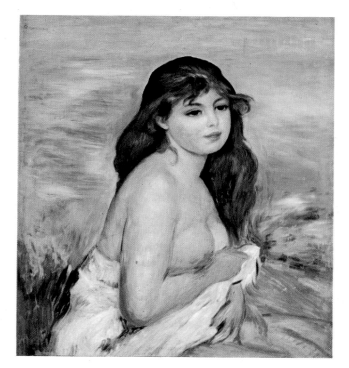

Renoir. The blond bather. 1887.
Nasjonalgalleriet, Oslo.

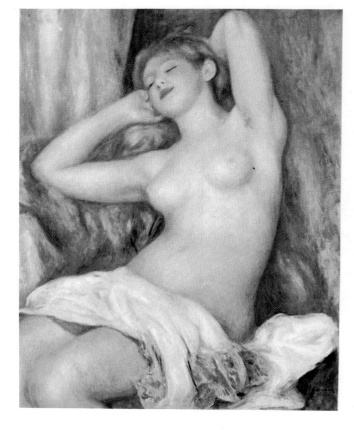

Renoir.
Sleeping woman. 1897.
Oskar Reinhart
Collection,
Winterthur.

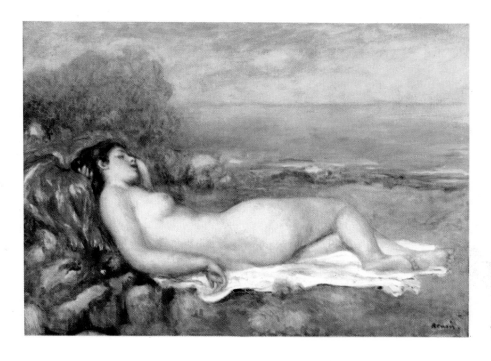

Renoir.
Bather lying
by the sea.
1890.
Oskar Reinhart
Collection,
Winterthur.

23

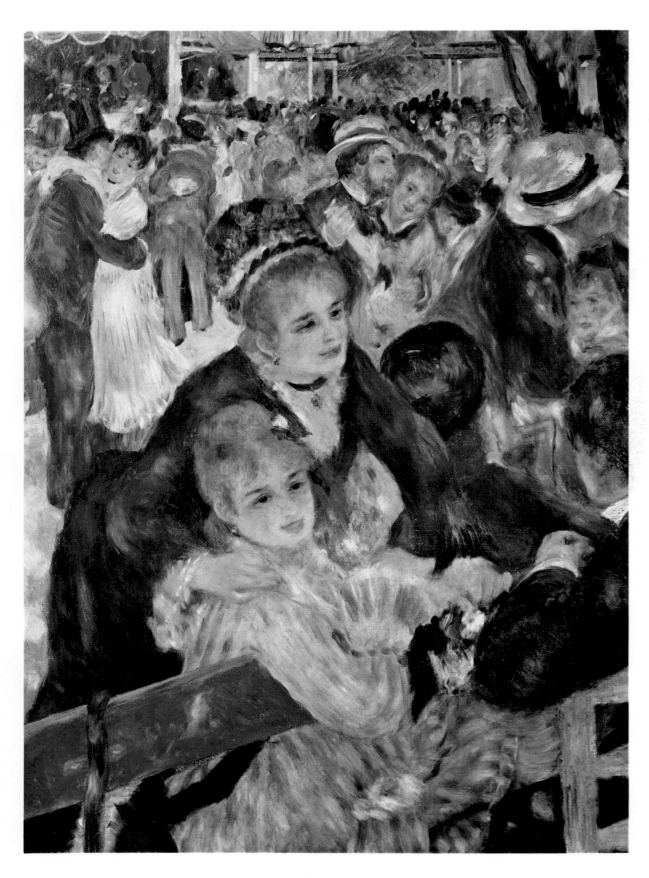

Renoir.
Moulin
de la Galette.
1876. Detail.
Musée de
l'Impressionnisme,
Paris.

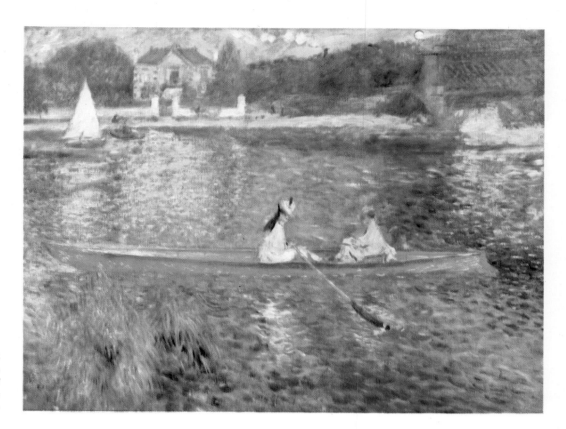

Renoir.
The yawl. About 1879.
Lady Aberconway
Collection,
London.

Auguste Renoir. Monet, Pissarro and Sisley are above all landscape painters. Renoir (1841-1919) is mainly, if not entirely, a painter of figures. He too made a religion of light; he brought it into play in each of his pictures, but rather than attempt to catch it, when fleetingly it alters skies, water, grass and trees, he took pleasure in seeing it caress the face or the naked body of a young woman. Furthermore, although he wanted the light to penetrate bodies, he did not want them to be dissolved in it. Their volume and to a certain extent their balance meant much to him.

In this respect his position offers certain analogies with that of Manet, whom he also resembles in the attachment which, although he was an innovator, he always felt for tradition. Like Manet he admired Titian, Velasquez and Delacroix, but he showed equal enthusiasm for Rubens and Boucher. The sensuality which he found in them was dear to him, which did not mean that it was of the same nature as his. Rubens and Boucher hardly ever painted a nude without suggesting the idea of forbidden fruit. To Renoir on the other hand nakedness seemed a natural state. If Eros is present in his work it is a pagan Eros and not the one to whom Nietzsche referred: " Christianity gave him poison to drink, which did not kill him ", added the philosopher, " but degenerated him and led him to vice. " Nothing could be further from vice than Renoir's nudes, there is nothing lewd or frivolous about them. In fact, these delicately pearly bodies do not seem even to have known the fevers of passion. They are before us in the state of innocence of a quiet animal life, unless they evoke the full and peaceful existence of flowers and fruit.

In this art we find no trace of torment, of intellectual anxiety or of psychological complications. Even in the portraits we are in the presence of radiant faces, which express nothing else than the pleasure of living openly beneath a light, which is both soft and intense. Most often in fact they are portraits of young women. Renoir's woman is Eve living in a paradise, where neither the tree of knowledge nor the serpent exist.

Something of paradise remains about her, even when she puts on the dress of the young Parisienne, when she goes dancing beneath the trees of the Moulin de la Galette, or when she is listening

25

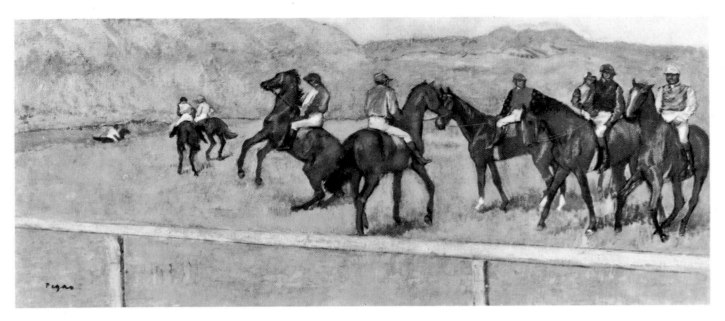

to a concert or trying on a hat at the modiste. All the same, she very much belongs to the period in which she was painted. Whoever wants to learn about Parisian society under the reign of Napoleon III or in the first years of the Third Republic and wishes to know what they wore and how they amused themselves, should turn as much to Renoir as to Manet.

Although he had painted a number of works that are among the masterpieces of impressionism, towards 1883, Renoir believed himself to have reached a deadlock. A long journey to Italy during which he greatly admired Raphael and the frescoes of Pompeii led him to think that he neither " knew how to draw or to paint ". He then decided to concentrate more on draughtsmanship and for several years he concentrated on it too much; his painting became harsh, his colours " acid ", his light stiff and his composition too contrived. However, he came through this crisis rejuvenated and matured. He removed the hardness from his drawing and yet gave a new firmness to form. His light was no longer rigid, nor did it regain its flickering quality. In the past it had merely bathed his bodies, now it impregnated them deeply and Renoir, who lived mainly in the south of France from 1897 on, liked to show them under a hot and ardent sun which ripened them like peaches.

When he imagined scenes in which women were relaxing, he no longer thought of the pleasures which town people enjoy; he thought of the more Dionysian ones that the human being finds when he escapes from the social conventions, in order to become one with nature. The bodies are now opulent, too much so, one might say, were it not obvious that the artist was looking for something more than mere prettiness: it is the exaltation of life, generous, primitive and vital. However, if everything in these last works is invaded by the same intoxicating light, if the blood which flows through the flesh of these women and the sap which circulates in the trees and plants appear to have a common source, the bodies still do not dissolve into the landscape; they enrich it with supple forms and precise rhythms, while keeping their vigour and solidity.

Edgar Degas. Although Degas (1834-1917) belonged to the impressionist group and showed at nearly all their exhibitions, he had very little in common with either Monet or Renoir. He rarely painted landscapes and had little interest in the out-of-doors. He looks for the instantaneous in the movement of a human being or a horse; the light which he analyses is preferably indoors and often even artificial. He is more of a draughtsman than a painter, whereas generally the impressionists drew very little.

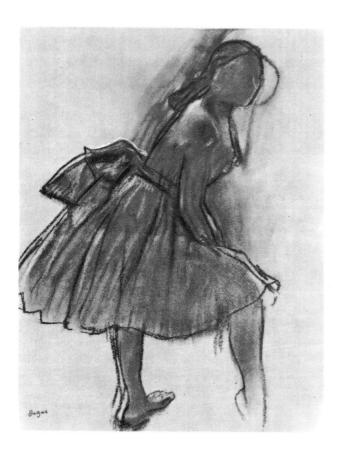

Degas.
Side view of a standing dancer.
Pastel. About 1878-1880.
Private Collection, Paris.

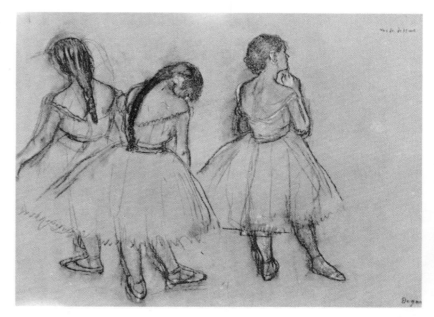

Degas. Three studies of standing dancers.
Pastel. About 1878-1880. Private Collection.

Degas. Dancer stretching.
Essence on green bristol-board.
About 1874. Private Collection.

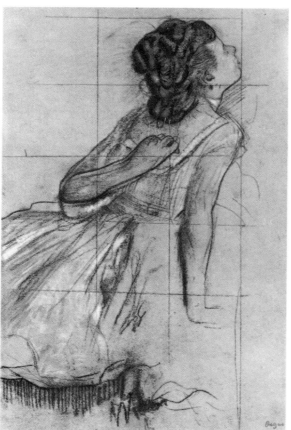

Degas. Dancer scratching her back.
Black crayon. About 1874.
Musée du Louvre, Cabinet des dessins, Paris.

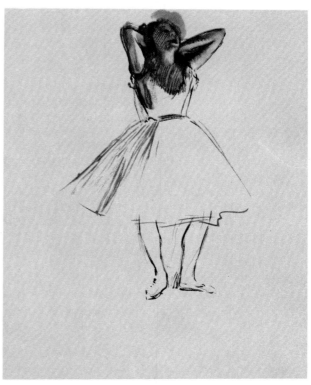

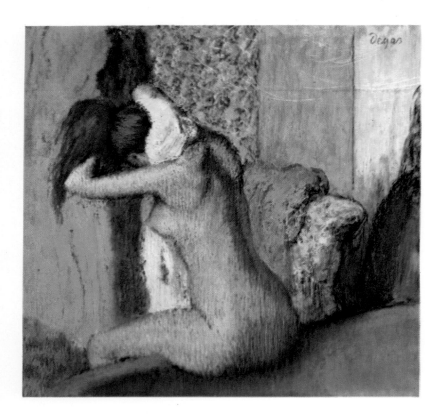

Degas.
Woman drying her neck
after her bath.
Pastel on board. 1898.
Musée de l'Impressionnisme,
Paris.

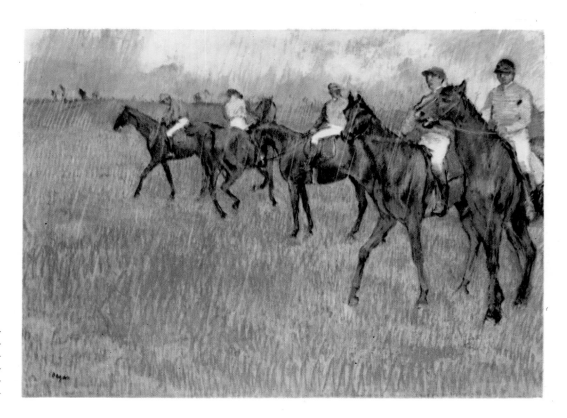

Degas.
Jockeys in the rain.
About 1881.
Burrel Collection,
Art Gallery and Museum,
Glasgow.

His artistic formation, too, led him to express himself primarily in line. He had been the pupil of one of Ingres' disciples and he made several trips to Italy where he studied the masters of the Quattrocento (Pollaiuolo, Botticelli, Mantegna) more than Raphael and Michelangelo. The eagerness with which he tried to understand the artists whom he admired did not prevent him, however, from having very advanced ideas fairly early on. As early as 1859, he wrote in his notebook, '' No one has ever

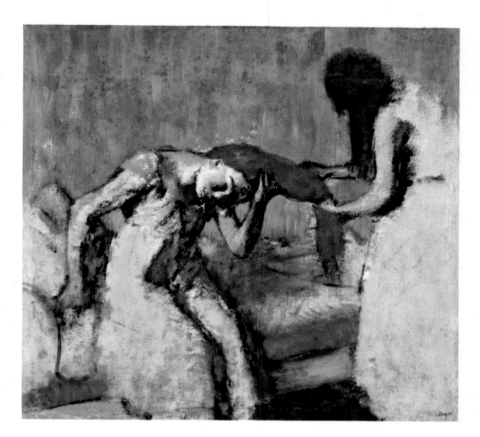

Degas.
The toilet.
Nasjonalgalleriet,
Oslo.

done buildings or houses from below, beneath, or at close quarters, as one sees them when passing in the street." He conceived the idea of executing series of pictures on the same subject; for example, musicians, dancers or lighted cafés. Before actually beginning on these subjects, he painted for the most part cold, legendary and mythological compositions as well as portraits, which are not without distinction.

The theme of horse-racing is the first of those he borrowed from contemporary life. Although he began to paint them in 1862, it was not until 1873 with *The Carriage at the Races* that he gave an interpretation which clearly revealed one of the most characteristic aspects of his art: the unexpectedness of his layout. His way of pushing the carriage (the main subject) into a corner of the canvas, cutting off the bottom of it, eliminating part of the horse's legs, even leaving out part of the leading horse, no European painter before Degas had ever attempted such treatment. Where did he get this boldness? The answer is obvious; he studied Japanese prints and looked at the work of photographers around him. It is no accident that his painting possesses much of the snapshot.

This characteristic was accentuated in the racehorses he painted the following year. He limited himself to the essential more and more and his form became more and more simplified. Anxious to increase the variety of postures and movements, he did not actually paint the race itself, but the moments which preceded it, when waiting for the start made the horses and jockeys nervous.

As for the movements of the human body, he studied them by observing the dancers of the Opéra. It is significant that he shows them oftener in the anteroom or practice room than on the stage itself; he looked less for their graceful movements than for their more unusual attitudes. He also always tried to vary his angle and choose one which made even the commonplace striking. This search for the unusual also led him to study the effects of artificial light—in a café entertainment, a theatre or the Opéra. Nor did he limit himself to capturing the strangeness of the white light and green shadows, which gas-light throws on to a face or an arm. He used this type of light to disjoint conventional space; using shadow to narrow it, light to widen and deepen it. He likes to dispense with landmarks;

29

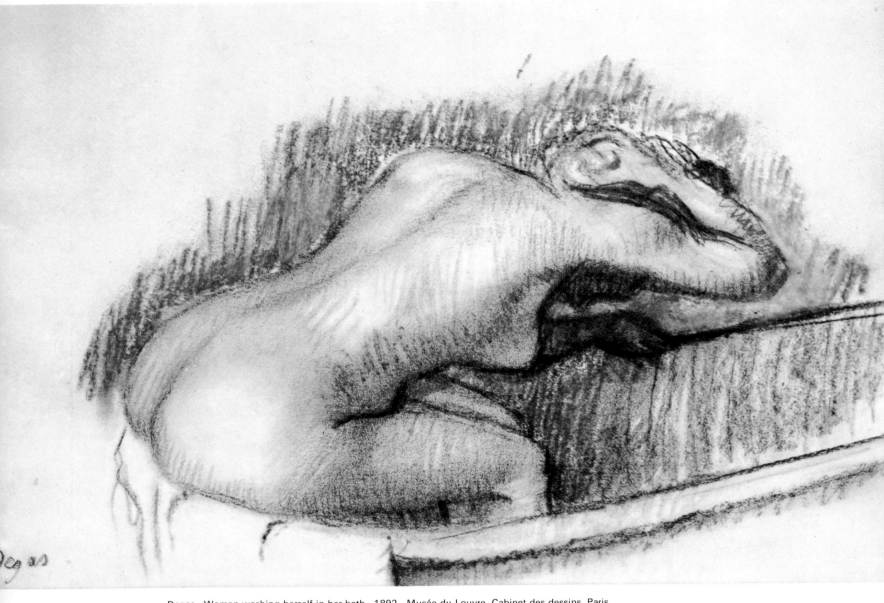

Degas. Woman washing herself in her bath. 1892. Musée du Louvre, Cabinet des dessins, Paris.

our eye is often plunged from the foreground towards the back, without being at first sight able to gauge the distance which it has covered. This results in a feeling of poetic bewilderment which is accentuated by the boldness of his cutting off.

Anxious to go on discovering new aspects of that part of reality which attracted him, Degas penetrated into milliners' shops and into rooms where yawning women ironed. He surprised women in their privacy, drawing them while they are squatting in a tub, busy washing themselves, getting out of their baths, attending to their toilet. If, however, his art is indiscreet it is not sensual. Degas observes with curiosity but without desire. Unlike Renoir he does not glorify nakedness, he does not show it as a natural state; on the contrary, he always makes one feel that it will only exist for a few seconds and that soon clothes will hide it again.

" No art is less spontaneous than mine ", he said. It is true that Degas does not record the impressions that chance brings his way; he chooses them, analyses them and then transposes them in a reflective and determined style. From 1880 onwards, he made more and more use of pastel which allowed him, in the most direct manner possible, " to be a colourist with line ". At the same time, he

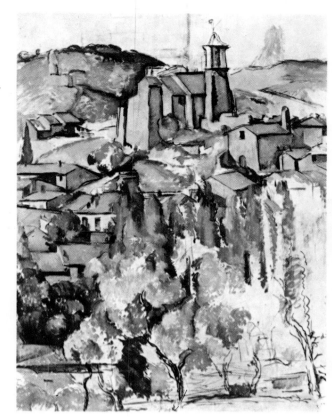

Cézanne.
View of Gardanne.
1885-1886.
Brooklyn Museum,
New York.

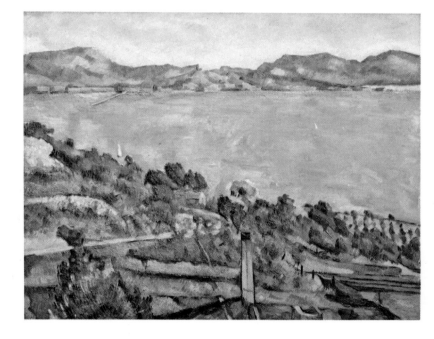

Cézanne.
The sea at L'Estaque.
1877-1882.
Musée de l'Impressionnisme,
Paris.

strengthened his colours, and the vitality of his cross-hatching, the width of his colour patches, the freedom and the glow of his tones, and the singularity of his harmonies never ceased to increase.

Paul Cézanne. Though Cézanne (1839-1906) had moved since 1861 in the same circle as the future impressionists, his painting had no connection with theirs for another ten years when he settled at Auvers-sur-Oise and listened to Pissarro's advice. Only then did the stormy style of his first period disappear and he painted peaceful landscapes in serene colours. But he was already less attracted by the fugitive than the permanent; he already refused to allow the form of objects to be blurred by the enveloping atmosphere. He consistently emphasised the structure of the painting and for this the houses, rocks, tree-trunks, everything that is massive, solid and can be defined by geometric lines were an essential element in his works.

For Cézanne to fulfil himself, he had to leave Paris and go to the south of France, where the dry and transparent air allows nature to appear at its clearest. He went in 1878 and lived there more or less continuously until his death. He worked around Aix, his birth-place, Gardanne and at l'Estaque. His originality is obvious in each of his pictures, but it is particularly striking in the landscapes which

31

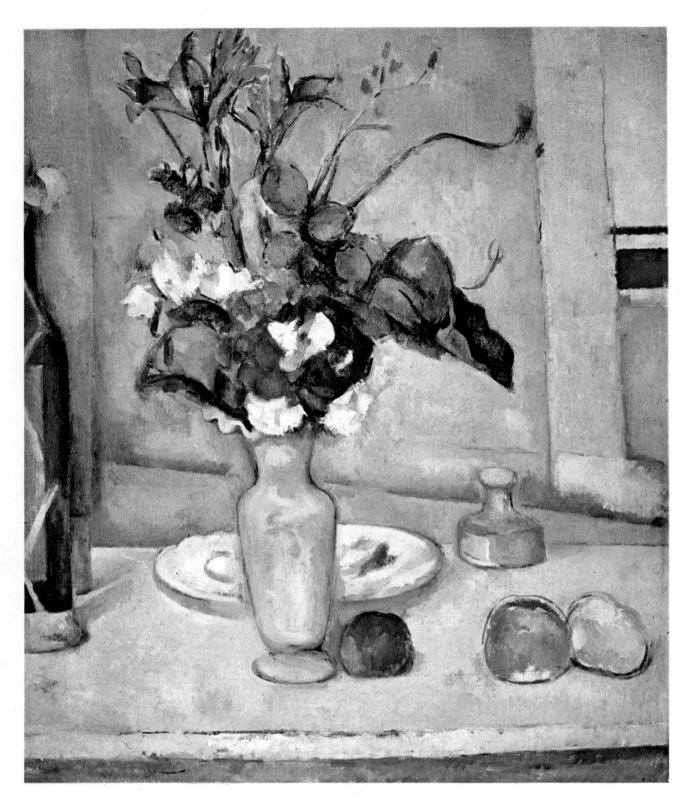

Cézanne.
The blue vase.
1885-1887.
Musée de
l'Impressionnisme,
Paris.

he painted of the Bay of Marseilles. The Mediterranean and the sky occupy their natural place, but they are firmly supported by a framework of stable elements. There is little movement and there are few reflections in the sea; Cézanne did not enjoy the play of shimmering waves so dear to Monet.

32 His water tends to be solid and the same applies to grass and foliage. His light is neither gay nor

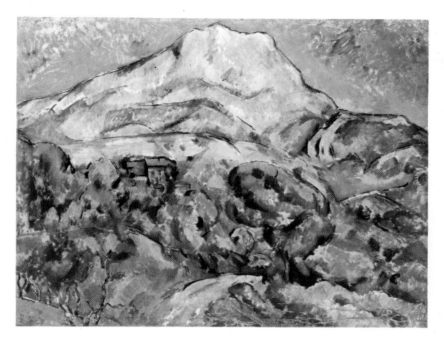

Cézanne. La Montagne Sainte-Victoire
from the path leading to the Château Noir. 1895-1900.
Pushkin Museum, Moscow.

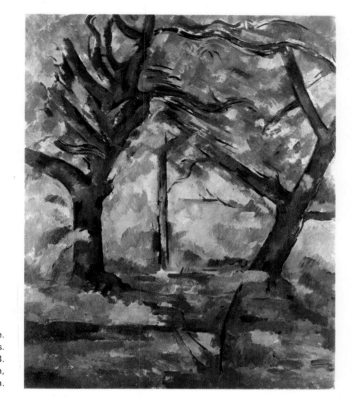

Cézanne.
Tall trees.
1895-1898.
Ann Kessler Collection,
London.

changeable. Colour does not translate fleeting moments, however attractive they may be. His colours
are less iridescent than those of the impressionists, less superficial too; it is almost as if the artist drew
them out of the objects themselves.

Actually, in Cézanne two contradictory tendencies were at war and were the cause of the slow
and painful painting of which he complained throughout his career. On the one hand, he wanted to
transcribe his keen sensations of nature without losing any of their freshness and intensity; on the
other, he was concerned with going beyond the disorderly and the transitory: he wanted to clarify
them, to organise them on canvas, consciously and intelligently. This second tendency finally domi-
nated his work; he ignored the perishable matter of objects and pushed their forms towards the
regularity and immutable perfection of geometric forms and gave colour an essentially pictorial
value.

When he painted nudes, their flesh did not interest him, nor anything which excites a caressing
sensuality; he used bodies to build a living architecture. When he painted fruit, one could believe that
he had never tasted it; he ignored the pulp and flavour. But he gave their colouring such richness,
their shape such purity and fulness that they were transformed into plastic elements of startling
strength. In other words, when he deprived objects of some of the qualities that nature confers on
them, it was to load them more heavily with the life given by art. The significant thing is that as

33

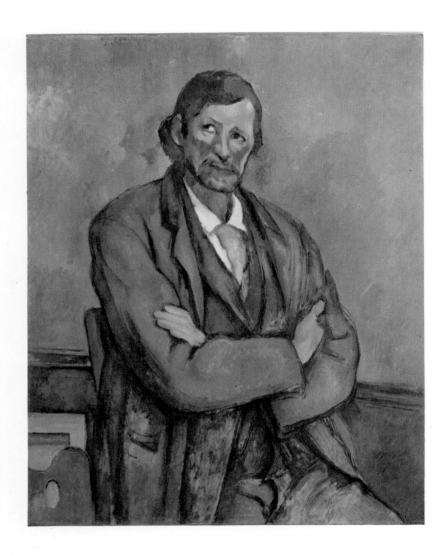

Cézanne.
The watch-maker.
1895-1900.
Solomon R. Guggenheim Museum,
New York.

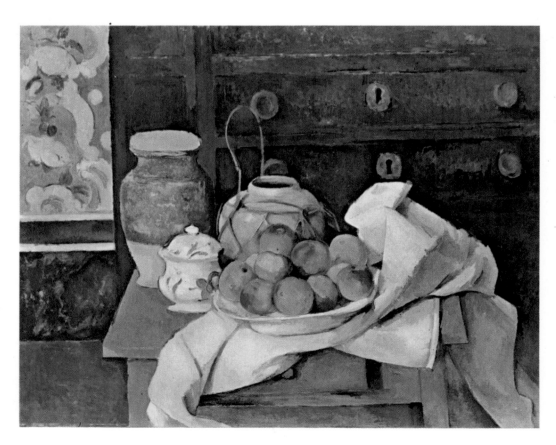

Cézanne.
Still-life on a chest of drawers.
1883-1887.
Bayerische
Staatsgemäldesammlungen,
Munich.

34

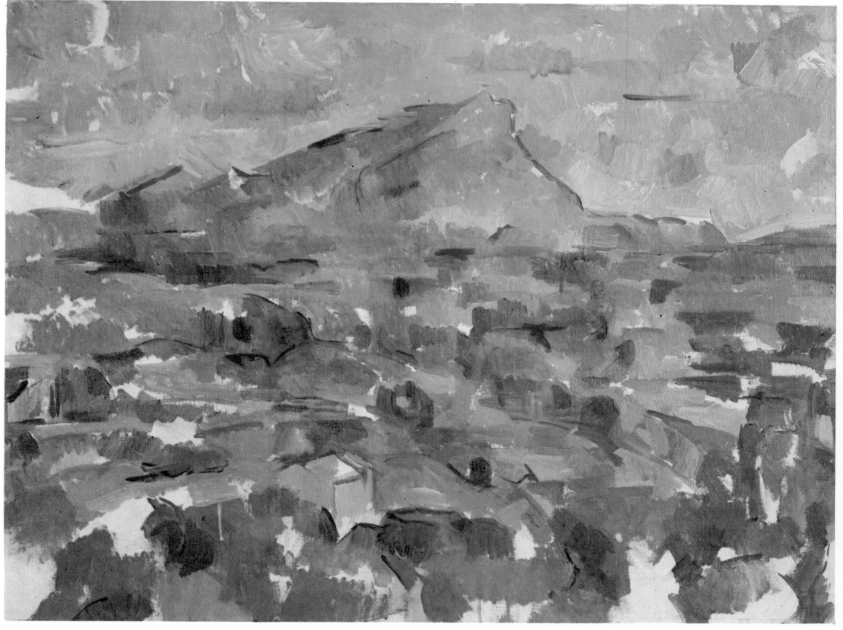

Cézanne. La Montagne Sainte-Victoire; view from Les Lauves. 1904-1906. Kunsthaus, Zürich.

nothing lends itself better to purely plastic research than inanimate objects, so we find numerous still-lifes in his work. One might even be tempted to say that Cézanne treats everything except landscapes as a still-life. Look at his portraits; they tend in no way to reveal the inner life of his subject. However, they move us by the quiet gravity of their colours, by the very stiffness of their appearance, which confers on them something majestic and solemn.

Towards the end of his life, Cézanne shows in his oils a freedom comparable to that which he had long shown in his dazzling water-colours. When about 1904-1906, he painted *La Montagne Sainte-Victoire* to which he had so often paid a moving tribute, his objects were less and less defined and merely expressed sensations of colour, of masses and planes. His lyricism did not, however, lead him to neglect structure; it only appears less obvious. It is no longer emphasised by lines, but evolves from the rightness with which the vibrating areas of colours are distributed.

'' I have blazed the trail; others will follow '', Cézanne said. Others came and were his followers It was he who inspired all the vital painting of the first half of the 20th century. The Nabis, the fauves and the cubists studied him with equal fervour.

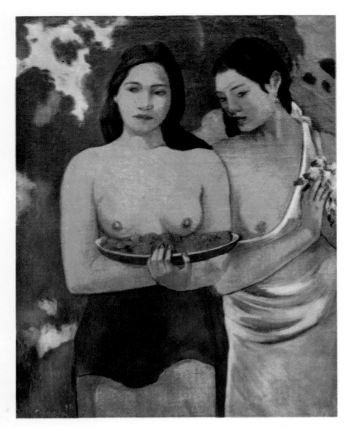

Gauguin. Tahitian women with mango blossoms. 1899.
Metropolitan Museum, New York.

Gauguin. Manao Tupapau: l'Esprit des morts veille. 1893.
A. Conger Goodyear Collection, New York.

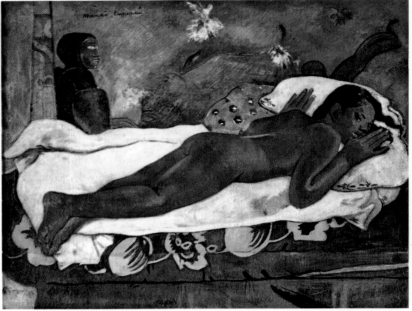

Paul Gauguin. Up to the age of thirty-four, Gauguin (1848-1903) was nothing but an amateur painter, who was friendly with Pissarro and came under his influence. Then suddenly in 1883, in order to be able to '' paint every day '', he left his very lucrative job with a Paris stock-broker, turning his back on prosperity before finally turning it on his wife and five children. From then on, poverty, suffering and bitterness were to be his lot and the conviction that he had only followed his destiny both consoled and exasperated him.

In 1886, he went to live at Pont-Aven in Brittany, in the first place probably because he was looking for somewhere that was not, like Paris, '' a desert for the poor man ''. But he also wanted to escape from civilisation. He already felt that the savage life was making him young again. The following year, he wrote, '' I am going to Panama to live an unsociable life... I shall find new strength far from any human being ''. He went from Panama, which disappointed him, to Martinique where the nature enthralled him, but which he had to leave because of ill-health, so that at the end of the year he returned, worn out by illness, and with a heavy heart. He went back to Pont-Aven and now his painting acquired a new and personal stamp. He at last found himself with the help of Cézanne, Japanese prints, discussions with the young Émile Bernard and even possibly through the latter's paintings.

36 '' Do not paint too closely from nature '', he told one of his friends at that time. '' Art is an abstrac-

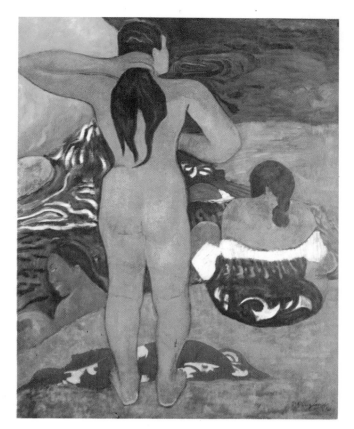

Gauguin. Tahitian women on the beach. 1891-1892.
Robert Lehman Collection, New York.

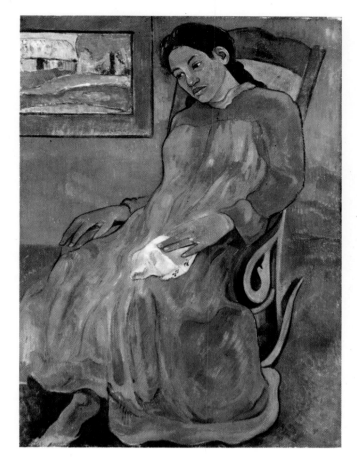

Gauguin.
Reverie. 1891.
William Rockhill Nelson
Gallery,
Kansas City.

tion. Draw it out of nature, dream about it, and think more of the resulting creation. The only way to attain God is to do as the Divine Master, create. " Consequently, he encircled his shapes with vigorous and synthetic outlines, he reduced modelling and only used the more dominating of nature's colours, which he spread on more or less flat. In addition, he dispensed with shadows, if he judged it necessary, abandoned aerial perspective and made scant use of linear perspective, suggesting depth mainly by planes and reference points of colour. Whether his subject was taken from reality. *(The Swineherd, The Haymakers)*, or from his imagination *(The Vision following the Sermon)*, whether it was a portrait or a landscape, Gauguin in the treatment of his subjects was always inspired by the spirit of the world around him. " When my clogs resound on this granite ", he said, " I hear the mute, dull and powerful sound which I look for in painting ". It was not only from the granite soil, but from the simplified and rough sculpture of the calvaries, as well as popular art in general that Gauguin, which was unusual for his times, did not hesitate to draw his inspiration.

In the end Brittany was unable to satisfy him. His soul thirsting for the primitive life, as well as his poverty, made him look for the " promised land " elsewhere, further afield, and in 1891 he left for Tahiti. Ill and penniless, he returned to France in 1893, but two years later he again set sail. In 1903 he died in the Island of La Dominique, in the Marquesas, where coming from Tahiti, he had settled

Gauguin.
Riders on the beach.
1902.
Folkwang Museum,
Essen.

in 1901. Although in reality the South Sea Islands were not the same as those he had dreamt of and living there he was spared neither suffering nor despair, it was there that his art found its supreme fulfilment. His forms became more ample, his drawing more forceful, his colouring richer and more harmonious. His works naturally took on an exotic character from the people and the vegetation he saw before him, but his exoticism was never merely picturesque; it expressed his feeling of life far more than it represented nature. He felt not as a primitive, but as a civilised European, who wanted to plunge himself into primitive life, which he regarded with nostalgia, fully realising that he could never recapture sufficient innocence to become a part of his Lost Paradise. That is why there is always in Gauguin's painting something melancoly and unsatisfied. The titles of some of his works *Alone*, *Nevermore*, *Where do we Come from? Who are We? Where are we Going?* underline this anxiety which consumed him. They also indicate the dangers that he was running and that he averted, because the interest of an idea never assumed greater importance in his work than its painterly realisation.

Just as he avoids the trap of literary painting, Gauguin in general avoids being purely decorative, which is extremely difficult for a painter who stylises, gives up chiaroscuro, relief, and applies his colours in flat areas. By doing this he managed in his turn to prove that the traditional road of artists since the Renaissance was not the only one which offered a means of emotional expression. He demonstrated it and also proclaimed, " I went right back, further than the horses of the Parthenon, right to the gee-gee, the old rocking horse of my childhood." He also said that he wished to " take painting back to its sources " and even added " I wanted to establish the *right* to try anything ". These words influenced 20th century painting as much as his works. Artists were to heed them and to be helped by them, even if they were not affected by his works.

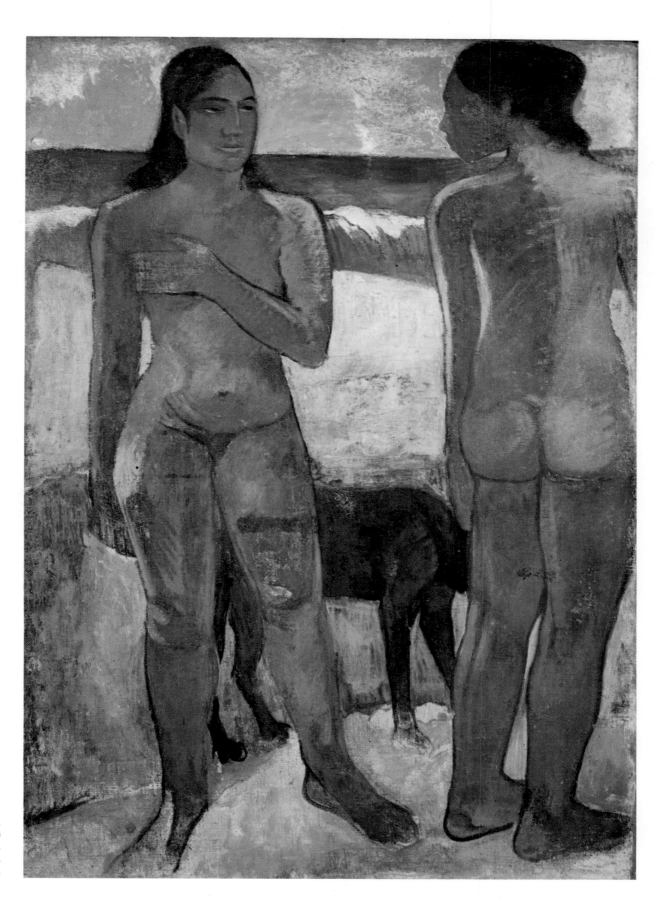

Gauguin.
Nude Tahitian women
on the beach.
Academy of Arts,
Honolulu.

Van Gogh. Boats at les Saintes-Maries. Water-colour. 1888.
Private Collection.

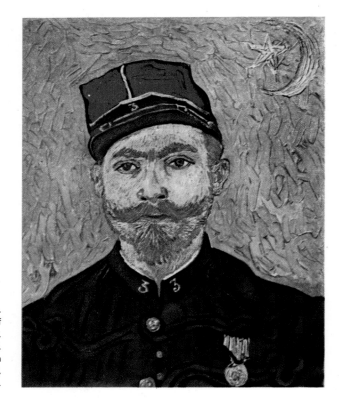

Van Gogh.
Portrait of
Lieutenant Millet.
1888.
Rijksmuseum
Kröller-Müller,
Otterlo.

Vincent van Gogh. Few careers were as meteoric as Van Gogh's (1853-1890). He was twenty-six when he dashed off those of his first drawings that he considered worth preserving, thirty-three when he started to discover his style and thirty-seven when he died. The reason for this late vocation is known. He started to draw out of despair, his life up to then having been one failure after another. The final blow, and the hardest to bear for this son of a Dutch minister, took place in the Borinage, where he had wanted to live as an evangelist among the miners. His inability to preach, as well as his '' exaggerated '' practice of Christianity, caused the removal of his licence. It was when everyone considered him a '' good for nothing '', that he turned to art, primarily no doubt because he wished to prove that he was '' good at something ''; and probably even more because he wanted to find some way of showing the love he felt for his fellow human beings. Far from being a game or a distraction, art for him was a mission.

Consequently then, it was not surprising that when he returned to Holland and lived in the country, he should become the painter of peasants. There is nothing surprising either in the fact that he admired and consulted Millet. But he also admired Zola and when towards 1885 his art took on a certain

Van Gogh. At the foot of the Alpilles. 1890.
Rijksmuseum Kröller-Müller, Otterlo.

Van Gogh.
Field under a
stormy sky.
1890.
V.W. Van Gogh
Collection,
Laren.

vigour, the author of *Germinal* and the painter of the *Angelus* both seem to have met in it. His figures were dignified and rough at the same time. His palette was generally dark and muddy, his style bold and harsh. Whatever may have been the value of the works painted in this manner, they would never have earned more than a national reputation for him. It was only when he came to Paris in 1886 that he won the place that is his in the history of modern art and became the beacon which in the 20th century lit the way for the fauves as well as for the expressionists.

Through his contacts with Pissarro, Gauguin and Signac his painting lost its peasant heaviness and sentimentality. His colours brightened, his touch lightened, became fragmented and even at times pointillist, he painted views of Paris, flowers, still-lifes and portraits, which strike one by their calm and by the airy character of their harmonies and by their relaxed drawing. Only in his self-portraits do we see that he was not entirely satisfied with Paris, his fellow painters and their discussions; in the end it all got on his nerves, and he felt the need for another change.

Attracted by the sun, he went in February, 1888 to live in Arles. He was thrilled by the south of France, he found it as " beautiful as Japan ", which, of course, he had never seen, but which he ima-

41

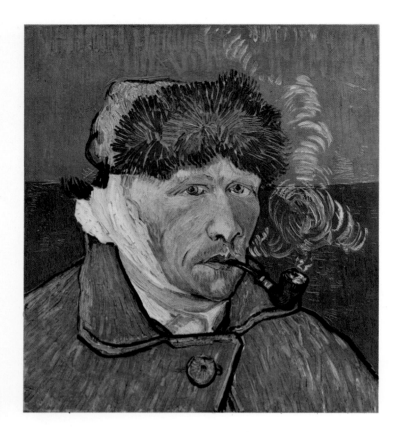

Van Gogh.
Self-portrait with a bandaged ear.
1889.
Leigh B. Block Collection,
Chicago.

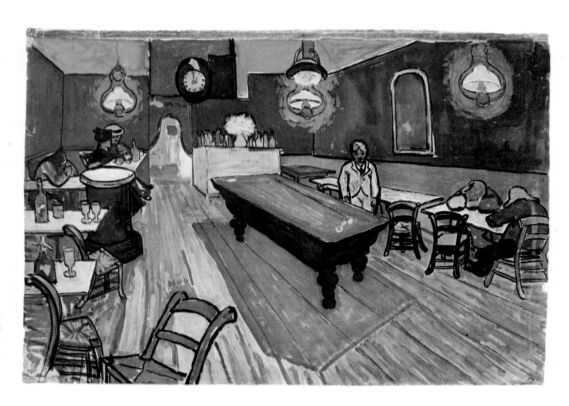

Van Gogh.
Café by night
at Arles.
Water-colour. 1888.
A. Hahnloser Collection,
Winterthur.

gined through the admiration he had for Japanese prints. Soon his stroke widened, his colours became heightened and his drawing firmer. He worked without sparing himself, in the hot sun, while the mistral blew, sometimes he even set up his easel at night in the middle of the fields. He was not satisfied with recording what he saw, he expressed the emotion of his whole being, the quivering of his heart and the inspirations of his mind. In order to intensify his expression, he exaggerated what

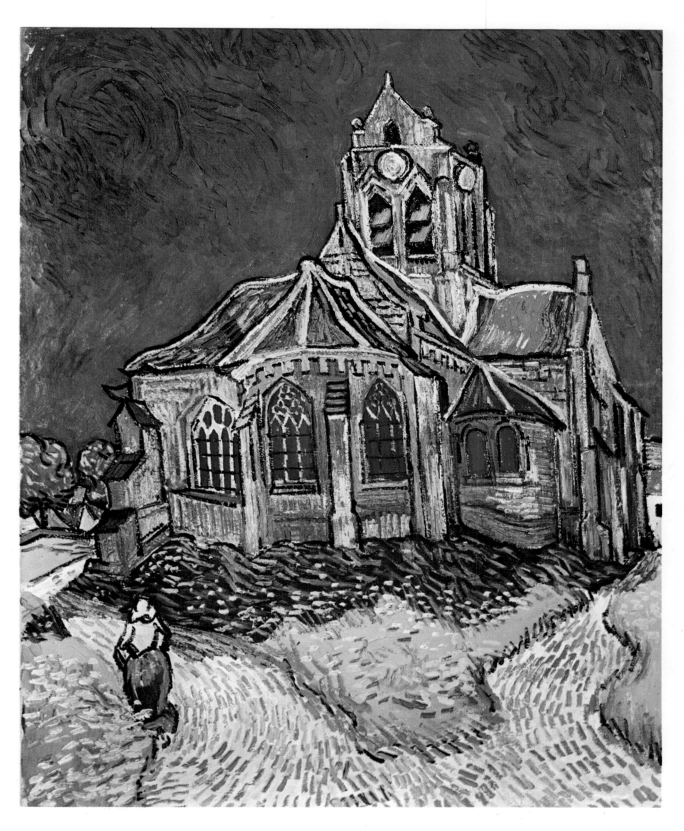

Van Gogh.
The church at Auvers.
1890.
Musée de l'Impression-
nisme,
Paris.

seemed essential to him, and dismissed what he judged trivial or insignificant. Haunted by the sun, which he adored all the more intensely as he was from the north, he gives us a much more brightly coloured vision of the south than did Cézanne, who was a native of Provence. Pure colour triumphs also in his portraits, his flowers, his interiors. He intended to give it a symbolic value. He painted a *Café de Nuit*, where he '' tried to express in red and green the frightful passions of human beings. ''

43

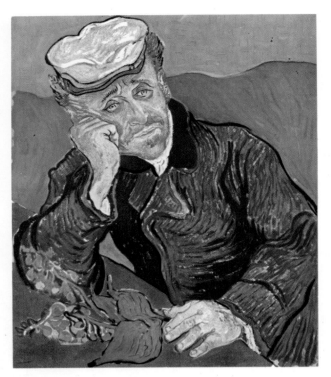

Van Gogh. Portrait of Doctor Gachet. 1890.
Musée de l'Impressionnisme, Paris.

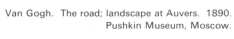

Van Gogh. The road; landscape at Auvers. 1890.
Pushkin Museum, Moscow.

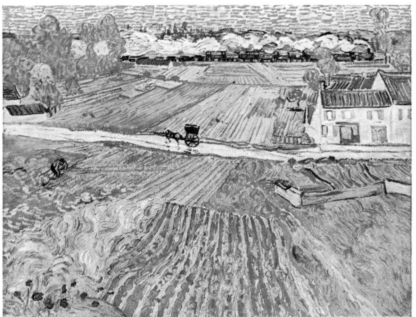

He dreamed of expressing " the passion of two lovers by a mixture of two complementary colours, their mixtures and their contrasts, the mysterious vibrations of their related colours ". At the same time he was engaged in drawing and he produced several works of considerable vigour with a pen or a reed. This man, who worked with spirit, tenaciousness and lucidity, neglected nothing.

His lucidity never deserted him even during his fits of madness, the first of which took place in December 1888 after a quarrel with Gauguin, which led him to cut off one of his own ears. Even at the lunatic asylum at Saint-Rémy, where he asked several months later to be admitted, between fits he was able to judge with clear-sightedness both his condition and his art. Although he no longer possessed the joyous colouring of the Arles period and his drawing became tortuous, whirled and appeared to be out-of-breath, although his works expressed a tearing anxiety and an incurable anguish, they were not the product of a delirious or of an uncontrolled hand.

Was there any difference in those he painted at Auvers-sur-Oise during the last two months of his life ? In some of them his hand seemed to have lost a little of its assurance, although his creative force seemed in no way exhausted. What could be more masterly than the *Portrait of Dr Gachet ?* What could be more expressive than those broad landscapes with their threatening skies, vibrating with anxiety when they are not whipped by a fierce wind ? Although his style was now more cursory than it had been, it remained full of vigour. It remained just as controlled and his paintings were still firmly composed in spite of the black despair that gradually drove him to suicide.

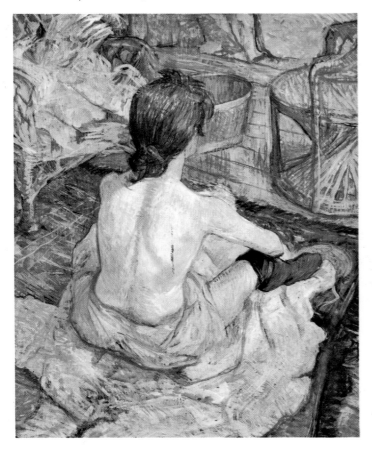

Henri de Toulouse-Lautrec. Artistic activity and destiny were as closely connected in Toulouse-Lautrec (1864-1901) as in Van Gogh and Gauguin. He was descended from the Counts of Toulouse and his father was an eccentric with a passion for hunting and horses. He broke both his legs in childhood, so that he grew up a crippled dwarf who could only walk with difficulty. This infirmity determined the flavour of his art just as it determined the course and details of his life.

Unable to lead the life, normal to those of the class into which he was born, he very soon withdrew from polite society. He came to Paris in 1882 to pursue his studies. Three years later he settled in Montmartre, where he soon spent a great deal of his time at balls, cabarets and brothels. Nowhere, did he feel more at home than in this world of debauch and easy pleasures. His eye was so keen, his mind so disillusioned, his heart so filled with irony and bitterness that often the picture he gives of this world is cruel and pitiless. His heart revealed itself too in the way in which he represented movements, whether of his father's horses or those of the dancers of Montmartre. The faster and the easier these movements were, the more he observed them with passion. He looked at them with envy, with secret malice, managing to catch them at moments when they looked not merely strange, but grotesque. His sharp, biting, cruel drawing has a caricatural side, in the same way as his colouring has an aggressive acidity. In all this he differed from Degas, whom he admired. He is close to him, however, in his love of the unexpected, his indifference to nature, his taste for artificial lighting and the importance he attached to line.

45

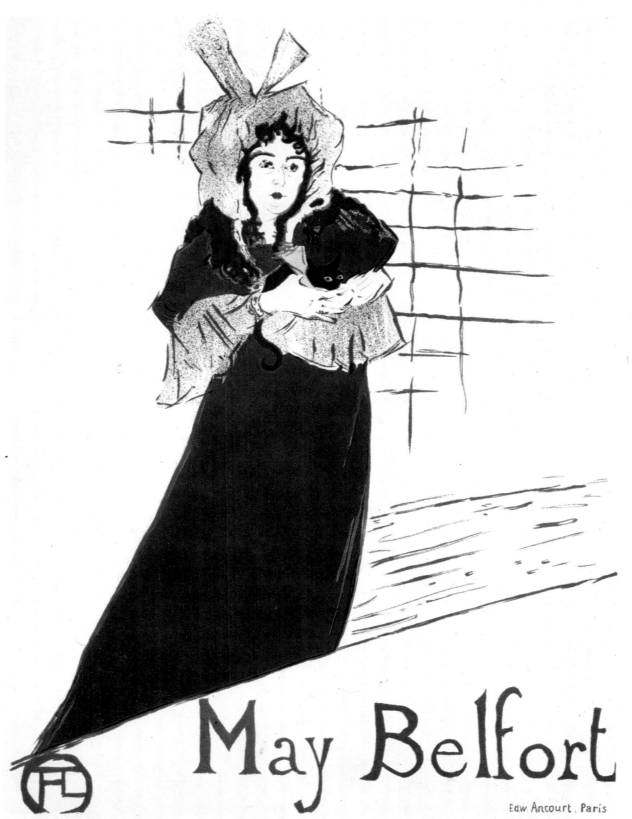

May Belfort

Edw Ancourt, Paris

Toulouse-Lautrec.
May Belfort.
Poster.
1895.

Toulouse-Lautrec. Yvette Guilbert.
Charcoal drawing heightened with colour.
Musée d'Albi.

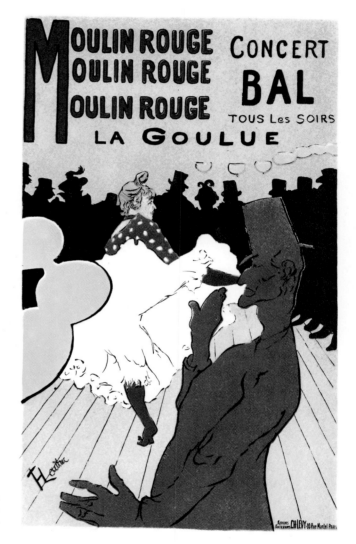

Toulouse-Lautrec.
Moulin-Rouge.
Poster. 1891.

In general, his models too are different from those of Degas. He did not look for them among young Opéra dancers; he found them at the Moulin Rouge, in music halls and circuses. Actually it was often he who contributed to their fame by making them appear striking and unforgettable in his posters, which plastered the walls of Paris.

His posters and lithographs are in general as excellent as his paintings. Often they are even more

Toulouse-Lautrec. Jane Avril dancing. 1894.
Musée d'Albi.

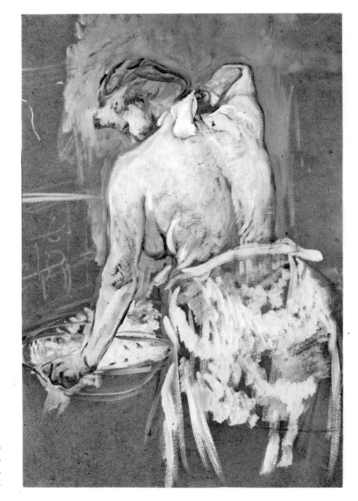

Toulouse-Lautrec.
The toilet. 1896.
Private Collection,
Paris.

masterly than the latter. Their success is generally dependent on the suggestive vitality of their outline, where form is reduced to its simplest expression. When designing posters, Toulouse-Lautrec kept in mind Japanese prints, whose lessons he had assimilated better than anyone else. However, his brush was freer than that of the Japanese artists and his expression more direct. Instead of the slightly stiff reserve of the Far East, we find in Toulouse-Lautrec's layout, drawing and choice of colour, an audacity, which barely avoids disrespect and is even at times tinged with insolence.

neo-impressionism

It is rare to find painters like the neo-impressionists, who have such a clear idea of what they want; rarely have artists felt so strongly the urge to put their ideas and methods on paper. Not only did Paul Signac, a member of their group, publish in 1899 a long treatise *(From Eugène Delacroix to the Neo-impressionists)*, but in 1890, four years after the first public appearance of the movement, Georges Seurat, the leader of the new school, felt the need to define his aesthetic theories in lapidary terms.

There were to be no vague perceptions recorded approximately with " random brush strokes ", Signac said to sum up. The neo-impressionists analysed closely what they saw and reproduced it by differentiating systematically between the local colour of the objects, the colour of the lighting and their reactions one upon the other. They carefully read Chevreul's book *The Law of Simultaneous Contrasts*, they knew the works of the physicists, Helmholtz, Maxwell and N. O. Rood, and did their best to take into account the teachings of science. Instead of blending colours, the neo-impressionists substituted optical blending. They placed their colours side by side, so that they should remain pure on the canvas and only combine in the eyes of the spectator, while preserving their luminosity and their glow. Their distinct touches were in theory meant to be " proportional to the size of the picture ". They took the form of a small spot or point, which led to the coining of the word " pointillism ". Signac, however, protested : " Neo-impressionism does not make a *point*, but a *division* " of colour and " dividing ensures all the advantages of luminosity, colour and harmony... "

How did art adjust itself to so much logic ? Unsuccessfully, one must admit, and a number of the neo-impressionist pictures became arid from having been executed too systematically. In fact what gave its importance to the movement was not its " precise and scientific method ", but rather the part that it played in the freeing of colour, and the serious attention it paid to grouping and composition, both by line and colour.

49

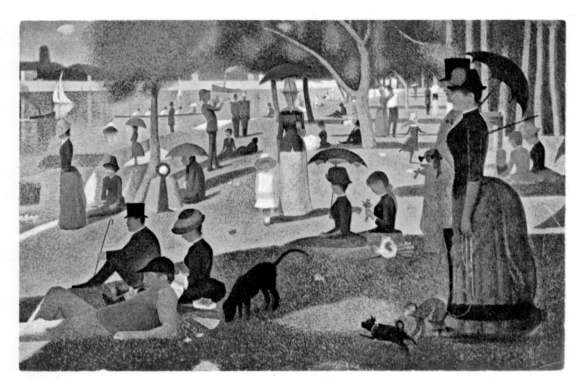

Seurat.
Sunday afternoon at the Grande Jatte.
1884-1886.
Helen Birch Bartlett Collection,
Art Institute, Chicago.

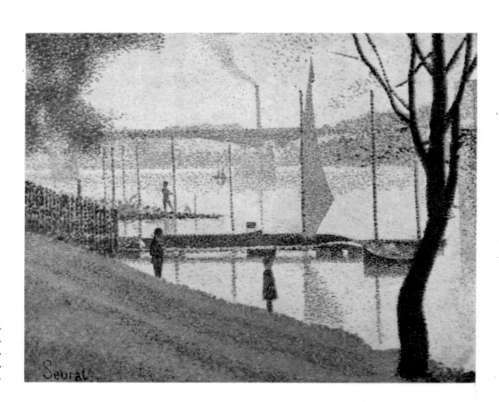

Seurat.
The bridge at Courbevoie.
1886.
Courtauld Institute,
London.

During the years that saw the break up of the impressionist group (its last exhibition took place in 1886), and the development of the movement, its adherents often dreamed of the advantages that art could derive from its relations with science. Besides about 1886-1890, neo-impressionism was far from appearing a dead-end. The group around Seurat and Signac not only included Camille Pissarro and his son, Lucien, H.-E. Cross, Angrand, Maximilien Luce and others, even Toulouse-Lautrec, Van Gogh and Gauguin followed it in practice although they rejected its theories.

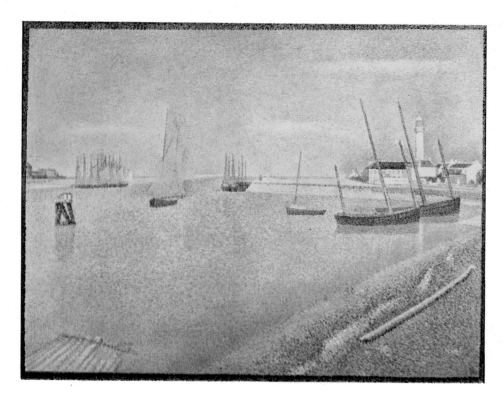

Seurat.
The Gravelines canal
looking towards the sea. 1890.
Rijksmuseum Kröller-Müller,
Otterlo.

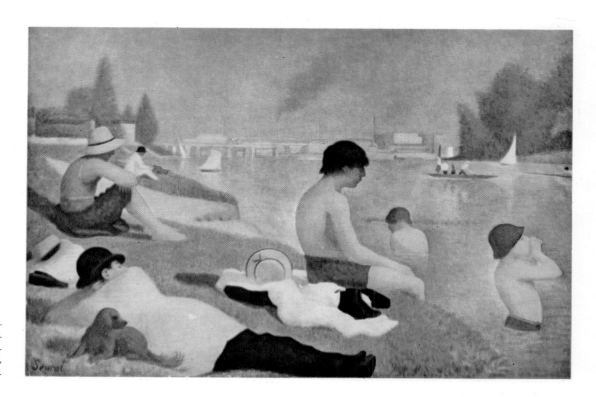

Seurat.
Une baignade.
1883-1884.
Tate Gallery,
London.

Georges Seurat. " Writers and critics see poetry in what I produce. No, I merely apply my principles; that is all. " When Seurat (1859-1891) said this, he was no doubt speaking sincerely about his experiments, but he was mistaken about the significance of his art, where fortunately the presence of the poetry is undeniable. Of all the neo-impressionists, he is in fact the only artist whose sensibility was never stifled by the rigidity of the system. This shows how vital that sensibility must have been and how much at ease in respecting the strictest of rules. Seurat was one of those artists

who dislike pouring themselves out, are inclined to conceal their emotions and hide them under an appearance of coldness created by a careful composition and meticulous technique.

From early youth he knew to what tradition he belonged; he copied Ingres, Poussin, Holbein and Raphael. Although he also looked to Delacroix, it was not in order to admire his romantic out-pourings, but to absorb the laws, which that artist applied in the field of colour. The same preoccupation led him to study *The Grammar of the Art of Drawing* by Charles Blanc. He discovered a sentence that impressed him deeply: " Colour reduced to certain, definite rules can be taught like music. " Enthralled by the certainty of science, he also studied the works of Chevreul, N. O. Rood and David Sutter's *The Phenomena of Vision*, etc.

Before 1882, he drew more than he painted and throughout his life he remained faithful to black and white. The vibrant pages which he drew with a Conté crayon possibly reveal the most poetic and attractive side of his work. No less attractive are the small sketches he drew on the spot in a lively, free style. These rapid sketches did not satisfy him; he wanted a more complete art, which satisfied the mind while moving the eye. He wanted colour to be more " exact ", shapes well defined whose volume could be felt, a volume that he suggested less by modelling than by the shaping of the outline. In addition he enjoyed arranging vast surfaces and filling them with numerous figures in varying attitudes. In consequence, the few large works, which his short life allowed him to produce, took shape slowly. He took two years to paint *A Sunday Afternoon at La Grande Jatte*, this " manifesto " picture, which, when it was shown at the 8th Impressionist Exhibition, marked the " official " entry onto the scene of neo-impressionism.

Although there are innumerable anecdotal elements in this work, it is not these that are memorable but the style. One forgets that the women's clothes appear ridiculous and sees merely the beauty of the play of lines for which they are a pretext. The parasols too are merely an excuse for elegant combinations of curved lines and the little monkey is nothing more than a witty arabesque. Everything is radically transposed into the domain of pure art so that life appears suspended. Movements are frozen into strange postures. Time is abolished and the figures look like statues standing in the still, rigid light of a museum. Does not a woman in the middle of the canvas remind us of the Hera of Samos ?

In later compositions the rigour softens, light quivers more, colours become clearer and lighter. However precious these works may be, it was in his less ambitious ones that Seurat showed his finest qualities: the landscapes inspired by the Seine at Courbevoie, the sea at Port-en-Bessin, the harbour at Gravelines. In these, an impalpable delicacy is combined with masterly composition, and subtleties of vibrating colour with a sensitive precision of drawing.

If in the majority of his pictures Seurat shows little concern for movement, he makes it triumphant in *The Circus*, which was to be his last picture. However fierily the horse gallops however momentary the positions of the acrobats, the painter is always in control. He shows us clearly defined figures surrounded by lines, which sometimes move with the subtle agility of a serpent and at others stiffen, break into acute angles or describe a rapid zigzag. Seurat's intelligence makes itself felt even in the way he painted the leaps. He always gives expression to the serene, balanced consciousness which distinguishes the classical painters, always contrasts irregularity and the confused richness of life with simplified, purified forms and clarity. He was to be admired by the geometrically minded artists of the 20th century, particularly certain cubists, who valued the total effect of his taste for discipline, the intellectual side of his art and the deliberate restraint exercised over his sensibility.

symbolism and the nabis

In 1886, Jean Moréas, the poet, published the manifesto of literary symbolism. Five years later, Albert Aurier, the critic, defined symbolism in painting. " Symbolic poetry tries to clothe the idea in a sensitive form ", wrote Moréas and Aurier developed this formula by adding that a work of art must be " synthetic, subjective and decorative ". As representatives of the new tendency, he mentions Gauguin, Van Gogh, Redon and, among the young artists, Sérusier, Émile Bernard, Filliger, Maurice Denis, Roussel, Ranson, Bonnard and Vuillard. In short, he mentions nearly all who at that point were opposed to impressionist realism, but the term " symbolist ", as he defined it, could really only be strictly applied to Gauguin and those who were working in his spirit.

Redon's (1840-1916) position was a special one. Born in the same year as Monet, his development was always on the fringe of impressionism. He was haunted by the nocturnal side of life, because of its obscure and enigmatic character. He drew a *Smiling Spider*, the *Eye with a Poppy* isolated in the white rectangle of a window, a *Marsh Flower* which was " a sad and human head ", hanging on a tired stem. His art, as we can see, was not free from " literature ", and at times his mysterious effects appear a little easy and somewhat artificial. However, Redon was a true visionary, and perhaps he proved it most convincingly when his works were closest to nature, in his flowers for example. Although he knew how to look at them with the eye of a botanist, what he produced were light, fragile, unsubstantial visions, which grow up in our world as if by a miracle; their colours remain delicate and indefinable even when they are bright; they surpass realism and are penetrated with the spiritual beyond.

The presence of this spiritual quality is noticeable in all Redon's works and it was this that made him dear to the young painters mentioned by Aurier. Most of them belonged to the Nabis group (Hebrew word for Prophet). One of them, Sérusier, was the artist to whom Gauguin spoke those famous words: " How do you see this tree ? Is it green ? Well then use green, the most beautiful green from your palette; and this shadow, rather blue ? Don't be afraid of painting it as blue as possible. " He trans-

53

Odilon Redon.
Vase of flowers.
Musée du
Petit Palais,
Paris.

Bonnard.
Le Pont de Grenelle.
1919.
Georges Renand
Collection,
Paris.

mitted this message to his friends Bonnard, Denis, Ranson, Roussel and Vuillard, who were influenced by Cézanne, Degas and the Japanese. It was through the latter that the Nabis were led to see the expressive and decorative value of line, and they enjoyed stretching and softly curving their outlines. In this, they anticipated the floral style, which was to become famous in Europe about 1900, known as Art Nouveau, Jugendstil or Modern Style. The Nabis, especially Bonnard and Vuillard, the most remarkable personalities of the group, were soon to abandon the impressionist range of colours and to replace it by greys, ochres and dull tones in general. These two artists gave up painting sunlit landscapes for quiet middle-class interiors and when they took the streets and gardens of Paris as their subjects, they did not turn them into sunny landscapes. Unlike their predecessors, the impressionists, they did not try to emphasise the vastness of the boulevards by deep perspectives; they liked to give a rather intimate character to their paintings and they suffused them with a gentle, dreamy light. Actually, what preoccupied them was not the effects of light, but the street as a setting for the lives of ordinary people, men going to work and women shopping.

Pierre Bonnard. If one had had to make a choice between Bonnard and Vuillard prior to 1900, one might have hesitated. Vuillard (1868-1940) then showed such exquisite sensitivity, his delicate colouring had such distinction and his composition such originality and discrimination that he inspires great admiration. Sometimes it almost seems as though Vuillard's work were the more restless and contained richer possibilities (about 1890, he was experimenting in different directions); sometimes he even seemed more inspired. All this changes, however, when one looks at the pictures Bonnard and Vuillard painted in the years 1930-1940; the latter had lost his finest qualities and all his boldness, whereas the former had improved in every respect. Does this mean to say that Bonnard (1867-1947) had developed late? No, but he never stopped enriching and renewing his art. Yet at the beginning he struck one by the ingeniousness of his vision and by his youthful malice. Less intimidated by life

55

Bonnard. The box. 1908.
Private Collection, Paris.

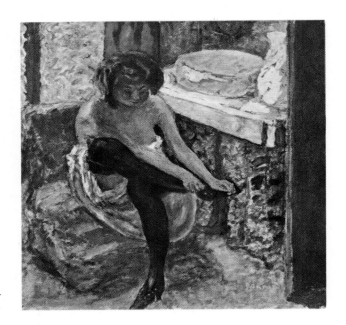

Bonnard.
Woman with black stockings. About 1900.
Rosengart Gallery, Lucerne.

than Vuillard, he was incapable of looking at the world without humour and irony, he could not look at certain sights without an amused smile.

The most commonplace objects attracted his eye and astonished him. His surprise was never forced or artificial; he never overexpressed it; he, of course, wished us to be astonished as well and did his best to surprise us, but although he was mischievous, he never exaggerated. However original his sample may have been, one is always under the impression that he gives us " slices of life " chosen at random. Bonnard's composition never seems studied; it almost seems to acquire equilibrium through a sort of magic.

During the Nabis period his colours were dull on the whole. Towards 1910 they started to brighten and at the end of his life, Bonnard, who lived a great deal at Le Cannet, became one of the boldest colourists of the 20th century. He transformed the world into a garden full of riotous flowers. He put strong colours side by side with fine irisations, the glow of reds and oranges singing the praises of the midday sun, with the subtle vibrations of morning light reflecting in the dew. Nothing was more daring than the successful use he made of lilac and violet, those dangerous colours.

Many of his later paintings make us think of a firework display, but the thrill which they arouse has nothing brutal or sudden about it; their enchantment is durable and we are invited to savour it slowly. Everything in his art was designed to give pleasure to the eye and joy to the senses. Bonnard does not worry about the fact that the pulp of the fruit is perishable; it refreshes us and flavours our palate. We are far from Cézanne, but very close to Renoir. Like the latter, Bonnard is a painter of the joy of living, of the wonder of a world transfigured for us by a friendly sun. What nevertheless distinguishes him from his predecessor is that he expresses himself with even more freedom. He interpreted his impressions with so much fantasy and used colour with such independence that, towards the end of his life, he seemed not only one of the richest and most lyrical of contemporary painters, but also one of the most inventive.

Bonnard.
Almond-tree
in blossom.
1946.
Musée National
d'Art Moderne,
Paris.

fauvism

" Painting as it is now ", wrote Van Gogh in 1888 to his brother, Theo, " promises to become more subtle, more like music and less like sculpture. At last it promises *colour*. " These prophetic words were at the beginning of the 20th century to be forcefully confirmed, in every respect but one, by a group of artists. The triumphant colour in their works did not begin by being subtle, on the contrary it was so violent and striking as to be like a roar. On seeing their pictures at the Autumn Salon of 1905, the art critic, Louis Vauxcelles, spoke of " fauves " (wild beasts), thus giving the group the name with which they were to go down in history. Generally the names given to artistic movements include very different sorts of art and this group was no exception. There was both a wild and a disciplined form of fauvism which heeded only its instinct and one which was directed by thought and logic. Considering only the pioneers who occupied extreme positions, we have on the one hand Vlaminck who according to his own admission tried to paint with " his heart and his guts, without worrying about style ", and on the other we have Matisse who said, " For me everything is in the conception. So it is necessary to have a clear vision of the whole right from the start."

Who gave the movement its greatest momentum? If Vlaminck is to be believed, " I am fauvism ", but there is no doubt that Matisse was the real leader of the group. Around him were gathered Marquet, Camoin, Manguin, Jean Puy, and even Derain himself, who was a friend of Vlaminck, benefited from his advice. Friesz, Dufy and Braque allowed themselves to be converted by his works. Who were the real fathers of fauvism? For Vlaminck there was only one—Van Gogh. Vlaminck was captivated when he saw a retrospective show of his work in 1901 at Arles. What does it matter if he was misled by the lessons that he gathered from the works that impressed him? What does it matter if in his eyes

58

Vlaminck.
On the bank of the Seine
at Carrières-sur-Seine.
1906.
Guy Roncey Collection,
Paris.

Derain. Sun reflected on water. 1905.
Musée de l'Annonciade, Saint-Tropez.

Matisse.
Woman wearing a hat.
1905.
Private Collection,
San Francisco.

Derain.
Port of Collioure.
1905.
Pierre Lévy Collection,
Troyes.

Marquet.
Travelling fair at Le Havre.
1906.
Musée des Beaux-Arts,
Bordeaux.

Van Gogh was nothing but a man who confessed himself spontaneously and freed himself unreservedly? This was what he himself intended to do, and he needed encouragement. Matisse too, even prior to 1901, studied Van Gogh, but he also learned from Gauguin and Cézanne. In addition, he turned to neo-impressionism and in 1899 he painted several pictures in the pointillist style. He started again to divide colour in 1904, when he painted at Saint-Tropez with Signac and Cross. From then on, he only had to choose his colours with greater freedom, enlarge his dots making them into blobs and flat tints for his painting to become fauve.

This happened the following year at Collioure, where Matisse painted this time in company with Derain. Undoubtedly the intensity of the southern light and the excitement that it communicates

Derain. Westminster. 1905. Musée de l'Annonciade, Saint-Tropez.

to northerners played their part in this new development. Whatever stimulants the south of France may have provided for the fauve group, they were not their only inspiration. Vlaminck managed quite easily without it; he discovered glowing embers in a street at Marly and set on fire the branches of the trees, silhouetted against the Seine. Derain, too, painted in London some of his most admirable landscapes that were even more highly coloured than those of Collioure. As well as this, the fauves, particularly Matisse, Vlaminck, Derain and Van Dongen painted the human face and even portraits, still using bright or violent colours.

However, the fauves did not limit themselves to heightening colour, any more than Van Gogh and Gauguin had done; they also gave it more freedom, freed it not only in relation to the outside world, but also in relation to the rules to which their predecessors felt it was necessarily tied. To indicate shadows, they did not only use cold colours, but on occasions even purple or red. As for complementary colours, they did not use them systematically; they looked for unusual harmonies and were not deterred by stridency or dissonances. This was not all; they entirely rejected chiaroscuro and relief in order to construct their shapes only with the help of line and colour; a line that was generally coloured as well and that tended not to define the object with precision.

Vlaminck. Red trees. 1906.
Musée National d'Art Moderne, Paris.

Vlaminck.
Portrait of André Derain.
1905.
Private Collection,
Paris.

" Remember ", wrote Maurice Denis, " that a picture before being a war-horse, a nude, or some sort of anecdote, is essentially a flat surface covered with colours assembled in a certain order. " This sentence always, seems to have been present in the minds of most of the fauves. " The need to proportion the colours could lead me to modify the form of a figure or to transform my composition ", Matisse declared. Does this mean that colours should be combined only for decorative reasons? Of course not. They translate sensations and feelings by bringing out their most intense and subjective side. Again Matisse said, " What I aim at above all is expression ", and added, " Expression for me is not in the passion, which is about to break out in a face or which is shown by a violent movement. It is in the arrangement of my whole picture: the position of the figures, the space around them, the proportions, all this has a function. Composition is the art of arranging in a decorative manner the various elements at the disposal of a painter to express his feelings. " Such conceptions were certainly not shared by Vlaminck, but he too looks for expression and goes as far as expressionism.

The extraordinary thing is that three years after its first vital and joyful appearance, the movement died. Amongst its most daring protagonists, Matisse and Van Dongen alone continued to pursue the way they had inaugurated. The latter remained faithful to fauvism until 1912 and even after the First World War, when he became the best known of the fashionable portrait painters in Paris, he did not entirely abandon the palette of a period during which he had been, if not one of the most innovating of painters, at least one of the most spirited and piquant of colourists. For all the others, there was a complete change of direction. Farewell to the blazing tones, farewell to the orgies of colours—Lent

Matisse. The siesta; Collioure. 1905.
Private Collection, Ascona.

Matisse.
Open window;
Collioure. 1905.
Private Collection.

follows carnival time. Those who had so joyfully sacrificed everything for the pleasures of the senses, now became austere ascetics. This was the moment when Cézanne's influence eclipsed that of Gauguin and Van Gogh; the moment when cubism was born of which Braque was to be one of the principal champions.

Dufy later came back to pure colour. Vlaminck, Friesz and Derain, however, never again possessed the harmonies that made their most inspired works. Derain was even led to rejecting all modern art. After leaning towards cubism and then producing painting with medieval affinities, he returned to a realist style about 1920. After that, whether he was painting nudes, portraits, landscapes or still-lifes, he firmly applied the ideas established by the Renaissance and discarded by contemporary art since impressionism.

As for Vlaminck, who, during the fauve period, had " wanted to burn down the École des Beaux-Arts with [his] cobalts and vermilions ", he too began by disciplining himself with geometric form, but about 1920 opted for a realistic expressionism, which he defended until his death. Although his headlong style showed that he still had the same exuberant, vehement temperament, his colour range sobered and afterwards it was particularly on the contrast between light and dark that his effects depended. They were emotional, sometimes theatrical effects, which nevertheless express at their best an intense, deep feeling. Vlaminck was particularly sensitive to the harsh atmosphere of winter evenings in the villages, when the overcast sky makes the snow shudder on the roof-tops and the sad, muddy white on the roads lies beside the tragic surface of ancient walls.

63

Van Dongen.
Spanish dancer.
About 1910.
Musée National
d'Art Moderne,
Paris.

Henri Matisse. Master of colour—no contemporary painter has more fully deserved that title than Matisse (1869-1954), who experimented ceaselessly through his career with pure colour and was constantly discovering fresh potentialities. The liveliness of his tones remind one of Van Gogh and Gauguin, but the refinement which he added to their radiance makes one think of the Persian miniaturists, whose flower-like and heady palette he admired. Even in the first works of the fauve period, where his style may appear hasty, the rareness of his harmonies and their " artificial " character show that, unlike Vlaminck, he did not paint " from the tube to the canvas ", but that his painting comes to us as the result of profound study.

None of his companions realised better than he did the complexity of the problems set by fauvism

Matisse. The piano lesson. 1916-1917.
Museum of Modern Art, New York.

Matisse.
Interior with a violin. 1917-1918.
J. Rump Collection,
Statens Museum for Kunst,
Copenhagen.

Matisse.
Odalisque with red trousers.
1922.
Musée National
d'Art Moderne,
Paris.

66

Matisse. The sideboard. 1928.
Musée National d'Art Moderne,
Paris.

Matisse.
The Persian dress.
1937.
Private Collection.

Throwing bright colours onto the canvas was not after all the essential point. What was needed was to interpret the world in a way that left colour its purity without impoverishing the picture in the process; to discard modelling, chiaroscuro and '' classical '' perspective while communicating sensations of volume, light and space; in short, it was to perfect a new idiom that would be as expressive as the one they had just challenged. It was this that Matisse endeavoured to do, so it is not surprising that he did not feel at a dead-end, when in 1908 the flames died on the palettes around him. Light he made flow from the brilliance of the colour harmonies. Volume the contour suggested, a contour that also had the value of an arabesque. Space he created both by the choice of colours and by the relations of objects that acted as landmarks.

Towards 1913, the cubist example led Matisse to make his work less lyrical and more severe. His drawing stiffened, became more geometrical; in his colourings the oranges and reds give way to

67

Matisse. Woman reading against a black background. 1939.
Musée National d'Art Moderne, Paris.

Matisse.
The sword-swallower.
Illustration for " Jazz ".
1946-1947.

purples, greys and blacks; his composition became purer, harder and even severe. It might have seemed that he was going against his real inclinations if he had not painted some of his masterpieces in this style, such as *The Moroccan Praying*, *The Piano Lesson*, which, although they owed a great deal to intellect, were neither cold nor sterile.

After 1918, the tension was relaxed. For a time, Matisse who from then on lived mainly in the south of France, gave up new ventures and, full of the joy of living, he limited himself to cultivating the ground that he had already gained. He even tried to seek a compromise with certain principles of the realist tradition; he sometimes resorted to modelling and, when he painted interiors occupied by indolent young women or by languid odalisks, he emphasised depth by linear perspective. He did, however, continue to create colours, which although less glowing than before, were often more refined and attractive. Matisse's painting was now nearer than ever before to the ideal he had described in 1908 when he said: " I dream of an art that is balanced, pure and calm, without any disquieting or absorbing subject, that can offer every brainworker, whether businessman or writer, a tranquilliser to soothe the mind, something analogous to a comfortable arm-chair that offers relaxation after physical exertion. "

Matisse. Michaela. 1943. Mrs Maurice Newton Collection, New York.

Was he going to continue along this road, where preciousness and prettiness lay in wait? Towards 1930, a distinct change came over his art and it rediscovered its boldness. As during the fauve period, but with even more mastery, Matisse united vitality with subtleness, and sought at the same time for rich effects and simplified means. His subjects hardly changed and it is not they that mattered. Whether they were, yet again, young women indoors, nudes, flowers or still-lifes; through the diversity of their colours and shapes, they fundamentally expressed the same thing: a love of life from which anxiety, torment and nervousness were banished, where only full, luxurious and voluptuous harmonies existed. Although the sun is never shown, Matisse's art is one of summer. In it is incarnated a serene exaltation; from it emanates a lucid intoxication.

Is he related to Bonnard? Possibly, to a certain extent. But Bonnard is more " fleshy ", Matisse more " abstract ". If the former makes us feel the flesh and juice of his fruit, the latter paints what remains when they have fermented; he only conserves their essence. One offers us delicious things, the other makes us drunk. The former is intimate, and even his lyricism is guileless; the latter is serious, lordly, even a little solemn. Matisse appears the less warm of the two: his sensuousness is less apparent because it is more refined.

69

Dufy.
Regattas. 1938.
Stedelijk Museum,
Amsterdam.

Dufy.
A horse at Longchamp.
Water-colour.
Galerie Pétridès,
Paris.

Dufy.
Epsom; the grandstand.
Water-colour.
Galerie Pétridès,
Paris.

Dufy.
The studio with a blue portfolio.
1942.
Galerie Louis Carré,
Paris.

Dufy.
The weigh-in at Chantilly.
Water-colour.
Galerie Pétridès,
Paris.

Raoul Dufy. The art of Dufy (1877-1953) has such ethereal grace that at first sight it may appear slight and even facile. In reality this grace was a victory, and the artist did not discover his style in a day. During the fauvist period, he barely perceived it. He suspected it even less in 1908, when at l'Estaque he painted landscapes in which he hardened his forms geometrically, while eliminating all colours, excepting greens, blues, greys and ochres. Dufy only found himself around 1920. From the time he discovered his personal style, he never changed and his painting developed rapidly.

No one can deny that he was indebted to Matisse. He recognised this himself. When he saw Matisse's *Luxe, Calme et Volupté* in 1905, he understood '' all the new reasons for painting '' and there, for the first time, he contemplated '' the miracle of the imagination transmuting drawing and colours ''.

71

Dufy. Seascape. Private Collection.

This does not mean that Dufy's drawing and colour were not his own and that if, like the elder artist, he was a painter of happiness, he is in a way that he shares with no one.

Dufy did not dislike painting interiors or flowers, but like the impressionists, he mainly painted outdoor scenes and landscapes. However, he was not satisfied simply by the visual pleasures nature provided. He allowed his soul to be submerged by the blue of the sky, he dived into the sea, enjoying the coolness of the water with the joyfulness of one saturated by the sun. He expressed what he felt, with directness and a sort of impatient acuteness, which he first of all translated through colour; colour which he exalted, re-enforced, spread out, modified when necessary, until it could achieve the sonorousness of a bugle, or a sparkling brightness, or a subtlety devoid of insipidness. Dufy in his oils could appear strident, but he was never aggressive or common; the distinguishing marks of his art were always charm and pleasantness. Although he always took into account the light appropriate to the places he painted, he was too fond of the precision of his colours to let them become dulled by atmospheric layers. Generally his air is crystal-clear, his world fresh as if it had just awakened, or as if the rain had washed away all dust and dirt.

72 Dufy's drawing accentuates this impression. It is supple, light, flickering; he never attempted to

Dufy.
The interval.
1945.
Private Collection,
Mexico.

Dufy.
The red violin:
" Music and painting
by Raoul Dufy ".
1948.
Musée National
d'Art Moderne,
Paris.

define objects, so that they should stiffen into thick and heavy shapes. However, though his lines were extremely elliptical, though he placed witty abbreviations side by side with invented signs, he was clear, alive and acute. And even when he appears only to be doing a casual scribble, he remains evocative. In drawing these open shapes, Dufy drew out these figures and objects from their isolation and permeated them with their surroundings. At the same time, he gave himself the chance of presenting the same subject several times, without becoming monotonous. Whether he painted scenes on the Côte d'Azur at Nice, the paddock at the races, regattas, cornfields, threshing or orchestras, each picture looks as if it were the result of his first contact with the subject; each was conceived so freely, and executed with such fresh and petulant zest, that it appeared as a unique invention and the result of a delightful surprise.

73

Marquet. Quai des Grands-Augustins, Paris. 1905.
Musée National d'Art Moderne, Paris.

Marquet.
Boulevard
de la Madeleine, Paris.
About 1923.
Private Collection,
Paris.

Albert Marquet. The reason why Marquet (1875-1947) took part in the fauve movement was primarily because of his friendship with Matisse. His character certainly did not encourage him to use violent colours. The pure hues to be found in some of his works appeal less through their boldness than through their sensitiveness and rightness. Besides, he showed all through his life that the nuance was more congenial to his temperament than the pure colour.

He was mainly a landscape painter and his favourite subjects were town scenes, ports and beaches, in fact, everywhere where human activity was added to the peace of nature. It was an activity that he watched from a height and at a distance, so that man is reduced to a tiny silhouette whose insect busyness sometimes takes on a somewhat ludicrous air. He painted under very different skies, Le Havre and Naples, Hamburg and Marseilles, Norway and Egypt, but he never seems happier than at Paris in front of the embankments and bridges of the Seine. He loved the light veils that enveloped everything in the moisture-laden air and was particularly sensitive to the effects of snow and mist.

He would have been in line with the impressionists if he had not endeavoured to synthetise his sensations rather than analyse them and if he had not always emphasised the basic structure of his painting by long lines. Admittedly, he made few innovations and his work is limited, but among the painters who remained faithful to realistic canons, he is one of the most sincere and the most genuine.

74

cubism

When at the end of 1907 Braque began to turn his back on fauvism, his aim was to decrease the strength of colour, in order to increase that of form, to emphasise not only line, but also volume. Thus several months later at l'Estaque he painted landscapes in which every object was a solid body reduced to a geometrical form, where foliage was no less hard than the tree trunks and the walls of the houses. " Monsieur Braque... reduces everything... sites, figures and houses to geometrical diagrams, to cubes ". This is what Louis Vauxcelles wrote about these works, and here he coined the key word, which was to describe the new tendency: cubism.

Obviously for Braque and for the Spaniard Picasso too, who was working along the same lines, it was more than a matter of cubes. Although the term can be applied with some justification to the works these two artists painted before 1910, it does not hold true for all they produced after this date. They then freed themselves from the influence of Cézanne and primitive art, which had been formative elements in their style until then, and cubism stood out as the most revolutionary movement to appear in figurative painting since the 15th century. In fact, it broke away from all the conventions of optic realism and completely discarded " traditional " perspective, modelling and verisimilitude of light effects, not because it was indifferent to objects, but because it wanted to analyse them more closely and try to give a more total representation of them. The cubists were the first to realise fully that by choosing a single viewpoint, the Renaissance had introduced a certain order in the picture, but at the same time it had condemned itself to giving only a partial view of things, that seen by a motionless observer. Now, modern man moves from place to place with increasing rapidity and the picture he receives of the world is complex. It was this complexity that the cubists endeavoured to transfer to canvas by juxtaposing on the same plane the different aspects of an object that the eye cannot see simultaneously, but that the mind has the ability to reunite.

It is no good pretending that all the details in cubist works can be explained by this concern to

Braque.
Glass and violin.
Oil and charcoal. 1912.
Kunstmuseum, Basel.

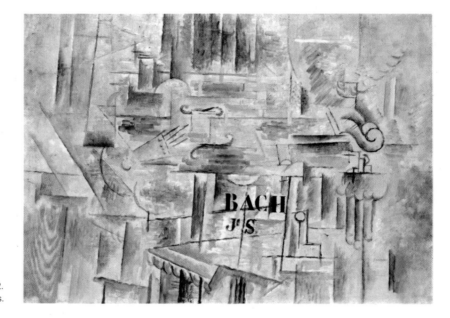

Braque. Homage to J.S. Bach. 1912.
Formerly in the J.-P. Roché Collection, Paris.

give a fresh interpretation of reality. It is quite obvious that the artists also enjoyed changing natural forms and even ignoring them or replacing them by imaginary ones. " The painter ", said Braque, " does not try to reproduce a situation, but to construct a pictorial fact. " His subjects, like those of Picasso, were quite insignificant. Their favourite genre was still-life, which usually grouped together a bottle, a glass, a pipe, a newspaper, a guitar or a violin. When they chose to paint a human being, they stripped him of all his dignity and importance. There was no place for psychology in this art, apart from its creators who substituted themselves completely for their sitters.

In several works of the period 1910-1912, Braque and Picasso fragmented objects to the point where they ended by volatilising and annihilating them. In other words, they had reached the confines of abstract art; but they did not cross the frontier. In their concerted development until the outbreak of war in 1914, they even made an effort to re-establish the pictorial values of objects and make them more obvious. They broke them up less and defined them more without having recourse to naturalistic devices. At the same period, they began to introduce typographical letters into their works composed into words such as *Bal*, *le Torero*, *ma Jolie*, which acted as a decorative motif and brought their associations into the picture. They went further: they invented *papiers collés*—pieces of newspaper, painted paper, packing paper, stuck straight onto a backing and sometimes touched up with colour.

Picasso. Page of music and a guitar. 1912-1913. Collage.
Georges Salles Collection, Paris.

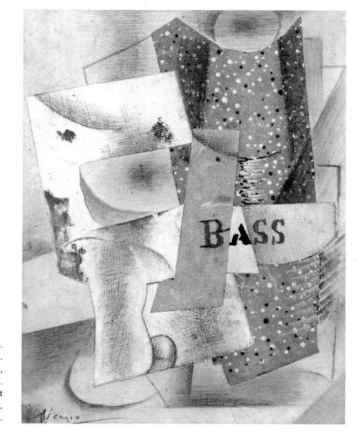

Picasso.
Bass. 1914.
Collage,
charcoal and oil.
Pierre Jeanlet
Collection,
Brussels.

Reality transmuted was placed side by side with reality raw and banal, so that the second was imme-
diately transformed and acquired both a pictorial value and an associative significance. In addition,
these *papiers collés* helped Braque and Picasso to develop from the analytical to the synthetic phase
of cubism. It led them to creating spatial sensations by using the most elementary means: two strips
of paper of different colours, for example. The *papiers collés* finally helped them to rediscover colour.
Their complete absorption in the problem of form had made the cubists choose the most ascetic
palette. Light focused arbitrarily over the picture area by the artist had been subtly graded into cadences
of grey, ochre and brown. About 1913, they abandoned this near monochrome and used a more
varied and, at the same time, stronger range of colours.

Colour had already held an essential place in the experiments of two other painters who were
connected with cubism: Delaunay and Léger. As early as 1910, Delaunay declared that Braque and
Picasso '' paint with cobwebs '' and in reaction he used a free, warm colour range, while Léger used
pure blues and reds from 1912 onwards. This was not the only point on which they disagreed with
their fellow painters. They too had been influenced by Cézanne, but his effect on them was different:
they geometrised form but without breaking or fragmenting it. Nor did they shut themselves up in
their studios and paint just the humble objects lying on the table. Delaunay was inspired by the *Eiffel*

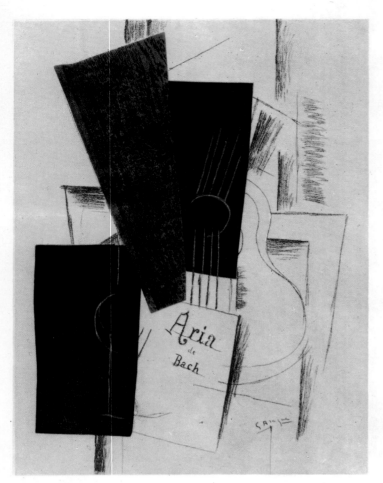

Braque. Aria by Bach. 1912-1913. Collage.
Mme Cuttoli Collection, Paris.

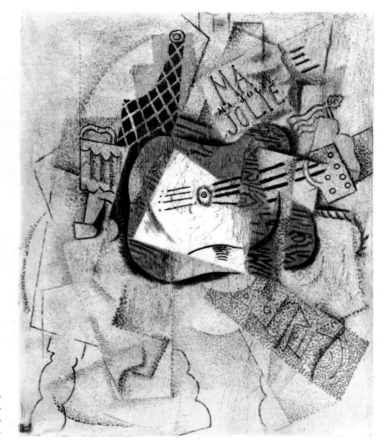

Picasso.
Ma jolie. 1913.
Private Collection,
Paris.

Tower, Léger painted a *Level Crossing* and a *View of Paris from the Window*, and both of them were acutely aware of the swift rhythm of modern life and the abrupt sensations of the new world that technology was building around them.

Although Braque and Picasso, Delaunay and Léger produced the revolutionary ideas of cubism, they were obviously not the only members of the movement; several other artists supported it. The most important among them can be divided into groups, although notable characteristics distinguished the individual artists from one another.

The experiments of Juan Gris, Louis Marcoussis and Emilio Pettoruti relate them up to a certain point to Braque and Picasso. Jacques Villon and especially his brother, Marcel Duchamp, were concerned with movement, while Albert Gleizes, Jean Metzinger, Roger de La Fresnaye as well as André Lhote saw cubism as a discipline, a means of simplifying form, strengthening composition and bringing new life to tradition. The influence of the cubists was considerable and everywhere painters can be found who were affected by it. Besides, their activities were not limited to painting, but included the poster, typography, theatrical design, sculpture and architecture.

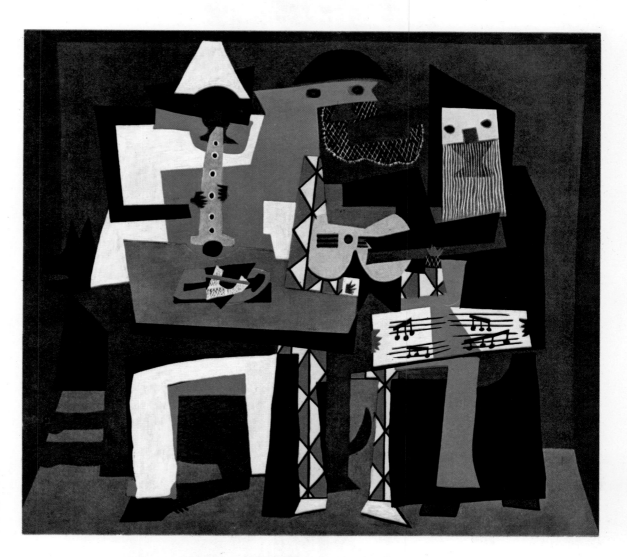

Picasso.
The three musicians.
1921.
Museum of
Modern Art,
New York.

Pablo Picasso. If there is one artist who represents modern art in the eyes of the lay-man it is certainly Picasso (born in 1881). Even for people who have never seen so much as a reproduction of one of his works, his name stands for everything that is most daring, aggressive and '' extravagant '' in art today. Actually, Picasso is not the most revolutionary painter of the 20th century. Kandinsky and Mondrian were more opposed to tradition than he is; they turned their backs and simply ignored it, while he outraged it. Is it because his art offers the greatest diversity? It certainly does not offer more than Paul Klee's. Yet, the fact that he has been made the symbol of every artistic audacity can be explained: no one else has turned the conventions upside down more violently nor, it seems, with such airy disrespect; no one has so bewildered the public with such unexpected and sensational volte-face.

When in 1900 he first came to Paris, he painted in Montmartre, in a somewhat spruce style, works which show the influence of Toulouse-Lautrec and Vuillard. The following year a cold blue began to dominate his palette and Picasso showed us bloodless and sad young women, sickly children and emaciated old beggars. Three years later this '' Blue Period '' was followed by a '' Pink Period '' which showed harlequins, acrobats and itinerant circus folk. Humanity was less afflicted than in the previous period, although here too, the resigned faces are never lit by a smile. Picasso, who had left Spain for good, installed himself in the famous Bateau Lavoir in the rue Ravignan in Montmartre, where shortly afterwards he began to develop cubism. He had so definitely committed himself to this path that it looked as if he would never be able to retrace his steps, but in 1917 he began to paint

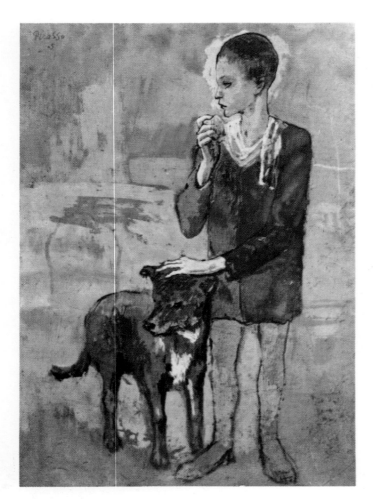

Picasso. Child with a dog. Private Collection.

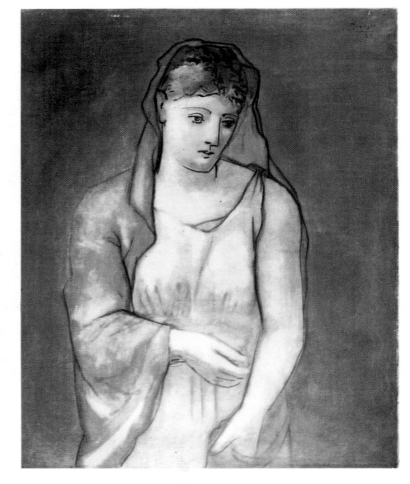

Picasso.
Woman with a blue veil.
1923.
County Museum
of Art,
Los Angeles.

portraits in the Ingres tradition. Did this mean a complete repudiation of the cubist achievements? Not in the least. For several years he alternated between the two modes of expression; until about 1921, he represented human figures in the neo-classical style, sometimes inflating their bodies with a certain impertinence; at others he reconstructed them entirely with the help of invented shapes. Later when he had again abandoned neo-classicism for a more and more autonomous style of painting, he still adopted the most contradictory attitudes; in turn he was balanced and torn, tender and brutal, friendly and pitiless. However, he always remained himself. This versatility, which in a lesser artist might have been considered lack of conviction, with him only proved the breadth and richness of his genius. It was a sign of his unquenchable vitality, of a permanent youthfulness and a continual anxiety.

It was also the result of a constant need in him to express himself with complete freedom. Picasso is probably the only man today who does exactly what he likes when he likes. In a society which tends more and more to organise life according to rigid rules and to standardise minds, an attitude such as his inevitably appears monstrous and provocative.

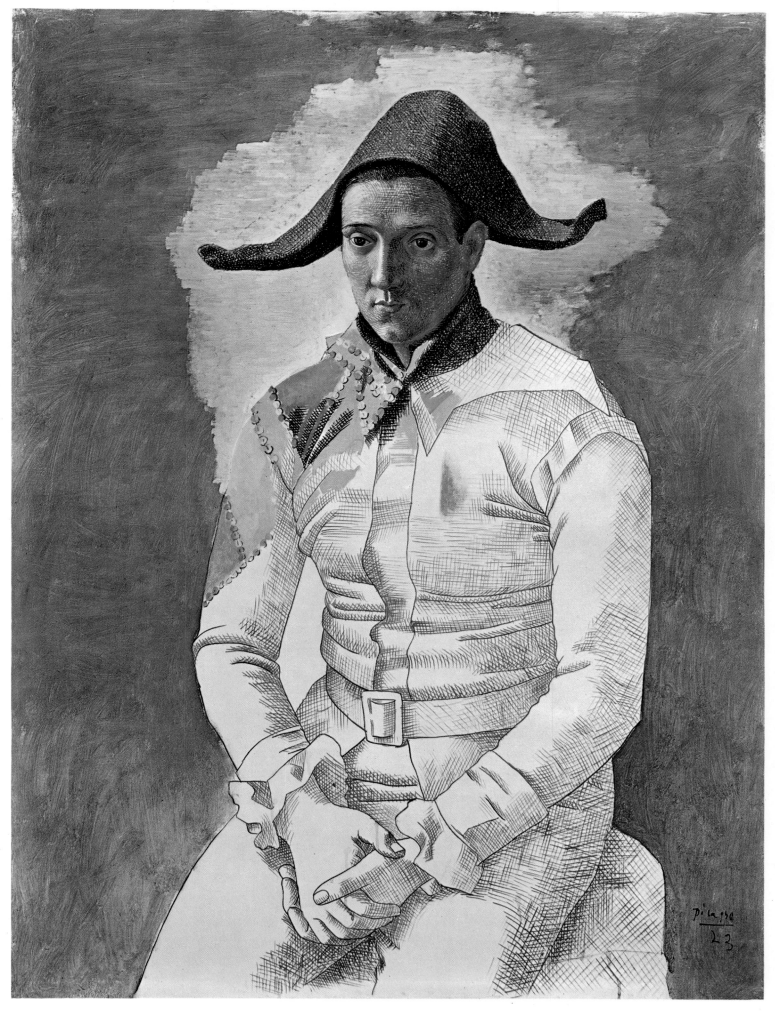

Picasso. The painter, Salvado, dressed as a Harlequin. 1923. Musée National d'Art Moderne, Paris.

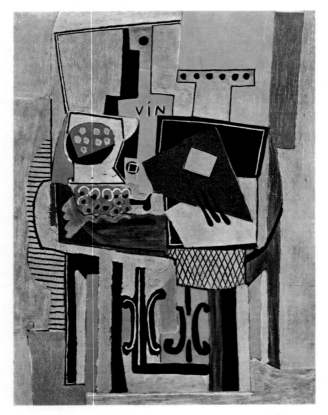

Picasso. Cuttle-fish, moray, fish, lemon and sea-urchins. 1946.
Musée d'Antibes.

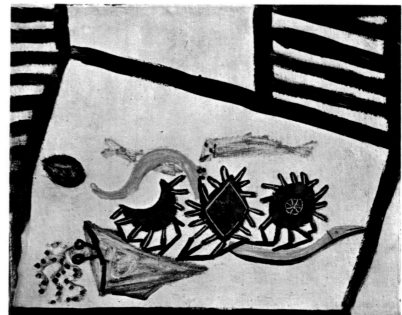

Picasso. Guitar with a fruit-dish and grapes. 1922-1923.
Private Collection, London.

What Picasso searches for above all is strength of expression, the incisive, impelling statement. He never tries to attract us. He would never have thought of wanting to make art '' a tranquilliser to soothe the mind '', as Matisse did. Far from it, he likes to excite us, make us uneasy, shake us to the depths of our being. His colours clash more often than harmonise and the composition of many of his works is striking because of his contempt for '' beauty '', his casual off-hand manner and his aggressiveness. His line can possess a feline suppleness, but it can also be abrupt, hard, steely and angular. Picasso, in short, is an expressionist, who, starting from his cubist experience, forged an idiom that was much more revolutionary than expressionism in the strict sense of the term. His love of freedom here again led him to experiment with form to see how far he could go without falling into unjustifiable excess. It would be disregarding the evidence of our eyes to pretend that he never did fall into it. One part of his art is indisputably a sort of game, at times cruel, at others amusing, but there are innumerable paintings from each phase that are deeply felt and vigorously conceived.

In 1937, a new strain became apparent in his art. It was a political event that caused it: the Spanish Civil War. Until then, he had been preoccupied with his own artistic and personal problems, now it was the fate of a nation that moved him just as much and, after the bombing of the little town of Guernica by Fascist planes, he painted as his cry of protest one of the most poignant works that the horror of brute destruction has ever inspired. After this, it is not surprising that he also took sides in the Second World War. It was then, in fact, that he painted a series of seated women with monstrously distorted faces, which communicate with almost unbearable intensity the torture and grief that possessed so many human beings during those terrible years. The art of Picasso is not an art distilled in

82

Picasso. Reclining woman, called " The sleeping Atlantid ". 1946. Musée d'Antibes.

a laboratory, it is an art that is " engagé ", an art of commitment, and intimately bound up with the life of the artist. He gives expression to its enthusiasms and rages, its pleasures, disillusionment and bitterness.

He expresses too an enormous will to power. Everything that Picasso touches he has to transform; he has to make of it something that only belongs to him, that would never have existed without him, even though he may have to twist it, rape and destroy it. Nevertheless, when he destroys, it is not to pile the ruins around him, but to build a new construction in which things are given new life, metamorphosed and made more expressive, more obsessive than ever before. Admittedly, there is an immense pride in such an attitude just as there is an immense pride in man today, who never ceases to upset the natural order and shape the world to assume more and more the image of his desires and needs. In this way, Picasso reflects one of the most characteristic tendencies of humanity in the 20th century. With an almost brutal frankness, he shows the triumphant side of that tendency but he makes us feel just as cogently the anxiety it rouses by suggesting the agonising questions facing man by the very extent of his power and conquests.

Georges Braque. Although during the cubist period Braque (1882-1963) was close to Picasso, the two artists are fundamentally very different. Whereas Picasso advanced in fits and starts and was always in a hurry, Braque's progress was thoughtful, logical and deliberate. Whereas the former treated both objects and human beings in the most cavalier manner, the latter treated them with humility and a certain kindness. Of course he " deformed " them in a determined way, but one is tempted to say that it was in reply to the secret wishes of the objects themselves.

Even during the fauve period Braque was not considered as one of the more moderate. Although amongst the bolder, he was the least carried away. There was no squandering of colour, no vehemence of style; on the contrary, there was a constant attempt to discipline emotion, and already we

Braque. Boats on the beach. 1929.
Private Collection, Paris.

Braque.
The palette.
1941.
Private Collection.

find this love of the curved line, which steadily takes hold of objects with successive strokes. Was it due to his contact with Picasso, which later led him to draw with a swifter rhythm and to increase the use of abrupt acute angles ? Probably. Even then, however, his line rarely has the biting and haughty character of his friend's; he softened its incisiveness by the restraint of his colouring. In any case, it was cubism that helped him to find himself, for nothing satisfied his nature better than meditative art, withdrawn, and where " the rule corrects the emotion ".

After 1918, his style altered, his objects acquired not only a less geometrical and a more individua-lised shape, but also a certain thickness. Far more than in the past they evoke certain qualities which

84

Braque. Woman's head. 1942.
Private Collection.

Braque.
The red guéridon.
1942.
Private Collection.

were theirs in reality. From now on, the fruit bowl holds the fruit better, the fruit itself is more substantial and easier to identify. The table is more obviously made of wood and intended to carry a jug, a pipe, two apples, a newspaper. Is this a return to realism? Braque never considered it for a moment. He kept the inverted perspective, which he and Picasso had used during the cubist period that presents the objects practically on a level with the vertical picture-plane bringing them close to us, so that they glide in front of our eyes. He also continued to modify their shape, to change their colour where necessary, in short to adapt them completely to the demands of the composition and to the atmosphere of the world in which they were situated. This is a world like that of Chardin and Corot, where life meditates silently in the softened light, where brown, beige, grey, olive green and black are dominant and, should red, orange, pale blue appear, they are surrounded by muted colours that subdue them. The effect of these colours is reinforced by the texture of the paint. Sometimes it is thin and smooth, at others thick and clotted, and it is a further attraction to the eye of the observer that lingers over the surface.

Braque remains intimate even in the majority of his seascapes, which he started to paint in 1929

85

Braque. Painter and model. 1939.
Walter P. Chrysler Collection, Warrenton, Virginia.

Braque.
Studio IX.
1956.
Maeght Collection,
Paris.

in Normandy around Dieppe. A grey or a dark sky generally prevents our eye from straying into the distance and if perhaps the somewhat menacing sky and light make us think of an approaching storm, we do not feel really frightened. Braque is not a man of pathos and drama, nor of violence.

Once, he seemed to change. Around 1930, he painted the *Baigneuses*, where following Picasso's example, he made of the human body a pliable object that could be stretched, gathered up and put together again at will. But this was merely a divergence and the figures he began to paint in 1937 all possess the qualities of his personal style. Freer than the robust *Canéphores* of 1923-1926, younger and more elegant as well, their presence is at the same time clear and discreet. They are integrated into the " decorative " plan of the picture and never attempt to attract attention by their psychological expression. They would be no more than dummies unless, as well as the part of them facing us which is pale and rounded, we did not see a fine black profile with a rigid, enquiring look, full lips and a wilful chin, that makes them sisters of those graceful goddesses on antique Greek vases. Suddenly they are something more than dolls or women of today; they are an incarnation of the eternal woman.

For a time it looked as if Braque had found his style and would only modify it slightly, but in the various versions that he has given us between 1949 and 1955 on the theme of the *Studio* his art is more " abstract " and increasingly complex. Objects are again flattened, the drawing has more breadth, his colours are freer, sometimes even warmer and more lively and the sensations of space are suggested more subtly. A large bird describes the figure of flight alongside the stillness of objects. It is significant that when he wanted to introduce movement into his art, Braque should have chosen movement of the lightest and quietest kind—the one that suggests to man the poetry of his most nostalgic dreams.

Gris. Glass and tobacco packet. 1914. Oil and collage.
Private Collection, Paris.

Gris. The album. 1926. H. Rupf Collection, Berne.

Juan Gris. Like Picasso, Juan Gris (1887-1927) was a Spaniard who came to Paris in 1906. Although he too lived in the Bateau Lavoir, and watched at close quarters the experiments and discoveries of his compatriot, it was only in 1911 that he joined the cubist movement. Compared to the works which Braque and Picasso produced at that time, his attempts might appear timid. Actually they show that Gris noted the effects of light, but did not wish to push his analysis to the point where objects cease to be recognisable and tangible.

Between 1915 and 1920, Gris in a series of still-lifes produced his most accomplished works in which he showed his greatest boldness and facility. His forms are so strictly geometrical that they are practically diagrams. They are, however, not mere stylisations. The colours are applied flat, dark and subdued. Certain of his harmonies have an outstanding distinction and correctness, particularly where black harmonises magnificently with greys and blues. In fact it was by the sensitiveness of his colours that Gris made up for the severity of his drawing and avoided the pitfall of overcontrived art. Nothing was left to chance. In the same way as Picasso proclaimed his freedom and believed he must satisfy its every whim, so Juan Gris loved rules and even systems.

Towards the end of his life, his art grew less severe. The line became less rigid and more functional; on the whole, it now corresponded to the outlines of objects, while before it often took on an autonomous life of its own. It has sometimes been said that he did not lack the will, but that he was rather tired, as if the disease, which had been undermining his health since 1920, was preventing him from giving his art the lofty tone and admirable tenseness that he had bestowed on it with so much distinction a few years before.

87

Léger. Composition. 1918.
Private Collection, Paris.

Léger.
Still-life on a blue background.
1939.
Musée Fernand Léger,
Biot.

Fernand Léger. Stripped of all prettiness, sentimentality or romanticism, the painting of Léger (1881-1955) is closely attached to the industrial civilisation of the 20th century. It is so far its strongest and most enthusiastic expression. Léger gave an unstinted admiration to this civilisation, which so many are inclined to describe as inhuman. Even the 1914-1918 war, in which he served as a sapper, did not prevent him from being '' dazzled by the open breech of a 75 gun in the sunlight, the magic of light shining on metal ''. He did not hesitate to declare: '' This breech has taught me more about art than all the museums in the world. '' Léger acknowledged the changes that this new civilisation had forced on man. About 1913, he painted robots with disjointed limbs, before creating about 1920 beings with bodies made up of metal tubes, whose arms were pistons and whose fingers bolts.

88 These figures in which human beings seem rather diminished, were followed by others in which

Léger.
Dancer with keys.
1930.
Musée National
d'Art Moderne,
Paris.

Léger.
Leisure:
homage to Louis David.
1948-1949.
Musée National
d'Art Moderne, Paris.

they are magnified: massive, majestic, indolent women like idols; idols, moreover, that were not fashioned by a system of metaphysics but by pictorial experiment; they grew out of the artist's desire to embody their calm power in a lapidary style. Later, with his *Divers* and *Cyclists*, he gave it expression in a more flexible, less hieratic manner, but they still belonged to a race that is more vigorous and more

healthy than our own. The reason for this is that Léger, who was so aware of the dynamic spirit in our age, was completely blind to the morbidness and anxiety inherent in it. While other artists of today tell us about their anguish, he pours out his zest; while others confess their confusion, he proclaims his certainty and optimism.

Although his work is untouched by anguish, it is not free from conflict. Each painting is a victory won over divergent forces. Léger achieved unity and equilibrium by reconciling sharp contrasts of colour, form and objects. The colours are pure and vivid, at times violent; the forms are robust, sometimes geometrical and sometimes irregular. Some of the objects were drawn from nature, others were selected from man-made products. About 1942, a further contrast began to obtrude into his paintings: he separated colour from outline and while the first became abstract, the second remained figurative.

Vigorous and strong, Léger's art is essentially monumental. So it is not at all surprising that, when asked to do the stained-glass windows for the new church at Audincourt, he designed one of the most impressive of his works, one which can be classed as one of the masterpieces, not only of modern art, but of the art of all time.

Robert Delaunay. To do justice to Robert Delaunay (1885-1941), two elements in his painting should be distinguished: its pioneering aspect and its emotive power. The two were not necessarily separate and before 1930 they were nearly always interwoven with each other; paintings such as *Simultaneous Windows* or the first *Circular Forms*, which Delaunay painted before 1914, are among the most beautiful and the most original that the cubist period produced. Yet even then he was exercised by the problems that were to preoccupy him for the rest of his life.

Delaunay was already asking himself whether colour by itself was sufficient to make a painting,

create form without the help of line and suggest space simply through the juxtaposition of flat areas; whether, in addition to this, it was capable of communicating the movement and expressing the dynamism of the world today. He was already convinced that he could reply in the affirmative, but although, at the beginning, his art was a vital illustration of that certainty, later on it became its dry demonstration and the lyrical quality of his painting suffered.

In the *Coloured Rhythms* and *Unending Rhythms*, which he painted after 1930, these ideas were realised with greater purity and strength than in the previous works. Colour had become the subject, and Delaunay achieved abstraction in the fullest sense of the term. The decorative qualities of these compositions are equally obvious and Delaunay was at the time actually trying to adapt his art to architecture. Yet these paintings are still rather too systematic to touch us as deeply as those he produced before with less assurance but more excitement.

Jacques Villon. " I was the impressionistic cubist " said Villon (1875-1963), " and I believe I have remained so. Perhaps less cubist, less impressionist; moreover, I don't know and I am still looking ". A cubist from 1911, he was interested not only in form, but also in colour, which he already used with characteristic delicacy and subtlety. He also showed us the human figure in movement, as well as in repose. Notable is his stimulating study of a troop of *Soldiers Marching* composed entirely of oblique lines and angular planes.

The war interrupted his work and when he was able to resume it, he turned towards engraving, which until 1930 took up practically all his time. Although the canvases he painted during that period were few, they are far from being unimportant. Normally Villon based himself on nature but twice, around 1920, and again after 1930, he produced non-figurative painting, containing nothing

Villon.
Joy.
1932.
Galerie Louis Carré,
Paris.

Villon.
The wide lands.
1945.
Louis Carré
Collection,
Paris.

but absolutely pure geometrical figures. The remarkable thing was that this naked and rigid geometry was never cold. However consciously these pictures were painted, the part played by inspiration seemed always more important than that played by calculation. Squares, rectangles, triangles and

Villon. Orly. 1954. Galerie Louis Carré, Paris.

trapezes lose their dryness and become as sensitive and poetical as the flowers and landscapes of other artists.

Villon gave more and more of his time to landscape and the 1939-45 war, by forcing him to leave Paris, gave him the chance of longer and more intimate contacts with nature and with light in the open. This did not mean that the impressionist was henceforth going to dominate the cubist; both were reconciled in works where each tendency developed even further. His painting grew more lyrical, but at the same time the sense of order and the inclination towards abstraction grew more marked. However irregular the motifs which inspired him may have been, whether rocks or trees, everything was translated with the help of geometrical lines, and the construction carefully built. The colours are no less premeditated. Although Villon's colours are those he derived from nature, they are heightened by the tones suggested by a wondering mind and a spell-binding imagination.

His skies are mauve, orange tinted and emerald. Side by side with greens that evoke the light and tingling acidity of spring tints, he places, in precisely demarcated shapes, black, rose and violets, artificial colours that are no less right in the landscape than the greens, yellows and ochres. They are chosen with the most refined sentiveness and distributed with unerring judgment.

There is nothing more exquisite than the harmonies of this painter, whose composition is not only one of the most subtle to be seen today, but whose inventive colouring is also among the richest and most delicate.

futurism

Although its first manifesto, drawn up by the poet Marinetti, was published at Paris in 1909, futurism was a strictly Italian movement and during its heroic period it had few adherents. Only five names appear the following year on the *Manifesto of Futurist Painters*, which was issued at Milan: Boccioni (1882-1916), Carrà (1881-1966), Russolo (1885-1947), Balla (1871-1958) and Severini (1883-1966). Their aim according to Marinetti was " To praise aggressive movement, feverish insomnia, a quick pace, the perilous leap, the slap on the face and the blow from the first ". The painters echoed him. They fiercely attacked " the admiration for old paintings, old statues and old objects ", the whole cult of the past: " Can we possibly remain indifferent ", they asked, " to the frenetic activity of big cities, the new psychology of night life, to the rake, the tart, the tough and the drunk ? "

" A galloping horse has not got four hooves ", the manifesto continued, " it has twenty and their movements are triangular ", However, by juxtaposing the various phases of a movement, the futurists broke it up and arrested it rather than giving greater force to its interpretation. There is no doubt that this fragmentation indicates the influence of cubism, just as it is indisputable that the cubist idiom was more revolutionary than the futurist. The futurists, it is true, created their own distinctive climate and they achieved one of their aims; they make us feel the clash of opposing forces, hurtling and crashing through a shaken world.

Their activities had little influence outside Italy, but they were important in Italy itself. It was in fact futurism that truly heralded the awakening of living art in the Peninsula.

Boccioni.
Elasticity.
1912.
Private Collection,
Milan.

Balla.
Mercury passing before the sun.
1914.
Private Collection, Milan.

Severini.
The blue dancer. 1912.
Gianni Mattioli Collection,
Milan.

expressionism

Few groups of painters offer such diversity as the expressionists. They shared one fundamental aim, to externalise what they felt in the depths of their being and they usually distorted the forms of visible reality more to reinforce the expression of their feelings than to serve the requirements of a painterly vision. In addition, their work had a certain common flavour, which was harsh, emotional, often anguished. Beyond this, it is impossible to generalise. While some were in such a hurry to pour themselves out that they neglected their technique, others never sacrificed the plastic beauty of their painting. While some remained faithful to chiaroscuro, modelling and traditional space, there were others that gambled with pure colours and there were even some who showed the influence of cubism. There is the further complication that the movement appeared in several countries and certain characteristics were modified by the locality.

The most virulent form of expressionism arose in Germany, so much so that it has been described as a specifically German phenomenon, a permanent and essential strand in the German soul. As a matter of fact, it was not in Germany that it first appeared. Its first exponents (among modern artists) were the Dutchman Van Gogh, the Belgian James Ensor and the Norwegian Edvard Munch; and all those who reacted against impressionist realism in France prepared the ground for it.

Munch (1863-1944) himself went to Paris, where he admired Van Gogh, Gauguin, Seurat, Lautrec and the Nabis. His first exhibition, which he held at Berlin (1892) caused a considerable scandal, but it established his reputation in Germany, where he was soon exerting a profound influence over young artists. The solitude of the human being before the immensity of nature as well as among the crowds of great cities was an anguishing experience for this pessimistic, morbid, restless man. Women attracted and at the same time frightened him. In his eyes, the exultant happiness they pro-

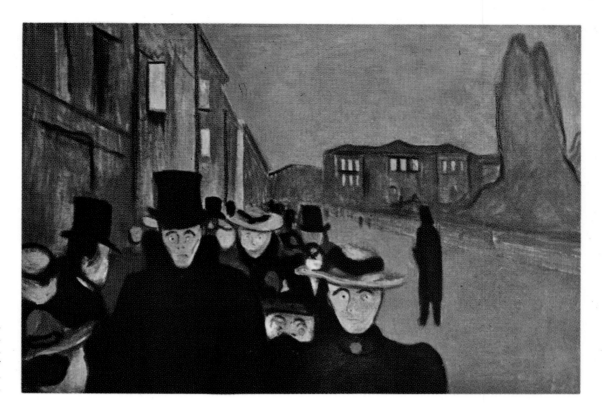

Munch.
Karl Johans Gate.
1892.
Rasmus Meyer
Collection,
Bergen.

Ensor.
Carnival.
1888.
Stedelijk Museum,
Amsterdam.

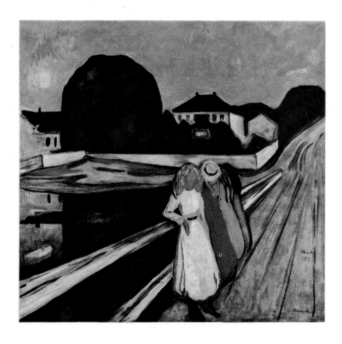

Munch.
Four girls
on a bridge.
1905.
Wallraf-Richartz Museum,
Cologne.

cured only brought conflict, regret and bitterness in its train. All this he expressed in his painting through long lines, stretching into the distance and curving with melancholy, and by using colours that were nostalgic even when they were bright.

It was in Dresden in 1905, that the group was formed which first launched German expressionism. Known as Die Brücke (The Bridge), the group at the start was composed of only four artists in their early twenties — Fritz Bleyl, Ernst Ludwig Kirchner, Erich Heckel, Karl Schmidt-Rottluff, who were later joined by Max Pechstein, Otto Müller, and for a short time Emil Nolde. Guided by post-impressionism, Negro and Pacific art and also old German wood-cuts, the founders of the movement used colours that showed their affinity with the fauves. They were in touch with Van Dongen but were more inclined to follow Vlaminck. They did not seek refinement in their harmonies; they wanted strong, piercing, strident overtones. The dominant personality of the group was Kirchner (1880-1938), an artist whose nervous, uneasy temperament is revealed in his nudes, landscapes and city streets. In 1911, he went to live for a few years in Berlin, where his violence grew calmer and he produced his most balanced works. But the disquiet remained; it can be detected even in the pictures he produced after 1917 in Switzerland, when he painted the mountains and the peaceful life of the shepherds.

No one, however, represented German expressionism at its most outrageous more than Nolde (1867-1956). Whether he was treating religious subjects by showing apostles as ecstatic louts, or painting the degenerate clients of Berlin night-clubs, or those flat landscapes in which tortured skies oppress us by their blackness or their theatrical lighting, he always tried to shock, and to achieve this no colour was too vehement or too coarse. He hacked form or drew it hastily as if his rapid hand were cutting it with a sickle.

The expressionism which the Austrian Oskar Kokoschka (born in 1886) gives us is more tormented and less rudimentary, as well as richer in pictorial qualities. Kokoschka started with portraits. No contemporary painter has painted portraits in such a hallucinatory manner, which reveal the deepest psychological truths. The intellectuals and artists who were his models were painted by the compatriot of Freud, as if he were psycho-analysing them. He penetrated into the very depths of their being and intuitively laid bare what was hidden in their anxious, sick, and gloomy hearts. A great traveller between 1924 and 1931, Kokoschka shows us Alpine landscapes and panoramic views of Paris, Venice, Madrid, etc., which are marked by their breadth, their visionary character, their strange rhythms, as well as by the impatience of their execution.

It is usual to include amongst the expressionists the painters who in Munich in 1909 founded the New Artists Federation, which was two years later to become the well known Blaue Reiter (Blue Rider) group. With them too, particularly the two Russians, Alexej von Jawlensky and Wassily Kandinsky, their lyricism was at times filled with impetuous romanticism. In Munich more than anywhere else in Germany, they looked towards France. Jawlensky and Kandinsky had also spent some time in Paris where they had been greatly impressed by Matisse. Their German friends, Franz Marc,

August Macke, Paul Klee, had on the other hand been in contact with Delaunay. Marc and Macke were killed during the First World War before they were able to produce many pictures. However, Macke (1887-1914) with his serious but amiable columnlike figures, and Marc (1880-1916) with his animals, which were religiously and poetically transposed into the purity of a legend, were both able to achieve more than mere promise. As for Klee and Kandinsky, we shall see that they were amongst the most original creators of our time.

Lyonel Feininger (1871-1956), who exhibited with the Blaue Reiter painters in 1913, also knew Delaunay and the taste for severe, clear composition, acquired from cubism, stayed with him all his life. His sensitiveness to effects of light and a delicate, mysterious colour range imparted something ethereal and transparent even to the solid geometry of ships and buildings.

The 1914-1918 War did not put an end to expressionism. Certainly in Germany the groups broke up, but those who had belonged to them did not alter their style. The upheavals brought by the war drove an artist like Beckmann towards a different kind of art from Kirchner's or Nolde's but it was still expressionist. Other centres sprang up elsewhere, particularly in Belgium, in Flanders, where expressionist painting took on one of its most convincing aspects. In fact it had already been introduced there some thirty years earlier by James Ensor (1860-1949), who, as has been pointed out, had been one of the pioneers of the movement in the international field. Up to the age of forty he had also been one of the great artists of his generation; even in France he would have figured as a forerunner. His famous *Entrance of Christ into Brussels* was painted in 1888, the same year as Van Gogh moved to Arles and Gauguin was still striving to find his style in Pont-Aven. Ensor at that time was already in possession of his world and of his style. By putting carnival masks on his figures, or by reducing them to skeletons dressed in rags, he satisfied his desire to moralise and to show his fellow beings their grotesque side. At the same time he used colour and form freely.

Those who in the 20's were to be the main exponents of Flemish expressionism, Frits van den Berghe, Constant Permeke and Gustav de Smet, did not possess Ensor's light colours, nor his sardonic wit. They spoke a rougher language. Brown dominated their palettes and they enjoyed making use of dramatic contrasts between light and dark. However, they gave expression to their anxiety or pessimism, but were less torn than the German expressionists. In Permeke's (1886-1952) generous and full paint we find the colours of freshly ploughed earth, of waterlogged fields, of the North Sea buffeted by the storm; one breathes the simpleness of country houses and even that of cowsheds. Massive and summary, his form is the result of an impetuous and brutal hand. His harmonies, however, are not vulgar and his matter never lacks charm.

The Luxemburger, Joseph Kutter (1894-1941) occupies a special place among the expressionists. He is neither raw, barbarous nor rustic; he is more vigorous than brutal, and if his soul underwent upheavals, he never translated them in a convulsive or disorderly style. Even when he was painting his *Clowns* where he lay bare the sufferings of his mind in such a poignant way, he was always concerned with the beauty of his style; his form remained solidly constructed, his colour rich and varied.

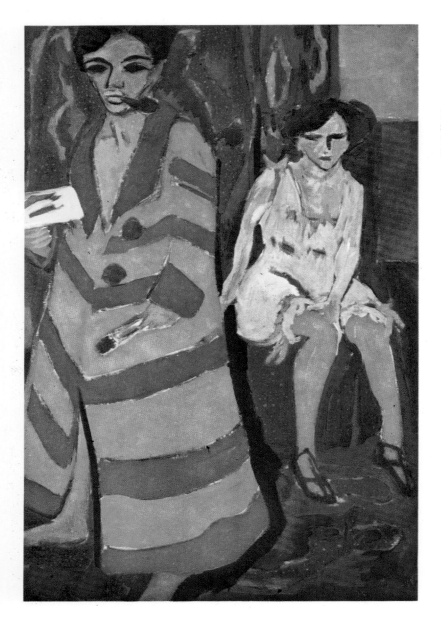

Kirchner.
Self-portrait with a model.
1907.
Kunsthalle, Hamburg.

Nolde.
Slovenes.
1911.
Ada and Emil Nolde
Foundation,
Seebüll.

Schmidt-Rottluff.
Resting in the studio.
1910.
Kunsthalle, Hamburg.

Jawlensky. The red shawl. 1909.
Private Collection, Munich.

Macke.
Walkers beside the blue lake.
1913.
Staatliche Kunsthalle,
Karlsruhe.

Kokoschka.
Woman in blue.
1919.

Rouault.
The blue bird.
Private Collection,
Paris.

Georges Rouault. It has often been said that as a general rule the French have a horror of expressionism. In fact, the movement found only a few isolated supporters amongst them, yet it was a Frenchman who represented the movement with the most complete assurance, a man who belonged to the fauve generation and who like them discovered his style at the beginning of this century: Georges Rouault (1871-1958).

He discovered his artistic personality at the same time as his revolt and his revolt stemmed from his religious convictions. Profoundly Catholic, better still profoundly Christian, Rouault could in fact not look at the ugliness, injustice and misery that surrounded him, without attacking them, without proclaiming to the world the sympathy and indignation he felt for those who were its victims. Nothing is more abject than his *Prostitutes*, wretched incarnations of the horror that purchased love inspired in him. Nothing was more, coarse-grained than his *Judges*' bestial faces, a mass of heavy flesh, that no human argument would appear capable of moving. As for his *Clowns*, they are pitiable. Life mutilated their faces by putting into their eyes the blackness of woe and sometimes the redness of spite.

There is in Rouault a popular and condemnatory spirit which links him to Daumier. He has a feeling for the grotesque that is not ridiculous, but poignant and terrible, which connects him with Goya. But there is in his case also something thoughtful and fraternal that is reminiscent of Rembrandt.

Rouault.
Pierrot. About 1948.
Private Collection,
Paris.

On the other hand he takes his place in the line of Byzantine and gothic painters and was the first for several centuries who knew how to give a moving picture of the Christ flagellated and crucified. Not only did he react passionately against the insipidity of pious art, but he offered in its place an art as authentic as that of the great periods of the faith. The Christ he gives us is neither that of the traditionalist nor of the bigot. It is the one living in the feverish soul of the mystics—who frequents the poor and those that thirst after justice. He is passionate when he paints faces and also when he paints landscapes. Whether they represent legendary Palestine or stifling industrial suburbs, they always draw their burning reality from the visions of the artist and his meditations.

His meditations? In fact, his art is less impulsive than it may appear. Even the early works, where the form seems lashed in with whip-strokes, are too compact and too subtle not to be something more than hasty effusions. Rouault never neglected his technique. However vulgar some of his subjects may have been, there is nothing vulgar in his harmonies nor in his textures. His tones are heightened without being gaudy, his paint is both thick and refined. It is so refined that the colours often seem to sing beneath a light shining from behind the picture, so that they have the deep vibrations and mysterious glow of a stained-glass window smouldering in the dying day.

Modigliani. Elvira. 1919. Private Collection, Berne.

Modigliani.
Portrait of
the painter Soutine.
1918.
Private Collection,
Paris.

Amedeo Modigliani. It is questionable whether Modigliani (1884-1920) can be classed among the expressionists. If he is, it can only be done with reservations; for the art of this Italian, who came to Paris in 1906, shows no inclination towards excess.

Attached to the cubists and to their friends, like them he studied Cézanne and negro art, but chose, however, a different direction. He wanted the simplification of form, not its disintegration. Besides, his essential means of expression was always line, a long, supple line, which makes its way languidly with a touch of morbidness. The line is that of the Sienese School of the 14th century, of Baldovinetti and Botticelli, but it has become melancholic and affected. As for his colours, they settle themselves unobtrusively into the compartments that the line traces out for them, giving nothing more to the picture than an additional melancholy, and at times in the nudes a muted and artificial splendour.

Modigliani had little interest in landscapes and none at all in still-life. His eyes were always turned on human beings and the uselessness and pain he saw in their existence. Nearly all his subjects belong to the same tired, nervous, anxious, vulnerable race. They sit stiffly before us inviting us to measure the sum of their sadness and the difficulty they have in living. Even the nudes, though some of them display their lascivious nakedness triumphantly, hardly seem to have known any other caress than the sinuous arabesque in which the artist has enclosed them with a proud elegance.

Soutine. The little pastrycook. 1922.
Jean Walter-Paul Guillaume Collection, Paris.

Soutine. Tree at Vence.
Katia Granoff Collection, Paris.

Chaim Soutine. With Soutine (1894-1943), we enter a very different world. A Lithuanian Jew, Soutine spent his childhood in a ghetto in Czarist Russia where pogroms were a constant threat. He lived there amidst destitution and fear; fear like starvation remained his companion when, having fled from his native village, he studied at the Vilna Academy. When he arrived in Paris in 1913, they had left their incurable scars on his heart and filled it with undying anguish. They remained even when ten years later he began to emerge from his difficulties and he seemed no longer to have any reason to feel himself a " damned painter ". Consequently everything which he touched he filled with anxiety and very often gave it an appearance of catastrophe.

When he painted a landscape he made the houses reel or turned them upside down, he threw gusts of wind against the trees, capable of uprooting them. Steep lanes make an assault up into the sky and disappear into the void. Even the sunny landscapes of the south of France seem to groan under the talons of a sadist. When he paints a human being, a woman, a choir boy or a page boy from Maxim's, there is something haggard and demented in the face. Certain faces look as if they had been skinned or smeared with fresh blood, which raddles absurdly a cadaverous pallor. Terrifying gleams of madness cross one face, another is shifty or falsely sweet. The bodies are sickly, deformed, dessicated and decaying. Never, or hardly ever does the artist look with warmth at these pitiful characters. All he did

105

Chagall. View of Paris through the window. 1913.
Solomon R. Guggenheim Museum, New York.

Chagall. Sunday. 1926.
H. Küchen Collection, Bremen.

was to record their downfall, their cruelty and their solitude, which is as agonising and as incurable as his own. He belonged to the race of those who suffer without question. When he turned to animals, he painted a side of beef, a plumed pheasant, a skinned rabbit in order to show us either blood-stained or anaemic flesh on the verge of putrefaction.

All this nihilism is compensated for by the life which he infuses less into his form (which was only that of realism disintegrated) than into his colouring and his pigment. It certainly is an impure life and at times a muddy one, but how rich and throbbing with beauty it can be. Beside violent reds, nocturnal or murky blues, we find tender pinks (and what does it matter that they should be those of decay and putrefaction?) or whites tinged with blue or yellow. Briefly, here we find delicacy and charm side by side with what shocks and sears us.

Marc Chagall. While painting in the 20th century has generally rejected outright any attempt at narrative, here we have an artist, who in every one of his pictures tells a story and it is very important that the spectator pay attention to this story. Does this mean that Chagall (born in 1887) stands aside from the main stream of modern art? No one would dare to maintain this. Everything in his painting shows that it is of today—the form, the colouring, the atmosphere, as well as the continual attempt at invention, which is one of the most characteristic features of contemporary art.

Whereas with other artists the effort of invention is primarily directed towards colour and form, with Chagall it is mainly based on the relationships between human beings, animals and objects. These meetings take place in a world which is no longer controlled by the universal laws of physics

Chagall. The anniversary. 1915-1923.
Solomon R. Guggenheim Museum, New York.

Chagall. The bride with a double face. 1927.
Ida Meyer-Chagall Collection, Berne.

and where the barriers that exist for common mortals between the various realms of nature and the phases of time are abolished. Things, which are normally foreign to each other, are here related and combined in a natural fashion. What exists only in memory is mingled with the present. Objects ordinarily considered inanimate become alive like the rest: bunches of flowers, a candelabra, a clock (with or without wings) may start to fly. In order to adapt its size to the curiosity of a woman leaning out over the street, a house may enlarge its window, so that it stretches the full length of the front. What may be nothing but a metaphor takes on an aspect as real as that which belongs to the field of normal experience. Does love, in the artist's mind, transport the lover? Here on the canvas we see the lover rising into the air. Is the poet possessed by inspiration? Here we see his completely green head upside down, ready to detach itself from a shaken body.

Never limited by verisimilitude, Chagall chooses and spreads his colours with complete freedom: if an acrobat has the head of a yellow cock with a green comb, why should not one of his hands be yellow as well, the other red, while his legs are blue?

In fact Chagall respects only one truth, that of the state of his soul, and it is to translate this, with all its complexity and lack of reason, that he lets loose such unbridled fantasy. Through his distortion, and his combination of elements borrowed from different creatures, in the way he places differing time and space side by side, he unfolds for us the happy or the sad surprises of his childhood in Vitebsk. He acknowledges the joys marriage gave him, he admits the tenderness he felt for domestic animals, he expresses his distress, his torments and his worries. In a final analysis, one can say that his art presents us with his intimate autobiography.

107

De Chirico.
Love Song.
1914.
Nelson A. Rockefeller
Collection,
New York.

metaphysical painting

Giorgio de Chirico. The Italian painter, Giorgio de Chirico (born in 1888), who settled in Paris in 1911, also tries to transport us to another country, but the world he takes us to is very different from Chagall's. His methods, for one thing, are not those of modern painting properly so called. At a time when all other contemporary artists were discarding Renaissance perspective, he saw a '' disturbing relationship '' between perspective and metaphysics, and he made startling use of it. There is no doubt that his style helped him to attain his aim; what he puts in his pictures is at the same time recognisable and mysterious, familiar and disconcerting. His piazzas, which are so logically planned, surrounded by porticoes and imaginary buildings, make us uneasy by the intensity of their emptiness; the shadows sharply defined in the melancholy light are obsessive. The statues in them are half way between living beings and their images carved in marble. They give the impression that any moment they could come down from their pedestals and share our life or remain petrified in utter indifference.

Less disquieting are the dummies, which replaced the figures about 1915 in his painting, the wooden laths, fitted together into skeletal rooms standing like useless scaffolding, and the realistic pictures of biscuits, which, when in the army, he was surprised to find in the ghetto of Ferrara.

The only sphere, where such impossible encounters occur with the same naturalness and where the same clarity masks an equally obscure meaning, is the world of dreams. De Chirico was admittedly not the first to be aware of that world, but he was one of the first to introduce it into the art of the 20th century.

Giorgio de Chirico did not remain faithful to the kind of painting that has been called metaphysical and that fascinated the surrealists; in the 20's he left it and his art became more and more literary, in fact more and more academic.

De Chirico.
The friend's departure. 1913.
Artist's Collection.

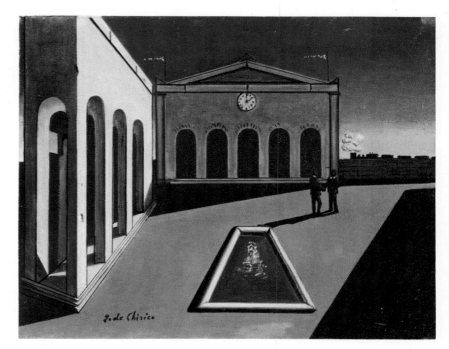

De Chirico.
Masks.
Jucker Collection, Milan.

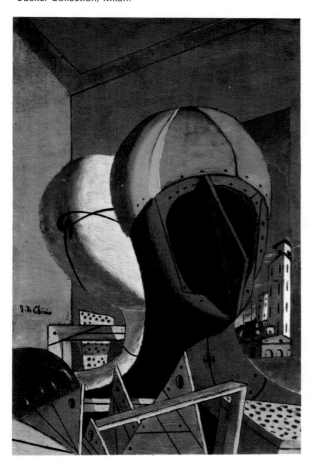

De Chirico.
Hector and Andromache. 1917.
G. Mattioli Collection, Milan.

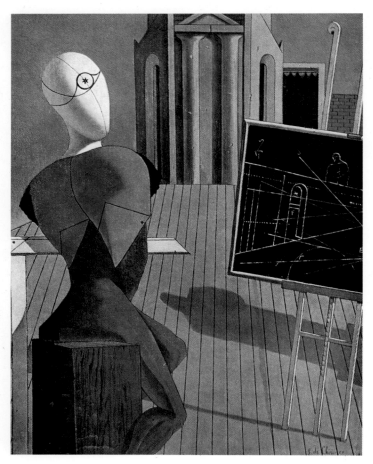

De Chirico.
The vaticinator. 1915.
Private Collection, New York.

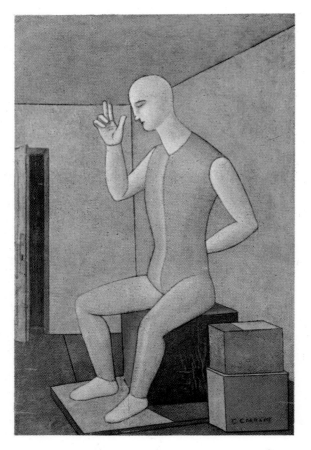

Carra.
Hermaphroditic idol. 1917.
Private Collection, Milan.

Morandi.
Still-life. 1918.
Jucker Collection, Milan.

Duchamp.
Chocolate grinder No. I. 1913.
Louise and Walter Arensberg Collection,
The Museum of Art, Philadelphia.

dadaism and surrealism

The dada group, started during the First World War, was not exclusively a group of painters. At Zürich, where it was given its name in 1916, its principal founders were the Roumanian poet, Tristan Tzara, the German writers, Hugo Ball and Richard Huelsenbeck, and the Alsatian painter and sculptor, Hans Arp. Indeed, two painters from France, Marcel Duchamp and Francis Picabia, introduced it to New York, but at Paris the leaders were the poets, André Breton, Aragon, Éluard, Soupault and Ribemont-Dessaignes. Its activities differed according to the centres where it developed; in Berlin their aims were political, but in the other cities, Zürich, New York, Paris, Cologne and Hanover, they were confined to the artistic and cultural sphere. Everywhere, however, the dada movement attacked established values. It proclaimed the futility of reason, logic and science and declared their bankruptcy; they had failed to avoid war and then had helped to drag it out and increase its horror. Dada also attacked the artistic ideas cherished by bourgeois society; either by setting new ideas against them, founded on a belief in the creative value of chance and the irrational; or by destroying the notion of art itself.

The first attitude was adopted by Arp who wrote: " We were looking for an elementary form of art, which should, we thought, save man from the raving madness of our time. We were hoping for a new order capable of re-establishing the balance between heaven and hell. " The other position was illustrated best by Marcel Duchamp, who wished to prove that any ready-made article could attain the level of a work of art. So he bought a urinal, signed it R. Mutt, the name of a manufacturer of sanitary equipment, called it *The Fountain* and sent it in 1917 to the Society of Independent Artists in New York. In the same way he took a reproduction of the Mona Lisa, added to it a moustache and presented it in 1920 under the title of *L.H.O.O.Q.* As for Picabia, he painted " ironical machines " with

Picabia.
A little solitude amidst the suns
(A picture painted to tell and not to prove). 1919.
Private Collection, Paris.

Arp.
Painted wood. 1917.
Artist's Collection, Meudon.

Arp.
Configuration. 1930.
The Museum of Art, Philadelphia.

112

Ernst.
Woman, old man and flower.
1923-1924.
Museum of Modern Art,
New York.

Ernst.
The kiss. 1927.
Peggy Guggenheim Foundation,
Venice.

precise but absurd mechanisms such as *A Compressed Air Brake or an Instrument for Breaking Peach Stones*. It is obvious that these artists, who not long before had both produced remarkable paintings, no longer considered themselves involved in the same kind of artistic creation; they wanted to ridicule what they saw as the idols of society: technical progress and an art that was admired blindly simply because it was enshrined in a venerable museum. As a general rule, the dadaists were less concerned with appealing to the emotions than disrupting them altogether; the important thing for them was not the work itself, but the shock they could produce and the confusion they could cause in the mind.

Ernst.
The nymph Echo. 1936.
Museum of Modern Art,
New York.

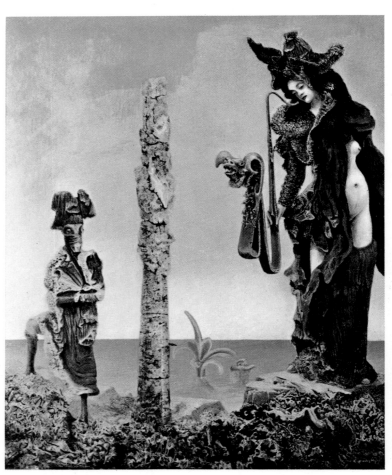

Ernst.
Napoleon in the wilderness. 1941.
Museum of Modern Art, New York.

Eventually, of course, such a negative tendency showed itself incapable of attracting followers. Thus we see in Paris, from 1922 on, within the framework of dadaism a new movement develop which, to make use of a term employed by Guillaume Apollinaire, was to be called surrealism. Here too the poets mingled with the painters and it was the poets who set the pace. Like dada, surrealism proclaimed the virtues of the irrational, but it did so in a constructive spirit. Guided by Freud, it wanted

114

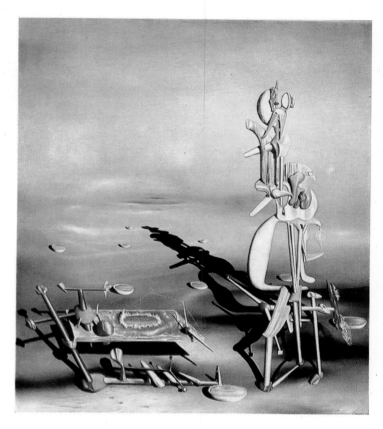

Tanguy.
Infinite divisibility. 1942.
Albright-Knox Art Gallery, Buffalo.

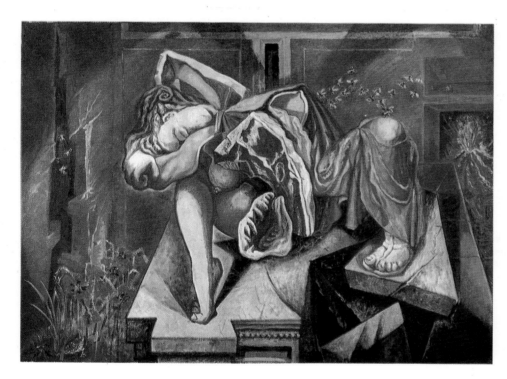

Masson.
Gradiva. 1939.
G. J. Nellens Collection,
Knokke-le-Zoute.

systematically to explore the subconscious and to cast a new light on the hidden depths of man. Its aim was thus less to create works of art than to make psychological revelations. With this in mind, as André Breton underlined in his *Surrealist Manifesto* (1924), he advocated " pure psychic automatism ", " the dictation of thought in the absence of all control exercised by reason, outside all aesthetic or moral considerations ". This recommendation was easier to apply in the field of literature

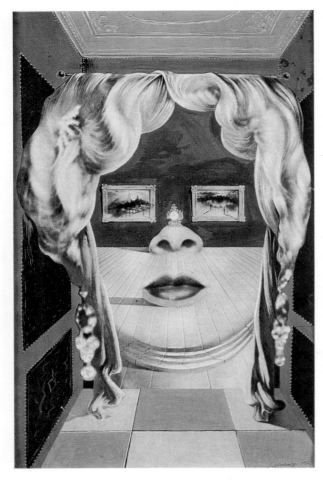

Dali.
Mae West. About 1934-1936. Gouache.
The Art Institute, Chicago.

Dali.
The ghost of Vermeer van Delft,
which can be used as a table. 1934.
A. Reynolds Morse Collection,
Cleveland.

than in that of painting; it is quicker to scribble on a sheet of paper words, which jostle each other in one's mind, than to put on canvas the images, which appear in one's head. Nevertheless, the surrealists are supporters of the image in art; to such an extent that the most orthodox, the German Max Ernst, the Belgian René Magritte, the Spaniard Salvador Dali, imitating De Chirico, deliberately ignore the language of contemporary painting. To show that they are concerned with problems other than form or colour, they are not afraid of using the most academic forms of realism. Realists in their details, their

Dali.
Soft construction
with boiled beans:
Premonition of civil war.
1936.
Museum of Art, Philadelphia.

Dali.
The old age of William Tell.
1931.
Marie-Laure de Noailles Collection,
Paris.

Magritte.
Philosophy in the boudoir.
1947.
Thomas Claburn Jones Collection,
New York.

Magritte.
The man in the bowler hat.
1964.
Simone Withers Swan Collection,
New York.

images do not by any means combine into a realistic whole. Just as in our dreams, they translate the obsessions and complexes of the subconscious and are filled with the arbitrary and the monstrous.

The surrealists enjoyed stressing eroticism as well as the horror of death. André Masson (born in 1896) shows us fish disembowelling each other, cock fights, bull fights, massacres in the sun. Dali's (born in 1904) work teems with beings in states of putrefaction and objects that lose their shape like soft, spreading pastes. In the work of Yves Tanguy (1900-1955), beneath a cold light, bonelike structures articulate landscapes of an anxious and nostalgic absurdity. Max Ernst (born in 1891) creates forests with luxuriant but petrified vegetation, antediluvian landscapes where a teeming

118

Magritte.
Every day. 1966.
Private Collection, Paris.

Delvaux.
Iron age. 1951.
Museum voor Schoone Kunsten,
Ostend.

life seems to have been caught unawares by death that stiffened it on an instant. In actual fact it is Ernst who has created the most compact and complex of the surrealist works. Less aggressive than Dali, his works obviously fulfil more profound desires and their mysteriousness is more authentic. Besides, while Dali seems to enjoy the vulgar colouring of cheap prints, Ernst has recently adopted a style influenced by certain aspects of cubism and abstract art. In so doing, he has given to surrealist painting the pictorial qualities that surrealism has often too light-heartedly sacrificed.

It is true that Masson never lost interest in plastic research, nor did the Spaniard Miró, who also belonged to the group, nor Klee, who in 1925 took part in their first Paris exhibition. But these three

Klee.
Green on green.
1938.
Dr Hans Meyer-Benteli
Collection,
Bern.

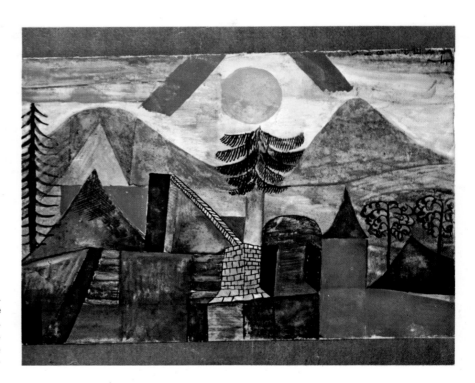

Klee.
Dream landscape
with conifers.
1920.
Private Collection,
Bern.

artists went beyond orthodox surrealism, which in the final analysis exists more through the ideas that it spreads than by the pictures which faithfully illustrate them. Its principal quality was that it consistently directed the eye towards the depths of the soul. Painting had before from time to time already explored this (Hieronymus Bosch, William Blake, Odilon Redon or Chagall) but a too narrow rationalism had always tended to deny or to forget its existence. This particular aspect of surrealism had its influence even on Picasso and some abstract artists today have evidently been affected by it.

Klee. Polyphony. 1932. Kunstmuseum, Basel.

Paul Klee. Of all the masters of modern painting, Paul Klee (1879-1940) is undoubtedly the one who at first sight remains the most reserved. He possesses neither Matisse's power of immediate appeal, nor Léger's strength; he neither shatters nor sweeps one away, as does Picasso. Not only does he remain more reserved than the others; he also seems less convincing. At first sight, his art seems like a game, and there is a strong temptation to talk of frivolous whimsy and pointless exercises.

We have to penetrate right into his work, into all its vastness to realise that it is a sort of labyrinth, which, when we explore it, allows us to discover a new marvel at every step. No other contemporary work, not even that of Picasso, possesses greater diversity. None is richer in inventions. None has greater unity or more logic. Although his art underwent numerous transformations it never knew those breaks, those sudden starts and regressions that characterised Picasso's progress. Klee seemed to grow like a plant, rather than like a human being. With him there was nothing forced, everything appeared naturally. Yet the role played by calculation and method in his art cannot be dismissed.

He only felt sure that he was a painter in 1914, although he had studied painting in Munich as early as 1898. This was because it was not in his character to press on too fast; he preferred to advance step by step. Before studying colour, he mastered drawing and proportion. He only convinced himself that he possessed a sense of colour during a trip he made to Tunisia with Macke and from then on his path was clear.

He was to say one day: " Nature is the art of another, which we must look at, as an example, capable of helping us to create something similar with the means plastic art gives us. " In other words, he studied nature not in order to reproduce its appearances but to understand its laws. The intimate

121

Klee. View of an old town. 1928.
Formerly in the Doetsch-Benziger Collection, Basel.

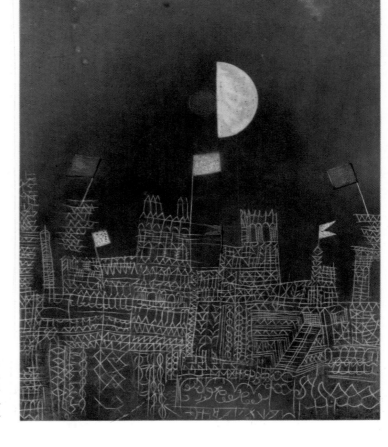

Klee.
Town decked with flags.
1927.
Private Collection,
Bern.

knowledge he possessed of natural creation allowed him to evoke it, even through shapes which preserve none of its traces, in fact through totally abstract works. He did not usually start from a precise motif, nor from an idea. The title of his pictures and the concepts, which they evoke, are not the origin of his works; they were added afterwards. They spring from the works themselves and not the other way round. Klee wanted primarily to create a purely pictorial composition. When in 1921, he became a teacher at the Bauhaus in Weimar he was led to make an extremely thorough analysis of the means the artist has at his disposal and his teaching was most systematic. Nevertheless, his painting never lost its " naïve " and inspired appearance as, despite all he expected from reasoning, he did not forget that " nothing is capable of replacing intuition ".

Although he was particularly careful to preserve the elementary purity of his means (hence the " childish " character of some of his art), he also wanted to be able to express complex things and even to attain a supreme refinement. The diversity of his drawing is no less great than that of his colours. Sometimes the line is fine, swift and ethereal, sometimes it seems drawn out and rather weak, at others it is broad, firm and slow. Sometimes the tones are muted and delicately shaded, elsewhere they are applied in flat areas that are clear, although not very bright. Thoughtful and deliberate, his touch may enjoy showing its effects, but it can also hide them, or even give way to the anonymous

Klee. Mask of a woman. 1933.
F.C. Schang Collection, New York.

Klee.
To left and right.
1938.
F.C.Schang
Collection,
New York.

style of spray painting. In one work, the planar composition is the most obvious; in another it is the depth, but here again there are various possibilities: he can create space with the help of a linear perspective that the eye can explore, or he can open before us an abyss that only the soul can fathom. Whatever style he may adopt, it cannot be confused with anyone else's and his art is always distinguished by that subtle relationship that he establishes between capriciousness and rule, firmness and gracefulness, between his poetic leanings, his love of symbols and his constant effort to fulfil completely the demands of the picture.

After 1930 his paintings, which had usually been small, grew in size, the number of elements involved was reduced, but their vigour was increased. Finally his draughtsmanship tended to use hieroglyphics and his colour became more vibrant. Here and there it betrayed an uneasiness and an anxiety that also showed in his drawings, probably the result of the illness which undermined him for five years until his death.

However this may be, Paul Klee's world was above all a world of kindliness, of affection and harmony. There is a place in his work for humour and an amused smile, but not sarcasm (although it occupied a certain place in the engravings of 1903-1905) and although there is melancholy and fear, there is neither violence, unleashed cruelty nor real anguish.

Miró. Woman. 1932.
Galerie Maeght, Paris.

Miró. Painting. 1952.
L.G. Clayeux Collection, Paris.

Joan Miró. There is no feeling of dislocation in turning from Paul Klee to Joan Miró (born in 1893); they both belong to a primitive world. Whereas Klee goes back to the primitive state of childhood, Miró rejoins that of prehistoric man—with spirit, but not without humour. He is related to the artists who painted on rocks and on pebbles. Miró first shows his sense of humour around 1923-1924 when he reduced every object to a simplified figure, practically a sign, through which he commented slyly on objects as well as evoking them. Nevertheless, it was only after having met the surrealists in Paris in 1924 that he was completely liberated and able to develop his own style, which was at the same time spontaneous, unselfconscious and expressive.

With an imagination that nothing was able to curb, he created rudimentary, grotesque little men, created them with a snigger and a touch of wickedness. Looking bewildered, greedy, vacant, and sometimes cruel, they were often put side by side with strange, polymorphic birds as well as with diagrammatic figures of the sun, the moon, or the stars. If some of Miró's figures may remind us of prehistoric idols, particularly neolithic mother-goddesses, they are their fallen brothers, as they always show that the humour, which helped to create them, ends by dominating them.

All this shows that in spite of all this primitivism, Miró is attached to our own times and a civilisation shaped by the unceasing development of science; in fact, his attraction to primitive art is a form of escape rather than a natural state of mind.

Miró
People in the night.
1942.
Pastel and gouache.
Private Collection,
Paris.

Miró. The white lady. 1950.
Private Collection, Paris.

Miró.
A red sun
gnaws the spider.
1948.
F. Graindorge
Collection,
Liège.

naïve painting

Henri Rousseau. The naïveté that was a rediscovery for Klee and Miró, other contemporary artists did not have to regain: they had never lost it, because they had never trained at an art school. These artists did not join in the search for a new idiom; fundamentally, they stand apart from modern art, although they have certain affinities with it. Their " popular realism " is really, like that of modern art, in opposition to traditional " optic realism ". Anyway, their vision of the world is more complete and more moving than that of academicism, a genuine vision that they fashioned for themselves in the wondering intensity of their contemplation. It is hardly surprising either that the greatest amongst them, Henri Rousseau (1844-1910), actually owed his reputation to the initiators and apologists of cubism.

This artist, who has become a legend, and who in certain respects remains enigmatic despite all that has been written about him, was a strange and disconcerting character. He was called " le Douanier ", although he was employed by the Paris Toll. He was called a " Sunday painter " although he retired at the age of forty in order to devote himself entirely to painting. Biographical details are known, which indicate an incredible naïveté, and yet he created pictures which were so solidly and magnificently constructed that they can stand comparison with any one of the masterpieces of his period.

His ingenuity is certainly the most immediate impression given by his work, yet it is odd that his sketches appear less ingenuous than his completed canvases. Was this ingenuity then a matter of style rather than of vision? I mean to say: was it connected with the way he had of giving all his objects in the completed works a distinct and differentiated form, clearly defining the identity of each,

Rousseau.
Père Juniet's carriole.
1908.
Jean Walter-Paul Guillaume
Collection, Paris.

Rousseau.
Exotic landscape:
Negro attacked
by a leopard.
1907-1909.
Kunstmuseum, Basel.

and conferring on every picture that glossy finish which was so dear to him? One thing is certain: this contemporary of the impressionists was never attracted by the accidental or the momentary. He painted what exists, what can be measured, felt and weighed. It was said that when he did a portrait, he took the measurements of the nose and the forehead. Nevertheless, besides the landscapes he could see, he painted others that were imaginary. Everything leads us to believe, in fact, that his virgin forests, which are so luxuriant and so fanciful, were not inspired by a visit to Mexico, as some

127

Bombois.
The dancer.
1926.
Private Collection,
Paris.

people liked to think, but that he created them from what he had seen in the Jardin des Plantes (the Zoological Gardens) at Paris. Whatever the truth, the mystery of his art remains and the sharpness of the drawing, the monumentality of the form, the crystalline transparency of the atmosphere, instead of dissipating it, only make it all the more fascinating.

Without achieving the Douanier Rousseau's authority, other contemporary naïve artists, too, present us with a reality to which candour has given all its dense mystery as well as its obviousness. Each of them shows us a different world. To quote only a few examples, André Bauchant (1873-1958) enjoys imagining historical or biblical scenes which he situates in enchanting landscapes. Louis Vivin (1861-1936) painted mainly architectural subjects, by building them stone by stone like a mason. Camille Bombois (born in 1883) with a suburban vigour shows us, in particular, acts at fairs and circuses, as well as buxom female figures; whereas Séraphine Louis (1864-1934) displays rich bunches of flowers and fruit picked from some fabulous garden.

Maurice Utrillo (1883-1955) cannot be considered a naïve artist in the same way as those we have just discussed. He does not show their astonished surprise when looking at life. Nor is his style as precise or as simplified as theirs. When in 1903 his mother, Suzanne Valadon, who was herself a

128

Utrillo.
Snow on Montmartre:
the Church of Saint-Pierre.
Private Collection,
U.S.A.

Utrillo.
The Church of Saint-Gervais,
Paris.
1910.
Paul Pétridès
Collection,
Paris.

painter, placed a paint brush in his hand to try to cure his drunkenness, he began to express himself in a style which was influenced by Pissarro. Later too, he practised a sort of primitive impressionism; that is to say, an impressionism with no breaking up of colour and no shattering of form. He contributed nothing new from the point of view of pictorial expression. Despite this his place in contemporary painting is unrivalled because of the works he painted before 1915.

Before him, no one had looked at the streets of Montmartre with such penetrating sadness. No one had given such a desolate picture of old walls. He gave them back the rough-cast surface, which cracked and crumbled and was covered with leprous decay and fungus. He achieved this in a texture, which whilst preserving its dull monotony made of it a rare, distinguished and vibrating object. In addition he showed a love for solid composition, and distributed architectural masses with a lordly sense of balance.

129

Utrillo. The Church at Châtillon-sur-Seine. 1911.
Paul Pétridès Collection, Paris.

Utrillo.
The Sacré-Cœur
at Montmartre
decked with flags.
1919.
Paul Pétridès Collection,
Paris.

Utrillo.
The Church of Saint-Pierre
and the Sacré-Cœur.
1910.
Paul Pétridès
Collection,
Paris.

early abstract painting

When painting deforms the appearance of the outside world to the point of making it unrecognisable, when it is understood that the significance of a subject is essentially due to its colour and its form, it would seem logical that painters should begin to sever the last ties, which attach their art to visible reality, and that they should honestly turn towards what is commonly called abstract art. However, what seems logical in the world of art neither necessarily happens nor makes itself accepted. When during the period of analytical cubism, Braque and Picasso by dint of fragmenting the object risked seeing it disappear, they did not abandon it, they reconstructed it—and their art is alive. Other artists, it is true, followed the direction that logic seemed to impose. They did so, however, not without hesitation, nor sometimes, it seems, without regret.

Wassily Kandinsky (1866-1944) painted his first abstract work in 1910, but references to the outside world came into his pictures up to 1913. In fact, his first abstract work was a watercolour, actually a sort of sketch, very nearly an exercise in style. The painter himself admitted that having once realised that objects did harm to his painting, he saw " a frightful void " appear beneath his feet. The flood of possibilities, which offered themselves to him, was accompanied by all sorts of anxious questions. What was to replace the object? Colours and shapes of course, but how was he to avoid their becoming " ornamental " ? He said " that it was only after many years of patient work... that I achieved my present style of painting ".

" Today " was 1913, and at that time his forms were far from " ornamental ". Large impetuous strokes streaked across the pages, scrawled lines wound round nervously, loud colours exploded and

131

Kandinsky. First abstract water-colour. 1910.
Nina Kandinsky Collection, Paris.

Kandinsky.
In the black circle.
1923.
Galerie Maeght,
Paris.

confronted each other with so much freedom that they risked tearing the picture to pieces. It was like the rumbling of a volcano or the braying and trumpeting of some musical compositions. Kandinsky admitted that Wagner helped to orient him, that through *Lohengrin* he discovered in art " an unsuspected force ". He thought at the time that " painting was a resounding shock of various worlds... " and that " a work is born in the same way as the cosmos, through catastrophes which from the chaotic roaring of instruments finally form a symphony, which is called the music of the spheres ". That Kandinsky should speak of the cosmos and the music of the spheres is significant. He means to express not only human sentiments, but the " secret " soul of the universe. By giving up figurative painting he did not dream of turning his back on nature—on the contrary, he sought a closer union with it.

After the 1914-1918 war, which took him back to Russia, his art lost its explosive character. His shapes became geometrical, his composition clarified itself. This tendency was strengthened, when in 1922 Kandinsky was called to the Bauhaus in Weimar, where a strong emphasis was laid on planned construction. Although, however, the dramatic tumult disappeared from his works, they did not cease to be charged with dynamism, even when they became light and slick and at times tended towards the decorative. Sudden, rapid movements often gave them vitality, and generally the forms floated in a space which was undefined, inter-stellar or as seen under a microscope. The colour, which adorns them, is rich and precious. They prove that Kandinsky remained an Oriental, despite the fact that most of his artistic life was spent in the west, first in Germany, and after 1933 in France.

The other pioneers of abstract art began to appear more or less at the same time as Kandinsky. The first non-figurative works that the Czech Frank Kupka painted in Paris date from 1910-1911.

Kandinsky.
Composition X.
1939.
Musée National
d'Art Moderne,
Paris.

Kandinsky.
Movement I.
1935.
Nina Kandinsky
Collection,
Paris.

Kandinsky.
Accent in rose.
1926.
Nina Kandinsky
Collection,
Paris.

133

Delaunay. Simultaneous disc. 1912. Burton
Tremaine Collection, U.S.A.

Picabia.
Udnie or the Dance.
1913.
Musée National
d'Art Moderne,
Paris.

A little later Delaunay painted his first *Circular Forms* also in Paris, while the Dutchman Piet Mondrian went in for variations on the theme of *Trees*, and Picabia created his *Procession at Seville*, as well as the vast compositions, which were so vigorously rhythmical and which he called *Udnie* and *Edtaonisl*. Around 1910, abstraction also appeared in Moscow in the painting of Larionov and Gontcharova. In 1915 Casimir Malevitch drew there his celebrated black square on a white background. The new conceptions also found partisans amongst the Italian artists; first Balla and later Severini were able to paint some of their most convincing futurist works. Others too joined the movement; in particular the Florentine Magnelli, Pettoruti and the future dadaist, Hans Arp. However, in referring to these painters as pioneers, it should be pointed out that they were not all equally revolutionary, nor all equally faithful to abstraction. It was only a temporary phase for some and for a long time abstraction was only practised by a small number of painters.

Delaunay himself gave it up for several years, but his contribution was one of the most valuable of all. Even in some of his figurative compositions like *Simultaneous Windows*, colour was '' form and subject '' and he expressed himself through it '' as one would express oneself in music '', he said, '' through the fugue of coloured, fugal phrases ''.

The fugue ? Kupka (1871-1957) in his turn used the term for some of his works. About 1912,

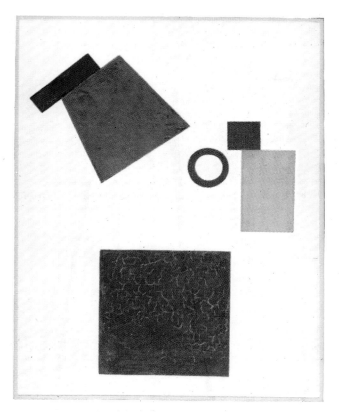

Malevitch. Suprematist composition. 1914-1916.
Stedelijk Museum, Amsterdam.

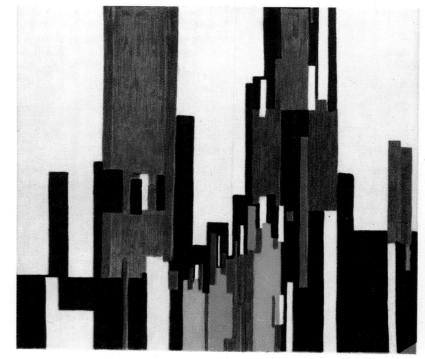

Kupka.
Blue and red
vertical planes.
1913.
Galerie Louis Carré,
Paris.

he painted *Fugues in Two Colours*, followed by the *Solo by a Brown Line*. Kupka also produced works of a constructional kind. His experiments varied a good deal. Here he suggests space by the simple juxtaposition of a few strips of colour, there the planes overlap and interpenetrate in complex constructions which open up to the irruption of light or to its mysterious meanderings. Elsewhere, ogival shapes come towards us in successive waves and one is under the impression that they surge up from the depths of the universe and of time. Elsewhere again, there is a profusion of floral patterning, so exuberant that it fills and almost overflows the picture, but the artist was in control of this outpouring. He often repressed it and in trying to be too disciplined, ended by being cold and dry.

To establish in art " the supremacy of pure sensibility " while using nothing but the elementary figures of plane geometry was the aim of Malevitch (1878-1935), the father of suprematism. He manages to bring to life his squares, his rectangles, his trapezes, his circles and his simple straight or curved lines by giving them a certain colour and arranging them in a certain order. Suddenly they become sensitive, related, acquire tensions, antipathies and harmonies. This result is more natural, to tell the truth, than it appears at first sight; that figures from strict geometry should have an emotional power has been proved by architecture ever since it has existed.

Before he evolved suprematism, Malevitch's work for some time resembled Léger's.

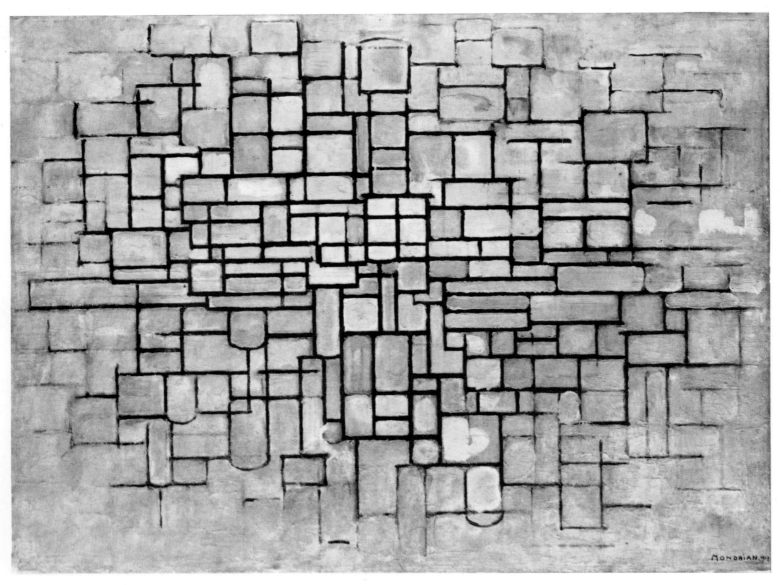

Mondrian. Composition in grey, blue and rose. 1913. Rijksmuseum Kröller-Müller, Otterlo.

Piet Mondrian (1872-1944) also went through a cubist phase when he moved to Paris in 1911. He was associated with Braque and Picasso, but he soon separated from them because of the need he felt to draw the " logical conclusions " from cubism that they would never draw. He reduced an object to mere indications of lines and rhythms, which he arranged on the canvas with the single purpose of creating an autonomous composition. This was only the beginning. Mondrian returned to Holland in 1914. Three years later, he gave up any point of reference to nature and endeavoured to " denaturalise " his art completely. His published writings, particularly in the review, *De Stijl*, which he founded in 1917 with Theo van Doesburg, explain the reason for this: behind the changing forms of nature there existed for him their reality, pure and invariable, and only pure, plastic relationships had the power to give expression to that reality. In 1921, at Paris, he painted the first picture that realised fully his new convictions and these pure plastic relationships. It was a sort of prototype, because the formula he used for it remained the basis for all the works that were to follow.

There is no place in this art for what is generally called form. Mondrian's neo-plasticism allowed nothing on the canvas beyond compartments defined by vertical and horizontal lines. Colour was reduced to red, yellow and blue to which white, black and grey were added. The three primary colours

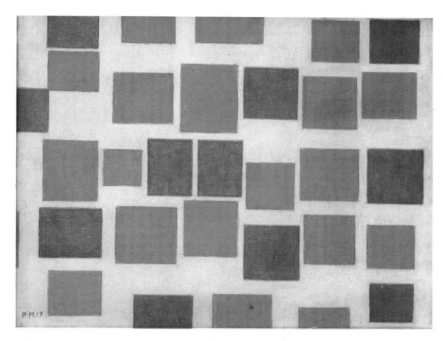

Mondrian.
Composition no. 3 with coloured planes.
1917.
Gemeentemuseum,
The Hague.

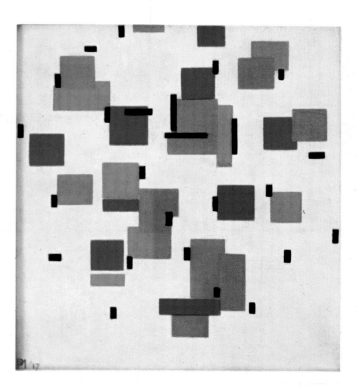

Mondrian.
Composition in blue B.
1917.
Rijksmuseum Kröller-Müller,
Otterlo.

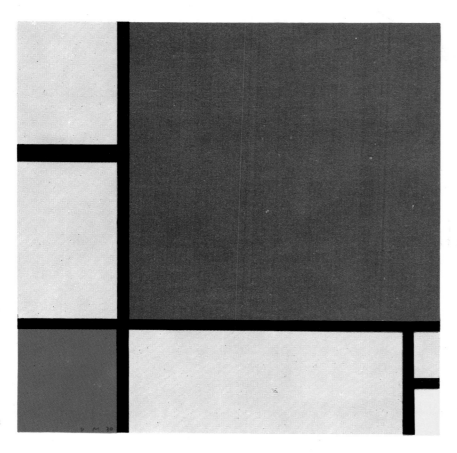

Mondrian.
Composition in red,
blue and yellow.
1930.
Bartos Collection,
New York.

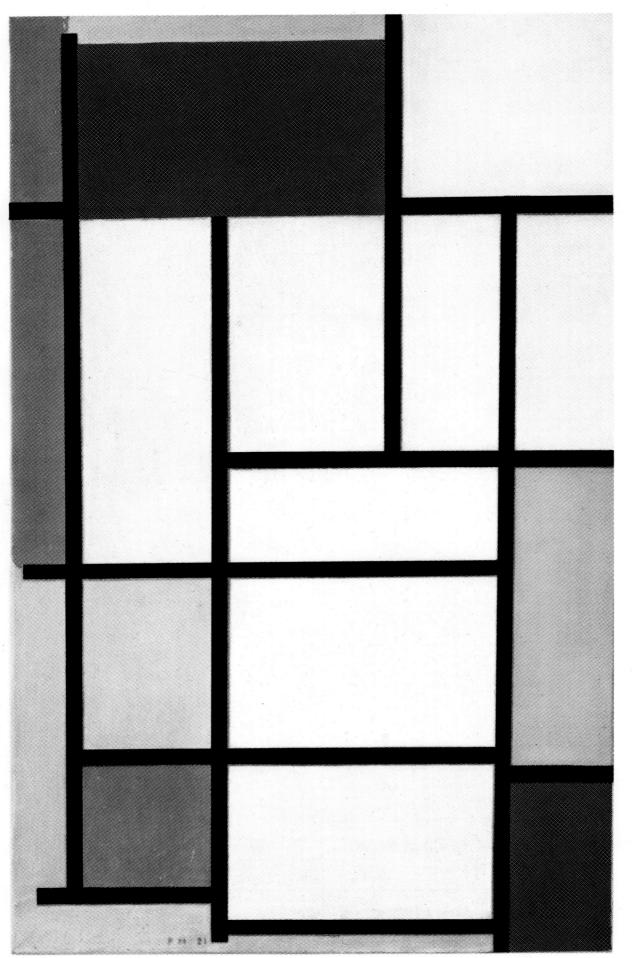

Mondrian.
Composition in red,
yellow and blue.
1921.
Gemeentemuseum,
The Hague.

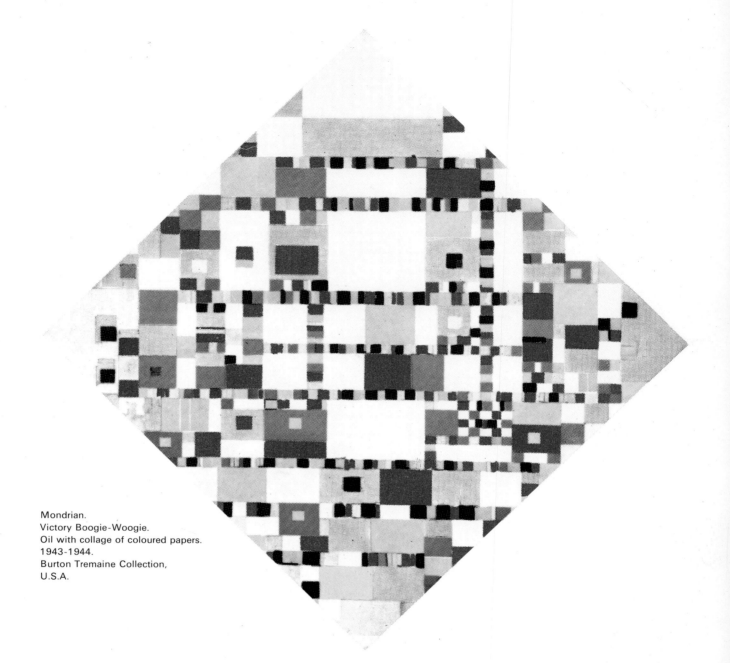

Mondrian.
Victory Boogie-Woogie.
Oil with collage of coloured papers.
1943-1944.
Burton Tremaine Collection,
U.S.A.

were never mixed, not all three were necessarily used together and some paintings simply consisted of a white surface divided by two or three lines. That the lines were black, invariably black, until 1942, when they became coloured, measures the rigour of the ascesis that this painter thought fit to impose on himself. It really was an ascesis, too; the works of 1911-1914 leave no room for doubt on the subject. It was not because he was insensitive or cold that Mondrian chose the straight and narrow path of neo-plasticism. It was because a puritanical sense of decency made him averse to romantic effusions; because he wanted to go beyond the particular and accidental to attain the universal and a perfect equilibrium. However right may have been the relationships that he struggled to establish between the different elements at his disposal, it is difficult not to regret from time to time everything that he sacrificed. His work taken as a whole does not escape monotony, although towards the end of his life, his stay in New York encouraged him to introduce into his *Boogie-Woogie* pictures a dynamic gaiety that seems alien to the angular austerity of his art. **Piet Mondrian** represents an extreme, one of the extremes between which abstract painting developed; the other was the lyrical Wassily Kandinsky of the 1910-1920 period.

139

abstract painting
pop art, op art

The art of Kandinsky and Mondrian has had a decisive influence on modern painting but only after the lifetime of both artists. Also at work were other influences which were both older and more difficult to trace. Apart from an art which has continued to survive, more or less dominated by traditional rules of pictorial representation and even academicism, painting after 1940 may be defined in its evolution as an effervescence of experiment and research and even of opposing movements which have swung from the figurative to the abstract and then back again to figurative art. We might say that modern art has always maintained a balance between two contrary styles such as impressionism and symbolism, fauvism and cubism, expressionism and surrealism, always within a context of realism. The artists who followed these diverging paths never questioned the fundamental principles of their art, for they were only endeavouring to renew its means. From Poussin to Cézanne, from Rembrandt to Van Gogh, painting had followed an uninterrupted line of development. Between Rembrandt and Van Gogh, Poussin and Cézanne the difference was only one of nuance, but Van Gogh who wanted to " add man to nature " is separated from Mondrian by a great gulf. The difference is just as great between Cézanne, who wanted to " redo Poussin after nature " and—for example—Kandinsky, who claimed the right to " abandon nature and the object ".

Whatever the truth may be, the fact remains that the pictorial revolution which had been started in Europe in about 1911 by Kandinsky, Robert Delaunay, Malevitch, Kupka and a few other pioneers did not really come into its own for another thirty or thirty-five years, for the intervening period was dominated by the powerful personalities of such artists as Bonnard, Matisse, Braque, Picasso and Léger. Freed from the laws of imitation and long-standing concepts of form, their art had held the stage

140

Kandinsky. Improvisation 35. 1914.
Hans Arp Collection, Kunstmuseum, Basel.

Mondrian. Composition. 1921.
Private Collection.

until 1940 if not even longer. But against all expectations, the war years were far from being a period of artistic sterility. War or no war, artists continued to work in their studios. Although the '' School of Paris '' had been dispersed after the defeat of France, their country's defeat did not stop Parisian artists from working. While France saw the rise of a generation determined to turn pictorial values upside down, the same urge towards a new outlook was felt in the United States, where painters as famous as Léger, Max Ernst, Chagall and André Masson from Paris had joined Marcel Duchamp and Ozenfant and were later to meet refugees like the Dutchman, Mondrian, the Germans, Josef Albers and Hans Richter, the Hungarian, Moholy-Nagy, emigrants like the Armenian Arshile Gorky, the Swiss, Glarner and the Dutchman, Willem de Kooning.

These personalities, whom the war had united, could not fail to stimulate the artistic life of America. That great country, it is true, had made attempts to free painting from traditional notions before their arrival. Exhibitions organised by Katherine S. Dreier, the foundation of the Association of American Abstract Artists in 1936 and the Museum of Non-Objective Painting in 1937, which later became the Guggenheim Museum, and the publication of several informative books had already familiarised the public with the experiments of the first abstract artists. Painters like Stuart Davis, Dove, A.E. Gallatin, George Morris and Baziotes, had supported the movement enthusiastically.

During the same period, Werkman in Holland, Carlsund in Sweden, the German, Schwitters, and Ben Nicholson in England, Torrès-Garcia in Uruguay, Pettoruti in Argentina, Arp, Kupka, Sonia Delaunay, Herbin and Fautrier in France, as well as artists working in Paris at the time, like Kandinsky, the Belgian, Closon, the Italian, Magnelli, the Fleming, Vantongerloo, had prepared the extraordinary upsurge of abstraction that characterised the period immediately after the war.

Arp.
Static composition.
1915.
François Arp Collection,
Paris.

Ben Nicholson.
Painting 1924 (Trout).
C.S. Reddihough Collection,
Ilkley, Yorkshire.

Macdonald-Wright.
Synchromy. 1914.
Private Collection, U.S.A.

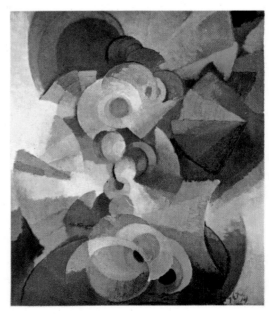

Schwitters.
Collage.
1927.
Mme Van Doesburg
Collection,
Meudon.

142

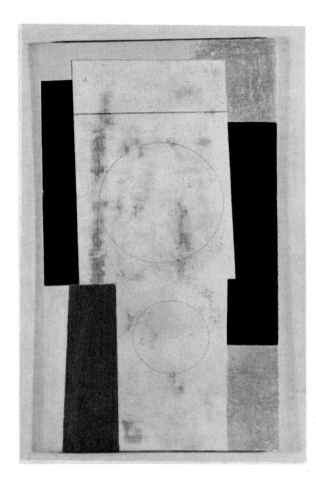

Ben Nicholson.
May 1957 (Monolith).
Bruno Adler Collection,
London.

Pasmore. Red abstract no. 5.
1960.
City Art Gallery,
Bristol.

Triumph of the new reality.

This was much less a coherent, concerted initiative than a common attitude towards a number of problems facing the creative conscience at a particular moment of civilisation. There was no question for these artists of living on the capital they had inherited from their illustrious elders, but of going forward beyond the limits where these had stopped. After 1944, painting in Europe and America found itself committed to a struggle at the expense of the realist tradition, which led to the elaboration of a new and original idiom.

Against all logic, masters like Picasso, Matisse and Braque, who had heralded revolutionary painting at the beginning of the century, found themselves outflanked by an avant-garde that wanted to make a clean sweep and start from scratch. Since so many liberties had already been taken with the object, they asked, why not eliminate it altogether from painting? At a time when many minds were beginning to refuse a world in which the relationship between awareness and nature could no longer be based on traditional foundations, reality became an obstacle for the individual and especially the artist. After all, the only reality which counted, the only reality which possessed undeniable authenticity and efficacity, was the inner reality of the intellect, the imagination and the senses. From then onwards, the painter's duty was no longer to give the spectator a more or less convincing illusion

143

Herbin.
Vein.
1953.

Magnelli. Disturbing vision. 1947.

Magnelli.
Staccato rhythm.
1938.
A. Blankart Collection.

Max Bill.
Two accents.
1949.

Hartung.
Pastel P.
1957-31.

of perceptible reality, but to replace this illusion by a new and truer reality, a reality which sprang from an autonomous act of the spirit—a subjective reality.

Two currents of abstract painting.

It was then noticed that as early as 1912 Kandinsky had been expressing similar ideas in his book *Concerning the spiritual in art*, and that he had been putting them into practice in the intuitive and emotional part of his work. This '' new reality '' which he had so insistently recommended became the title *(Réalités Nouvelles)* for a Paris Salon held in 1946 under the aegis of Herbin, Kupka and Magnelli, who were, nevertheless, hostile to Kandinsky's romanticism if not his theories. They were, in fact, more disciples of Malevitch and, above all, Mondrian, whose reasoned, static art, constructed out of pure geometrical elements, was to influence artists for several years once they had been won over to non-figurative painting.

The so-called '' abstract '' movement in painting soon split into two mutually antagonistic currents, one deriving from Kandinsky and grouping lyrical and expressionist painters, the other from Mondrian and including the rationalists, the classicists and all the anti-romantics: Gorin, Herbin, Magnelli, Hélion in France; Balla and Prampolini in Italy; Leuppi and Max Bill in Switzerland; Vordemberge-Gildewart in Germany; Ben Nicholson and Pasmore in Great Britain; Peeters and Servranckx in Bel-

145

Hartung.
Painting.
1954.
Private
Collection,
Paris.

Schneider.
Cérak.
1955.
Raymond Mindlin
Collection,
New York.

gium. On the fringe of these two tendencies, two others should be noted: the lyrical vision of Paul Klee, which was too personal to have any followers, and Robert Delaunay's orphism, which influenced German art before the First World War and was introduced into the United States by Morgan Russell and Stanton Macdonald-Wright.

Pure, intellectual abstraction found a response in America encouraged notably by Albers, one of the former Bauhaus teachers, Diller and Glarner, two followers of Mondrian, who had remained faithful to their master's neo-plasticism. This was why, when Mondrian settled in New York in 1940, he was better appreciated and understood than in Europe.

Notable among the first to continue the tradition of Kandinsky were Hartung, a German artist who had become a French citizen and who had abjured figurative art some ten years before the war; three artists of Russian extraction: Nicolas de Staël, who died tragically in 1955 shortly after having begun

Soulages.
Painting.
1947.
Oil on paper.
Galerie de France,
Paris.

a return to representational art, Poliakoff and Lanskoy; the Swiss born Gérard Schneider, whose dramatic violence of style was in striking contrast to the serene, powerfully constructed forms of his twenty-three year old, younger follow-artist, Soulages. It should be noted in passing that the abstractionists who made a name for themselves then in France were not of French origin. The phenomenon which had occured immediately after the First World War was repeated after the end of the Second World War, but with the difference that painters did not come to France so much to learn or to seek inspiration as to find a more congenial environment for their work. They formed a new " School of Paris ", larger and more motley than the first, in which individuals, far from grouping together, jostled and vied with each other.

For a while it was thought that the disciples of pure abstraction would draw the whole movement

Wols.
Phoenix.
1947.
Philippe Durand-Ruel
Collection,
Paris.

after them in their wake. This was a mistaken view. Opposition if not break-away movements, which are still as vital as ever, soon arose in the very heart of the non-figurative movements to give rise to such well known categories of representational art as impressionism, fauvism, surrealism and expressionism. Some artists claimed descent from Monet—the Monet of the *Water-lilies*— or from Bonnard and even the Chinese brush-painters, while others claimed to derive from the violent chromatics of Vlaminck in his 1905 period or the automatic writing process that André Breton had recommended.

In Europe, as in the United States, the need for form was felt less and less. Fresh potentialities were discovered in paint; the effectiveness of colour in itself, dissociated from form; or paint thrown, dribbled, squashed and splattered onto the canvas, sometimes with an aggressive violence, sometimes with the most delicate refinements of tone. A new expressionism and mannerism appeared in abstract painting which had their followers, not only at Paris and New York, but also in England, Italy, Spain

Sam Francis.
Composition.
1953-1954.
Galerie Ariel,
Paris.

and even Japan. While the supporters of '' cold '' abstraction, whose works, it must be admitted, were already contained in embryo form in constructivism, orphism or neo-plasticism, diminished in numbers and influence, the '' hot '' abstractionists won ground almost everywhere and developed a lyrical art which ranged from the gentlest effusion to the most torrential eloquence. All sorts of terms were invented in France, America and England for these different tendencies: *art autre*, tachism, non-representational or non-figurative art, action painting and gestural painting, which indicated the appearance of the work far better than the attitudes inspiring it. In short, it was an instinctive art that had its admirers and enemies, who accused it of being an act destitute of any purpose or thought, a complete surrender whose appearance coincided with a profound disintegration of civilisation. It was condemned for other reasons, too: a refusal or inability to understand form, interpret sensations or control the medium, besides offering unrivalled opportunities to fools and impostors.

Fautrier.
Neon lights. 1962.

Triumph of lyric abstraction.

Nevertheless, lyric abstraction made rapid advances and gained a number of proselytes, some of whom were unquestionably gifted and won an international reputation; Jean Fautrier (1898-1964) in France, for example, who was the first to feel the need for a non-figurative art, a new dimension of space and a new pictorial substance; and Wols (1913-1951) who spirted his overflowing passion and fantasy onto the canvas.

While Claude Monet's followers, of one kind or another, contented themselves with atmospheric painting, and others exercised themselves with juxtaposing areas of colour or applying touches of saturated colour, more recruits were attracted to a form of graphic expression, which was already characteristic of Miró's invented signs and Dubuffet's humorous personages. Although some abstract expressionists, of whom Georges Mathieu seems the most gifted, pursued a gestural painting that was distinctly calligraphic, there were other painters who felt the need to communicate their emotions more directly to the observer with forms that were more suggestive of human personality. Signs lost their power, splashes of paint took the place of lines, deliberate formlessness of form. The vestiges of any pictorial concepts tended to disappear altogether before vagueness, nebulousness, diffusion. Painters no longer did preliminary drawings, but attacked the canvas directly with the brush, or squirted and splashed it with colour.

Beside these painters who abandoned themselves without any control to their sensorial or emotional impulses, there were others who, with complete lucidity, identified their own effusions with the

Tobey. Blue-grey composition. 1955. Private Collection, Paris.

great rhythms of the universe and let themselves be penetrated by the smell of the earth, the changing seasons, the roaring winds, the union of the sky and waters. Others again, like Bazaine, Estève, Manessier, Piaubert, while rejecting the rules of representational painting and without giving their allegiance either to lyric or geometric abstraction, preserved the plastic values of their pictorial idiom all the more resolutely the more these values were neglected.

In the United States, the master of lyric abstraction was Jackson Pollock (1912-1956) who reached the extreme of irrationality with his dripping technique that allowed the painting to come alive with a life of its own. He did, nevertheless, intervene at just the right moment to establish an absolute relationship between the work and himself, between his creative will and the autocreation of his painting. Jackson Pollock, Franz Kline (1910-1962) with his powerful imagination, Willem de Kooning, Clyfford Still, B.W. Tomlin, Mark Rothko, Philip Guston, Adolph Gottlieb, Helen Frankenthall were the leaders of action painting and, with it, America had for the first time a vital, spirited school of painting, conscious of its originality, although it was largely imbued with European and sometimes Asiatic culture. An oriental flavour is, in fact, perceptible in the works of Kline, Motherwell, Clyfford Still, Rothko and particularly Mark Tobey whose inward-looking art was much appreciated in France, especially as a number of French painters were also attracted to Sino-Japanese art.

Whether it was called action or non-representational painting, the numbers and activity of artists practising lyric abstraction left only a handful of zealous devotees for geometric abstraction. When this assumed a greater importance, the painters of lyric abstraction tended to disappear or turn to another manner except for those who had found in it the most appropriate idiom for their particular gifts.

151

Tomlin.
Number 20.
1949.
Museum of
Modern Art,
New York.

Pollock.
Painting no. 12.
1952.
Nelson A.
Rockefeller
Collection,
New York.

Tobey.
Still-life,
Sumi ink.
1957.
J.F. Jaeger
Collection,
Paris.

Rothko.
Number 10.
1950.
Museum of
Modern Art,
New York.

Kline.
Green vertical.
1958.
Sidney Janis Gallery,
New York.

Pollock.
Painting no. 5.
1948.
Alfonso A. Ossorio
and Edward Dragon
Collection.

Bissier.
Ronco. 1959.
Gimpel Fils Gallery, London.

Baumeister. Safer with a pipe. 1953.
Galerie Jeanne Bucher,
Paris.

Among these were Mark Tobey and Willem de Kooning in the United States; and in France, Camille Bryen, Georges Mathieu and Jean Dubuffet, who exploited the potentialities of paint in his own original manner in *Texturologies* and *Célébrations du sol*.

Primacy of the artist's materials.

Dubuffet was the first to demonstrate that the painter's materials alone were sufficient to define space and light and that, instead of being passive and secondary, they could become the essential element of a painting. Rejecting the old technique with smooth, uniform paint, artists appreciated and used the expressive qualities of a pictorial medium. It broke in floods of lava over Hosiasson's paintings, gave the dryness and roughness of a wall to the work of the Catalan, Tapiès, exploded over the canvases of Feito, another Spaniard, petrified under the hand of Damian, a Roumanian, and elsewhere evolved almost bare images, in relief, which communicated a primaeval emotion, pregnant with the poetry of the newly created world. The Spaniards, Millares and Saura, incorporated twisted, wrinkled fragments of cloth into their paintings.

Some years earlier, the Italian artist, Burri, who had been an army doctor in the war, had made use of amalgams of colour and worn materials such as sack-cloth, charred wood, plaques of iron and pieces of plastic. For him, it was not a question of destroying painting as such, but rather of really creating pictures which were to be rationally composed of naturalistic elements chosen from the most vulgar and common-place débris. This surprising but logical choice was justified in that Burri

Poliakoff.
Painting.
1951.
Galerie Ariel,
Paris.

was attempting to defy the forces of annihilation and fight against aesthetic refinement. The same cannot be said of a number of other artists who used the most degraded and repulsive materials mainly in order to do battle in favour of anti-painting. This then was the origin of that '' dust-bin art '' which was to be taken up again and systematically exploited by the neo-realists. Painters became fascinated by broken earth, garbage, erosions and mouldiness, thereby showing an unexpected renewal of interest in the real, the concrete and nature.

Protagonists of non-figurative art gave the impression that they were consummating their divorce between the ego and the exterior world. It was believed that their art was subordinated to fits of temperament, the miasmas of the unconscious and the muffled pulsations of organic inner life. In reality all they were doing was to reproduce the rough surfaces of walls, the wrinkles in old leather, the rust on old iron, the bark of trees or the grain of stone, wood fibres, skin textures, and the molecules produced by the phenomena of crystallisation or cementation as revealed by the microscope.

Towards a resurgence of naturalism?

In short, the miniaturist's lyricism of a Tobey, for example, seems less the product of abstraction than the imitation of the infinitely small, a micro-realism that was no more antinomic of reality than abstract impressionism, when it produced Monet's last versions of the *Water-lilies* without the lilies, or than abstract expressionism when it submerged in lashings of paint the forms that Ensor, Soutine and recently Kokoschka had already distorted.

155

Staël.
Composition.
1951.
J. Le Guillou
Collection,
Nantes.

Staël.
Sicilian landscape.
Private Collection.

What a babel of terms, reflecting the babel of aesthetic tendencies! Since 1950 artistic activity has become so complex that the onlooker may be excused if he loses his way in it. But nonetheless, one guiding thread does run through it—the multiplication and emphasis of naturalist analogies in non-figurative art.

It could not be denied that reality had begun to make its appearance in the works of Bazaine, Beaudin, Manessier and to an even greater extent in the works of Pignon. The retrogressive evolution in the art of Hélion and Nicolas de Staël, which at first was a purely individual phenomenon, gave rise to a general movement after De Staël's suicide in 1955. Bissière himself (1888-1964) who had declared in 1920 that " we should look around ourselves less and into ourselves more " and who joyously

Staël.
Jazz
musicians:
memories
of Sidney Bechet.
1952.
Private Collection,
Paris.

Bissière.
Painting.
1953.
Galerie
Jeanne Bucher,
Paris.

Vieira da Silva. The golden city. 1956.
Pierre Granville Collection, Paris.

expressed himself only with the discreetest and softest of colours, began again to look around himself in the last two years of his life.

This return to naturalism encouraged the development of a sort of neo-surrealism, which is represented in the work of Toyen, Hantai and Leonora Carrington. The fact remains that about 1959 a new figurative painting arose to the detriment of non-representational painting. In France it was called neo-realism; in America, pop art. Before giving an account of it, we must describe more fully the context of its development.

The art of anti-reality, which swept the studios at the end of the war, had first taken the form of pure abstraction, mainly lyric abstraction, which had itself been torn between Latin mannerism, Nordic

Vieira da Silva.
Egypt.
1948.
Artist's
Collection.

expressionism, American action painting and had become chaotic in its diversity, especially at Paris. The frenetic gaudiness of Appel's and Jorn's paintings contrasted with the almost monochrome work of Marfaing and Downing and the complete monochromy of Yves Klein, who died prematurely in 1962.

We have pointed out that other artists explored the striking effects that the material of painting could produce. The logical development of this was that the painter's medium was at first pictorial and then disintegrated into fragments of objects or aggregates of natural elements. Burri's sack-cloth and wood compositions were followed by Schultze's rag-pictures, Kalinowski's frame-pictures, and the metal-pictures of Kemeny. Painting, in short, tended to become confused with sculpture. It even found an ally in science; Parisians saw Schöffer's spatio-dynamic machines and Tinguely automats.

Faced with the chaotic attacks of lyric abstraction, the defenders of " cold " abstraction maintained their positions. In France, after Herbin (1882-1960) and Magnelli, Vasarely led the movement of geometric art. Its principal artists were the Danish Mortensen, the Englishmen, Victor Pasmore and William Scott, the Italians, Bonfanti, Rho, Reggiani, who were the successors of Prampolini (1896-1956), and the Swedes, Carlsund and Baertling. Albers and Glarner formed a school in the United States. These various painters, however, could hardly be very formidable adversaries for the adherents of lyric abstraction, which was more effectively opposed by the new realists of Paris and New York. Paradoxically, this challenge originated in lyric abstraction itself, the painting that thought it had refused all compromise with the world of outward appearances and, as we have seen, suddenly

159

Manessier.
Salve Regina.
1945.
Musée des Beaux-Arts,
Nantes.

Estève.
Tricornu.
1959.
Svensk-Franska
Konstgalleriet,
Stockholm.

clothed itself in the rags of execrated realism. It had already been possible to identify the " dripping " of Pollock with the nervous system of the human body, Wols' scrawls with the texture of matter and Hosiasson's torrents of paint with the palingenesis of the earth. Everything pointed to a new naturalistic renaissance and a few individual transitions from non-figurative to figurative art gave added impetus to the process.

Continuity of figurative art.

As a matter of fact, the vogue for abstract art had never affected the painters of older generations and the masters of fauvism, cubism, or expressionism. Bonnard, last of the impressionists, had died in 1947, Dufy in 1953, Derain in 1954 and Vlaminck in 1958. The two great expressionists, Ensor and Nolde, died in 1949 and 1956 respectively. Two years later Rouault died. Italy lost its greatest futurist, Balla, in 1958 and Morandi, who had invented " metaphysical " painting with De Chirico, in 1964. In

161

the five years before his death (1955), Fernand Léger emphasised his realism and in his *Builders* and *Parties de campagne* had even returned to subject matter and anecdote. The technique of " papiers découpés " (" paper cutouts ") that Matisse (1869-1954) had invented when illness prevented him from using a brush, the series of *Studios* and *Birds* that Braque (1882-1963) began in 1955, and Jacques Villon's (1875-1963) methodically analytical portraits and landscapes by no means exhausted the vocabulary of representational art. Picasso (born 1881) himself had employed the whole vocabulary on his own, either successively or simultaneously in his many-sided and contradictory work, in which form was made to submit in turn to a classical perfection, a seductive mannerism or the torments of a typically Spanish, pitiless extravagance. In the same period, Kokoschka, only five years younger than Picasso, was in Salzburg completing a career that was marked by the dying spasms of German expressionism. Not one painter survived who still remained faithful to the orthodoxy of the original cubist movement. Some, like Metzinger (1883-1957) and Hayden (born 1883) moved towards figurative art while others, such as Gleizes (1881-1953) and the Argentine Pettoruti (born 1895) turned towards abstraction. Marcel Duchamp (born 1887), who helped the rise of neo-dadaism in the United States, otherwise known as pop art, is the only survivor from the *enfants terribles* of the Dada group.

A remarkable change.

Thus, while the newer generations of artists could only think in terms of " abstract art ", most of the older artists who had renewed pictorial language and vision in the first half of the century continued to paint in the figurative, or, we might say, the de-figurative style. But neither Braque, Villon, Léger or Picasso was to bring about that return to figurative art in about 1960, which was in its principles

Lanskoy.
Gouache.
1954.
Galerie
Jacques Dubourg,
Paris.

Lapicque.
The sea.
Water-colour.
1951.

Tal Coat.
Sign and return.
1952.
Private Collection,
Paris.

Mathieu.
Capetian entelechy.
1954.
D.H. Clark Collection,
New York.

163

Dubuffet.
Extremus Amibolis.
Assembled painting.
1956.

Tapiès.
Brown, grey and red relief.
1962.
Private Collection,
Paris.

Burri.
Ferro 59.

Atlan.
Painting.
1954.
Private Collection.

and means so opposed to radically abstract art. On the contrary, it was abstract painting itself and lyric abstraction, in particular, that had always maintained a certain relationship with the world of outer appearances and, by its very facility, encouraged such a proliferation of artists who were often lacking in experience.

All this prepared that singular transformation that brought the golden age of non-figurative painting to an end. Non-figurative painting became the '' new figurative painting '', the concrete replaced the abstract, and the formless took form again. As this naturalistic extraversion went hand-in-hand with a distinct tendency to self-destruction, avant-garde painters soon were no longer content to outline or suggest the object with lines and colours, but included the objects themselves and made the real, tangible world in which we live their own, together with its towns, its factories, advertising, mass-produced articles.

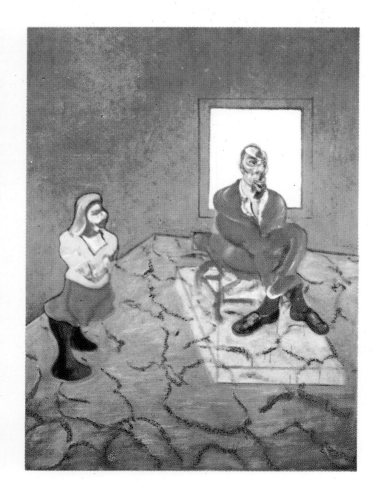

Bacon.
Man and child.
1963.

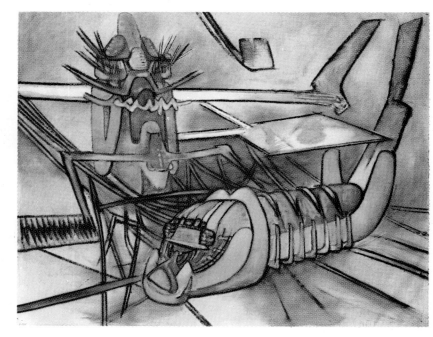

Matta. Who's who. 1955.
Private Collection, New York.

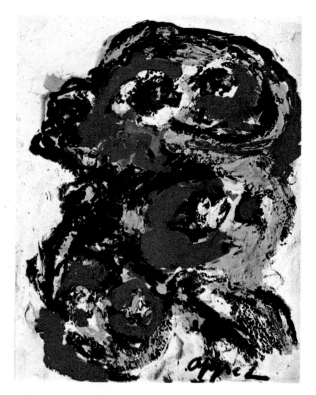

Appel.
Sketch
for the cover
of the review « Du ».
1963.

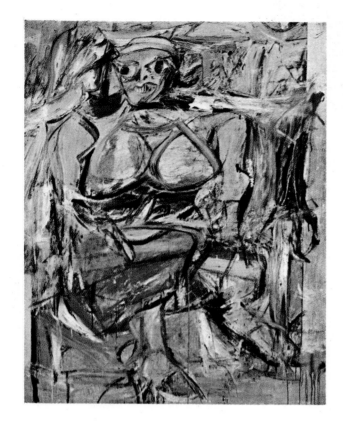

De Kooning.
Woman I.
1950-1952.
Museum of
Modern Art,
New York.

Gorky. Agony. 1947.
Museum of Modern Art, New York.

About 1959, when the quarrel between the lyric painters and rationalists had reached its peak, the new realism appeared simultaneously at New York and Paris, aggressive, youthful and ambitious. Some artists had already anticipated the movement. As early as 1950, Rauschenberg realised that action painting was exhausted, although he was an established abstract expressionist himself. Two years later he exhibited his first '' combine paintings '', scrap objects against a pictorial background which went beyond Marcel Duchamp's '' ready mades '' and Schwitters' collages. Encouraged by the experiments of a precursor, Larry Rivers, and the even earlier ones of Marcel Duchamp, Rauschenberg and Jasper Johns made an uncompromising stand in defence of an idiom that used the materials of the urban landscape. This was the birth of a movement that was rightly described as neo-dadaism, better known by the name of pop art, which is justified by the character of its popular vulgarisation.

At the same time in Paris, Hains and Villéglé were exhibiting their torn posters, Yves Klein (1928-1962) was attracting attention by his impregnations of pure colour and Tinguely by his painting machine. Their three experiments in the immediate and quantitative apprehension of reality led the French critic, Pierre Restany, to draw up his manifesto of the *Nouveau Réalisme*, in April 1960. This was the name given to the new tendency that included Arman's rubbish heaps, Raysse's publicity displays, Spoerri's trap-paintings, and Deschamps' crumpled paper. After that, assemblages of objects, aggregates of scrap iron, collages of torn posters and shreds of tissue piled up inside and outside France.

167

Sonia Delaunay.
Composition.
1952.

Dewasne. Badia. 1954.

Prampolini.
Composition. 1955.
Jonas-Cassuto
Collection,
Milan.

Mortensen.
Jargeau.
1953.
Aronovitch
Collection,
Stockholm.

Vasarely.
Yellan.
1950.
Galerie
Denise René,
Paris.

Success of pop art.

The work of the French neo-realists ran parallel with that of Rauschenberg and Johns, who were now joined by Rosenquist, Wesselman, Jime Dine, Segal, Oldenberg and Warhol. Although the neo-realists and pop artists shared the same fascination for familiar objects, they should not be confused. Everyday reality, which the Parisian neo-realism presented in all its bareness, was the material of pop art too, but the American art differed because it used the mass communication techniques of press and radio. Everything in the United States which goes to make the background of daily life, in the streets, on the walls, in shopfront and in comic strips—the aggressive, banal and typically American reality—this was the avowed province of the pop artists. So familiar was this world to the American citizen that the nation acclaimed those who defiantly hurled it in the face of the universe, and tried to make the new art accepted abroad by exporting it and giving it official recognition.

It was to succeed in this since the International Biennale at Venice gave the First Prize for Painting to Rauschenberg in 1964 and, in the same year, the galleries of Ghent, The Hague and Amsterdam all warmly welcomed the new art. There could be no mistaking the facts: for the first time an independent, autonomous, conquering American art had found its way into history. Naturally enough, it found followers in Europe such as Hamilton, Boshier, Allen Jones, Hockney and Peter Phillips in England, Pistoletto in Italy, and Fahlström in Sweden, to name only a few.

The wave of realism that swept over modern art was a strong one, but it soon met with resistance, on the one hand from artists in the tradition of Malevitch and Mondrian, on the other by a revival of

169

Jasper Johns.
Field painting.
1963-1964.

pure abstraction under the double form of optical and kinetic art. Both depended on geometric effects, contrasts in colour and relief, the discoveries of science and technology, which combined to make a striking visual impact. The juxtaposition of static forms and colours, or forms and colours in movement, particularly in kinetic art, vibrated on the retina. Whatever the means, the aim of both optical and kinetic art was to induce the observer's active participation in the artist's work.

In France, Vasarely headed the movement, which also included Tinguely, Morellet, the Israeli, Agam, and several South Americans, notably De Soto, Cruz-Diez, Vardanega, Tomasello, whose imagination, ingeniousness and austerity gave all the equivalents of painting to their syntheses of forms, space, light, rhythm and energy. They substituted combinations of prisms, plexiglas, aluminium, gyrating discs and projected lights for the traditional materials of canvas, brushes and the chromatic range of the palette.

170 This challenge to accepted notions of time and space was not entirely new. Marcel Duchamp had

Rauschenberg.
Tracer.
1964.

long before created a " ready-made " with a bicycle wheel. Moholy-Nagy's luminous wheel in 1930, Calder's *Mobiles* as early as 1932 had drawn sculpture from its traditional immobility. Now it is painting that has begun to move. The most varied techniques are used today, either alternatively or simultaneously, borrowed from optics, the cinema, mechanics, electricity and electronics. As the technical knowledge required is sometimes beyond the abilities of an individual, groups of artists combine for a single creation. Teams have been formed in France, Italy, Germany, Yugoslavia and Spain, the most lively of which is the " Groupe de recherches d'art visuel " of Paris.

Optical art found artists to practise it and a public to welcome it in the United States as elsewhere. In January 1965, the Museum of Modern Art in New York organised the *Responsive Eye*, an exhibition of optical works, which was soon followed by others in several galleries. The curiosity it roused was all the livelier because the initial explosion of pop art had already died down. An appreciation of a simple, purified, coherent idiom, coinciding with the decline of lyric abstraction, had already been

171

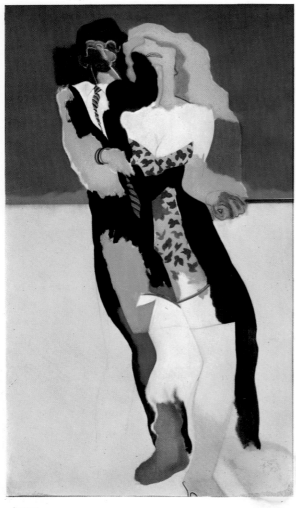

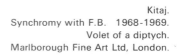

Kitaj.
Synchromy with F.B. 1968-1969.
Volet of a diptych.
Marlborough Fine Art Ltd, London.

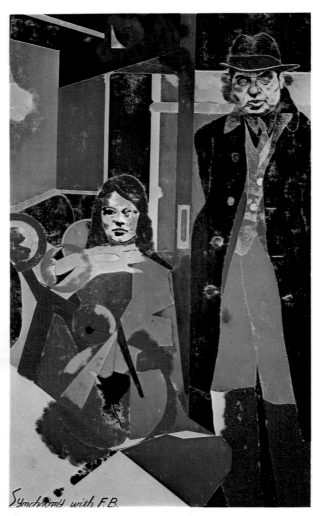

Synchromy with F.B.

Jones.
Hermaphrodite. 1963.
Walker Art Gallery,
Liverpool.

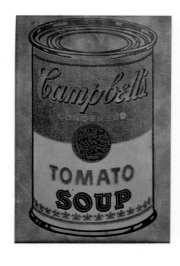

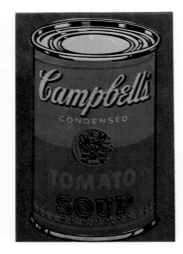

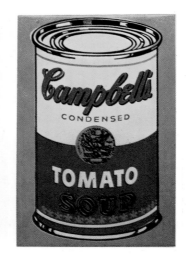

Warhol.
Campbell's Soup cans. 1965.
Left:
Museum of Modern Art, New York;
Center and right:
Leo Castelli Gallery, New York.

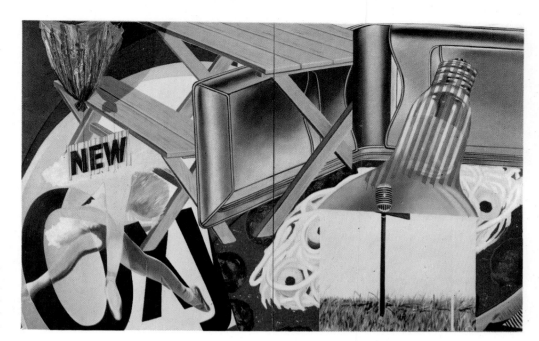

Rosenquist.
Nomad. 1963.
Albright-Knox Art Gallery,
Buffalo.

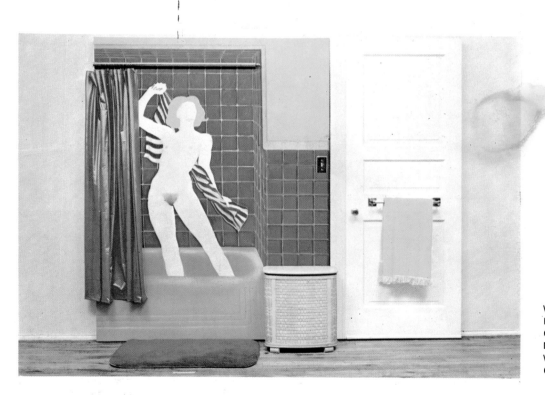

Wesselmann.
Bathtub Collage No. 3. 1963.
Combine painting.
Dr Peter Ludwig Collection,
Wallraf-Richartz Museum,
Cologne.

awakened by the hard edge, constructivist painters, Ellsworth Kelly, Kenneth Noland, Kack Youngerman, Frank Stella and Morris Louis. The support of optical artists, like Benkert, Goodyear, Mieczkowski and Stanczac, sent a wave of geometric abstraction sweeping over the American market: op art, as it was called, in contrast to pop art.

Although pop art spread to Europe and attracted the new generation of artists, it did not find a public. The neo-figurative style imported from the U.S.A. made little appeal to the sensibilities and culture of the old world, where, as in America, op is in process of driving out pop, as pop drove out action painting.

Vasarely.
Orion. 1961.

Vasarely.
Gotha. 1958. Black-White.

Albers.
Fugue. 1925.
Incised
and painted glass.
Kunstmuseum,
Basle.

At all events, a large section of modern painting on both sides of the Atlantic is making a very marked return to a figurative style, while the other section is going back to Mondrian's principles, which seem to have supplanted Kandinsky's. While the neo-constructivists of hard edge or op art bind themselves to a rational method of composition, they are also inclined to depend on the added effects of psycho-sensorial experiment, in a attempt to condition the spectator with the help of materials and techniques offered to them by science.

174 There is no doubt that science has immense possibilities in store for pictorial art which cannot fail

Vasarely.
Vonal. 1966.
Permutational.

Vasarely.
Caracas. 1955.
Black-White.

to be enriched unless the monstrously perfected means at its disposal result in its decline. In any case, it would now seem that easel painting has lost much of its former prestige and that painting is now tending to merge with the other arts to form syntheses that will respond more to the needs of the masses. But there will always be the individual artist to create masterpieces with the simplest and most traditional of tools while others express themselves in a language more appropriate to the century of the atom and electronics. We are now living in an age in which the validity of the old humanist principles is being challenged and the efficiency of our tools has increased enormously. In its affir-

Klein.
Anthropometry. 1960.
Private Collection, Paris.

Monory.
Irena. 1969.
Artist's Collection.

mations and denials, its confidence and its doubts, which make it appear so confused, it is still evident that painting is reflecting the revolution in thought, ethics and even the conditions of our existence. The same questions arise at all the great turning-points in history: how can man reconcile himself to a world which overwhelms him? How can the artist who is tempted to adopt an attitude of refusal, isolation or despair, manage to fulfil himself both in the world and against the world?

The sight of a painting that is slowly groping its way towards as yet unknown horizons should no longer surprise us. Nietzsche said that '' art has no need of certainty ''. What it does need is individuals who are capable of rising to their full height and controlling the torrential forces menacing their integrity. There will always be such individuals.

list of the illustrations

drawings

Bonnard. Woman with an umbrella. 1895.

179

Braque.
Fruit-dish, pipe and glass.
Ink drawing. 1919.

Cézanne. Harlequin. About 1888.
The Art Institute, Chicago.

180

Chagall.
Above the town.
1922-1923.

Chirico. Premonitory portrait of Apollinaire. 1914.

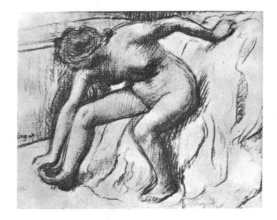

Degas. After the bath. 1890-1892.

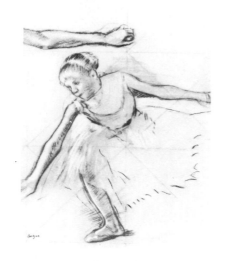

Degas. Study of a dancer.

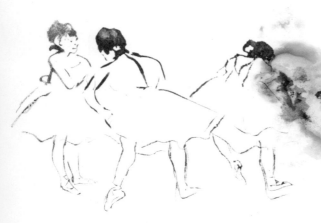

Degas. Three dancers. About 1876.

Dufy. Jockey. 1934.

Gris. Still-life.

Klee. Little girl with a doll. 1930.
C. Schang Collection,
Westport, Connecticut.

183

Manet.
Study for « Olympia ».
1863.

Léger. Still-life. 1949.
Galerie Louise Leiris, Paris.

Matisse.
Nude study. Pen drawing.
1936.

Matisse. The lovely Tahitian.
Linocut. 1937.
University of California,
Los Angeles.

185

Miró. Drawing. 1950.

Miró. Lithograph from the Album No. XIII. 1950.

Modigliani. Self-portrait. About 1918.

Mondrian.
Tree. 1911.
Munson Williams Proctor
Institute Collection, U.S.A.

Picasso. The Frugal meal. Paris, 1904. Etching.

Picasso. Head of a man.
Drawing with collage. 1912.

Redon. Figure in armour. About 1885.
Metropolitan Museum of Art, New York.

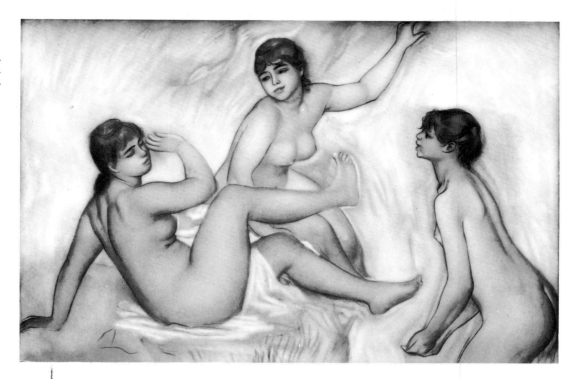

Renoir.
The bathers.
1884-1885.
Musée du Louvre, Paris.

Seurat. Portrait of Paul Signac. 1889.

Toulouse-Lautrec.
The " Promenade des Anglais ", Nice.
Water-colour. 1879-1880.
Private Collection.

Toulouse-Lautrec. Yvette Guilbert taking a curtain call.
About 1894.
Museum of Art, Providence, U.S.A.

Van Gogh.
Boats at Les Saintes-Maries.
Ink drawing. 1888.

Utrillo. Place du Tertre. About 1925.

Van Gogh.
Enclosure at sunset.
1889-1890.
Neue Staatsgalerie,
Munich.

Van Gogh. Self-portrait. 1886-1887